THE COMPLETE GUIDE TO

NATURE

PHOTOGRAPHY

THE COMPLETE GUIDE TO
NATURE
PHOTOGRAPHY

Professional Techniques for Capturing Digital Images of Nature and Wildlife

SEAN ARBABI

AMPHOTO BOOKS

an imprint of the Crown Publishing Group
NEW YORK

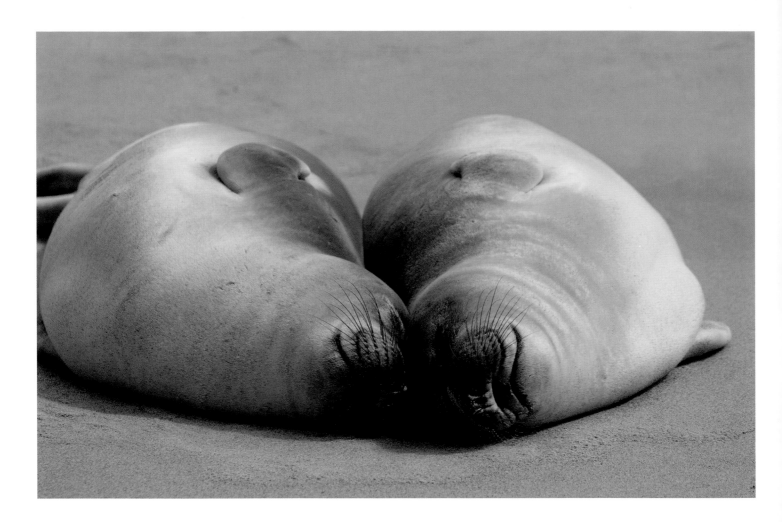

Published in the United States by Amphoto Books, an imprint of the Crown Publishing Group, a division of Random House, Inc., New York.

www.crownpublishing.com

www.amphotobooks.com

AMPHOTO BOOKS and the Amphoto Books logo are trademarks of Random House, Inc.

Library of Congress Cataloging-in-Publication Data
Arbabi, Sean.

The complete guide to nature photography : professional techniques for capturing digital images of nature and wildlife / Sean Arbabi. — 1st ed.

 p. cm.

Includes bibliographical references and index.
ISBN 978-0-8174-0010-1 (alk. paper)
1. Nature photography. I. Title.
TR721.A73 2011
778.9'36—dc22

 2010046695

Front cover and interior design by veést design
Front cover photograph by Sean Arbabi
Printed in China

ACKNOWLEDGMENTS

I must thank the many who have played a part with this second book and throughout my photographic career. Rarely can you accomplish your goals without the help and trust of others.

To my gorgeous wife, whom I met more than 18 years ago, thank you for the best years of my life. You have allowed me to be the person I need to be, encouraged me to follow my dreams, and supported me in every way. Through all of life's struggles and successes, I couldn't be prouder of the family we've created. And to top if off, you continue to get more beautiful each year—how lucky I am.

To my lovely daughters, to watch you grow into such wonderful young girls makes me smile every day. I can see the effect of my passion transferring to you both through your own art and vision, and I couldn't be happier. Sharing my love for nature as your father is a true joy, and I look forward to all of our adventures around this amazing planet.

To my parents, for all their support through my artistic career—I knew this was my destiny, but your love and support helped make my dreams come true.

To all my dear friends and family who have enriched my life in so many ways, you make the time on this earth so much more meaningful. I have always considered my friends as part of my family, and my family as my friends—thank you for all the care, laughter, and love.

To Galen Rowell, Ralph Clevenger, Tony Stone, John Grossman, Julie Coyle, Mark Burnett, Maggie Perkins, Alan Avery, Tim Mantoani, George Olson, Mary Risher, Jose Azel, Timmi Wolf, and all the various friends, clients, editors, art buyers, and art directors who helped my career flourish, and whom I have had the pleasure of working with over the past 20 years as a commercial photographer, thank you for the advice, the articles and assignments, the photo shoots, and the stock sales. Each and every one of you allowed me to follow my ambition, and I thank you for your trust and business.

And finally to Julie, Victoria, Autumn, and the Random House crew—thank you for the opportunity to author my second book, for believing in my work and efforts, and for your patience and assistance. Together we created a book I could not be more proud of, an excellent source for all nature photography enthusiasts.

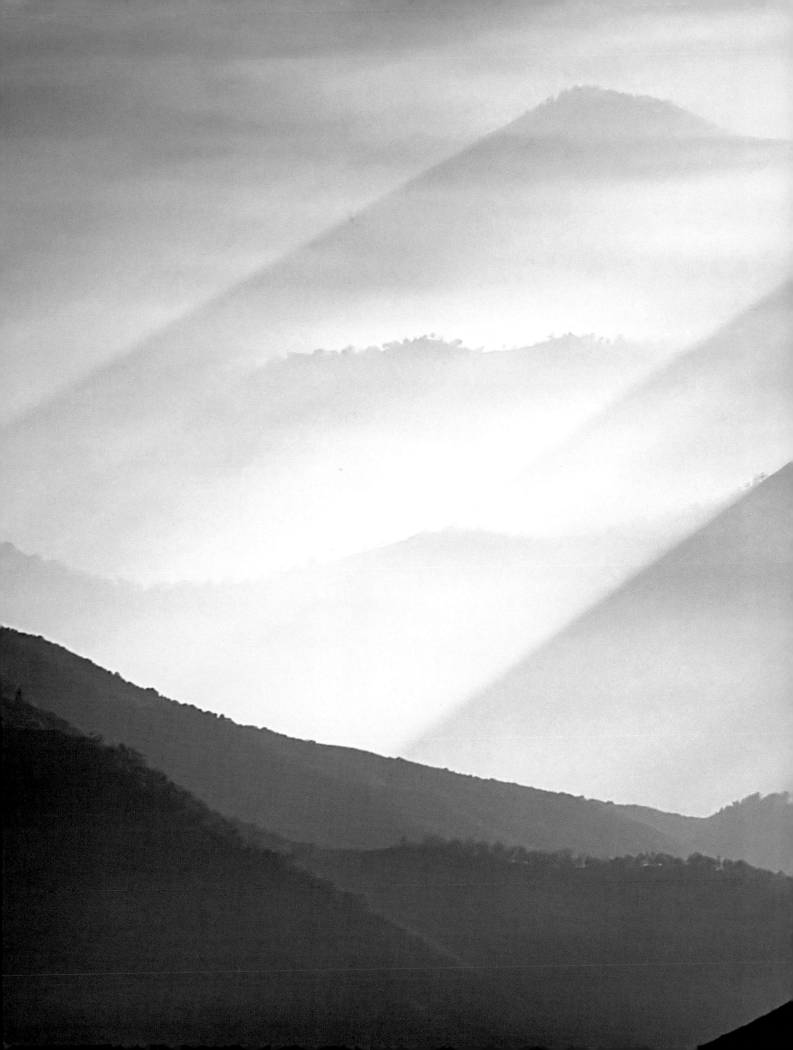

To my wife, Ursula—

I met you early in my days, and I look forward to spending my sunsets with you.

CONTENTS

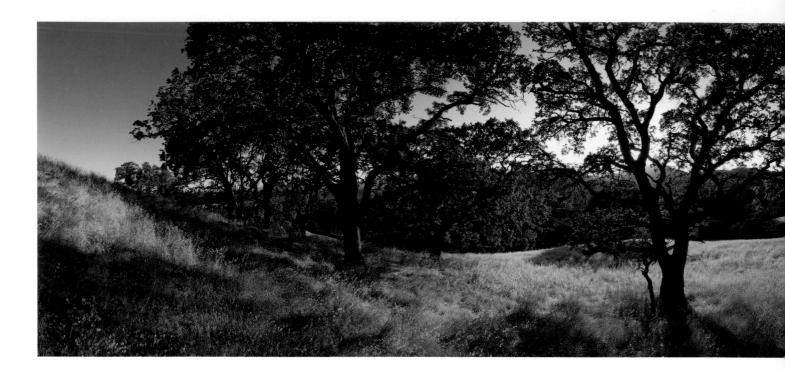

INTRODUCTION

Some of the first photographic images were of the natural world. Today nature remains the most popular subject in photography, dating back to the late nineteenth century, when photographers like William Henry Jackson and Carleton Watkins were capturing the frontiers of the American West, documenting locations such as Yellowstone and Yosemite National Parks. By permanently recording the natural world for millions to see, Jackson, Watkins, and others started the process that led to saving lands, protecting species, and eventually preserving habitats around the world. Thus the power of the still image was born. Illustrating the awe-inspiring force of nature has been an important form of communication as well as a tool for educating. Trees that were seedlings before the time of the pyramids, waterfalls thundering down half a mile into lush valleys, deep canyons carved over millennia, the smallest of living things—intricate leaves, alien-looking insects, and delicate wildflowers—all have been captured on camera and are changing our perception of the world.

I was inherently drawn to the outdoors as a kid. It frightened me a bit, the unknown and its strength; it probably still does in small ways. Even so, I found nature to be an amazing, exciting, and unpredictable experience. Whether I was pulling up the rear on a family walk, rock and shell hunting, searching with the secret hopes of finding a history-changing fossil along a Northern California beach, or fishing for trout and catching water snakes from a paddleboat in Karag Dam—a lake nestled between the Caspian Sea and Tehran in northern Iran—it was all a world of discovery for a small boy, fraught with beauty, danger, and wonder.

Nature is the closest thing to religion in my life. Derived from the Latin word *natura*, which means "birth," it is where my belief in self-education was born and my spirituality was found. To paraphrase Ralph Waldo Emerson, there is no closer place to God than to be in nature. John Muir wrote, "I only went out for a walk and finally concluded to stay out till sundown, for going out, I found, was really going in," describing the cerebral journey that occurs just as much in nature as anywhere else. Whether sacred or secular, this is what I was most drawn to about the natural world; that is, a transcendent place where you learn on your own, push beyond your limits, stretch your imagination, and discover a peace you cannot find anywhere else.

When I found photography early on I could not have known how it would enhance my life and expand my interest in the outdoors. Recording nature onto film was my

first photographic love, and although I capture a mix of commercial outdoor and travel work in digital form today, creating images of the wild still remains my favorite. From taking pictures with a 110 camera on my seventh-grade Albany Middle School class camping trip in Yosemite Valley, to treks as a teenager through California's Sierra Nevada, my fervor for photographing the outdoors quickly formed. Traveling to the far corners of the globe as a young pro, I rafted down class IV rivers in Argentina and carried a 75-pound backpack through the rain-soaked jungles of Borneo. The camera has pushed me to go places I never would have gone and to do things I never would have done had it not been for the thrill and hope of returning with great images. Through it all, a plethora of amazing moments were added to my life, yet I had my fair share of less-than-positive experiences, too. I've been attacked and stung more than 25 times by wasps in Mendocino, experienced back spasms while hiking trails in the Caribbean, acquired food poisoning on assignment through the Mexican Riviera, ran out of water backpacking through Yosemite, and even felt the dreaded homesickness while camping in the Channel Islands. None of it cured me of the wanderlust to see more of the world. In fact, most people assume I love nature wholeheartedly, but I don't see it that way. I describe it more as having a full relationship with the outdoors. I have felt enlightenment, fear, joy, frustration, exhaustion, vulnerability, solitude, and exhilaration —every emotion that makes you feel alive.

So when asked to write a book on the topic, I was excited to merge these two major interests in my life. Some may wonder why I would write a book on nature photography; hasn't it been done? Sure it has, but advances in digital photography have steered the art in a new direction, providing state-of-the-art features and cutting-edge ways to capture the natural world that require a bit of a learning curve to master. The black-and-white masters most likely would have embraced the precise control of programs like Photoshop, the lack of generational loss when creating digital duplicates, new techniques such as high-dynamic range imagery, as well as the mobility of today's small and lightweight equipment. Combining these new digital aspects with the technical knowledge needed to understand and master your camera, such as composition and exposure, is yet another part of the puzzle. However, as important as it is to be technically sound, great nature photography is not about applying a cookie-cutter approach, merely picking up technical details and attempting them on location. This

cannot do the job alone. None of the new digital features or well-established techniques override the importance of developing your vision, a critical skill since the beginning of photography. Producing high-quality nature photography is about the marriage of three facets: learning photographic techniques, knowing how to react to a scene, and having the ability to be creative at a moment's notice. We each bring our philosophical approach to the art. This book not only covers new aspects as well as tried and true methods, but also describes and defines my modus operandi.

When it comes to art, there is only so much you can teach; the rest is up to the individual. The passion to rise at ungodly hours before sunrise, slide out of your warm bed or sleeping bag, and head out into the cold morning for a beautiful landscape image; to hike the long, steep trail on a blazing hot day, by yourself, in hopes of finding some wildlife to capture; fighting the cold permeating through your body on a frigid winter day to catch amazing dusk light—these ventures aren't for everyone. My goal is to help photographers find their personal vision, an enigmatic trait only truly defined through the work each individual produces, combining their skill, technique, experience, and effort. As you read this book, I encourage you to take notes, to try not to get ahead of yourself, to focus on one feature at a time, to reread chapters, to limit your variables, to build a method, and to test yourself in the field. These steps will help you improve over time in a way you can recognize and in a manner that is easily understandable. Part of the goal is to show you my process of capturing nature, to give you ways and ideas on how to document places, to discuss rules of thumb when it comes to photographing wild places, and to share my thought process on the subject. Let your goal be to practice these rules and to find your own system, to mold your particular method and approach to nature photography. You can't work like others when it comes to art and photography. The best strategy is to learn how others do it and adopt a way that works best for you and to exhibit to others how *you* see the world. Don't just take pictures—capture the way it feels out there; convey the power of a storm, the strength of a tree, the movement of a river, and the ephemeral quality of the moment. By doing so, part of the awe and impact of the natural world will come through in your photographs to educate and inspire others.

Ultimately, you cannot forget about the reason for being out there. I simply enjoy the feeling of being in nature and the anticipation of discovering a new area, what it may look like and what I may come back with. Most of the time my experiences are nothing like I expected, and my images are hardly what I could have ever imagined capturing. I believe nature changes people. The process of photographing nature changed me. Documenting places that lift our souls and give our lives balance reveals the power of photography and the splendor of wilderness. Even at times today, the phrase "O God, thy sea is so great and my boat is so small" fits my outlook so well when I'm in nature. I am humbled and overwhelmed by it. I fear and embrace it. Nature is an integral part of my enthusiasm for life and an innate part of all of us. Capturing emotionally driven images to share with others is a privilege I cherish, one that has increased my passion for my art and my love for the outdoors.

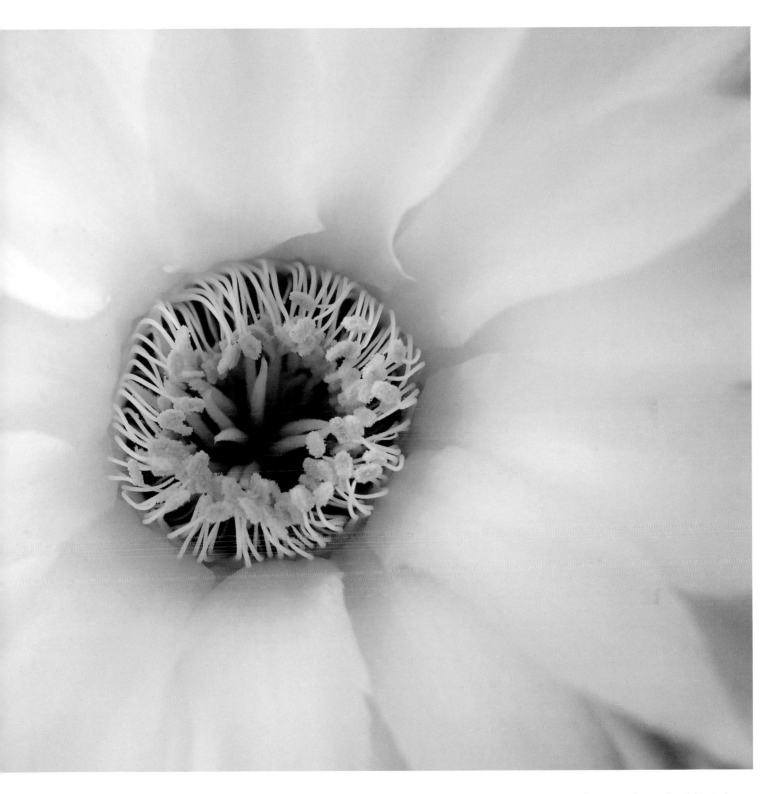

A macro photo of a delicate barrel cactus flower, blooming from a prickly plant fiercely armed with heavy fishhook spines. Captured with a 60mm F2.8 macro lens at f/4 for 1/250 sec. using ISO 64.

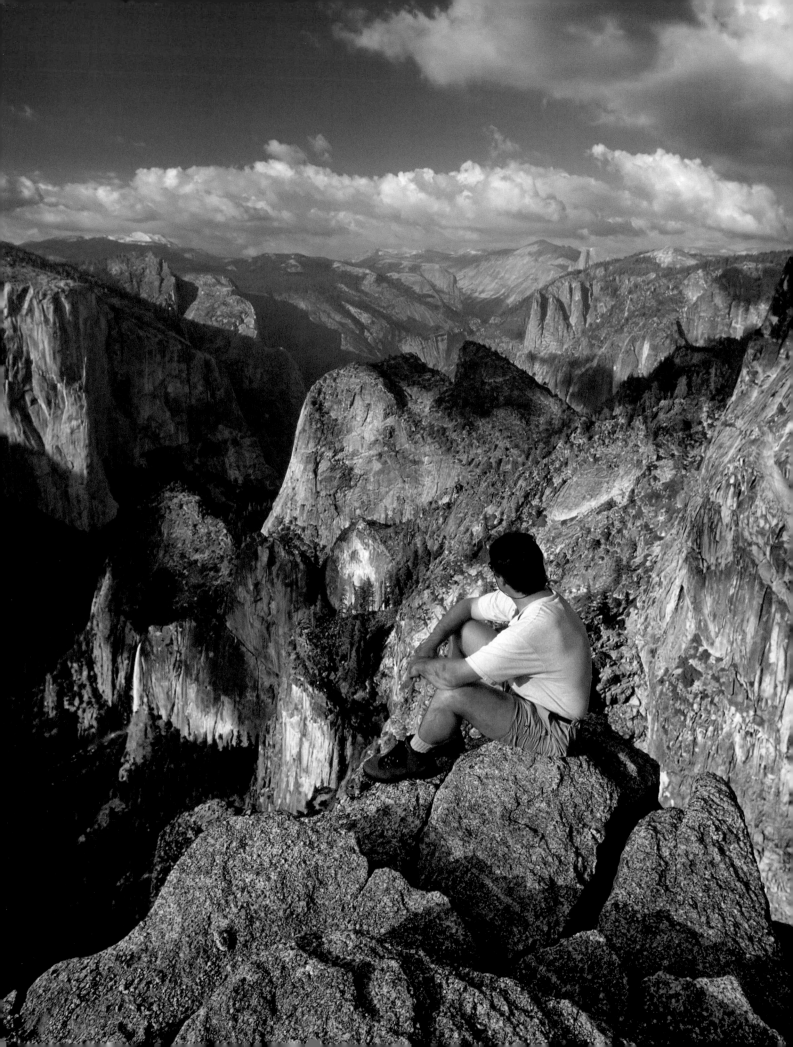

UNDERSTANDING NATURE

Crank up your favorite tunes and roll down the windows to smell the fresh air and feel the wind, or perhaps just walk out your back door and hop onto a trail with your camera. However you do it, at least you are off on a trip to photograph some outdoor location. But is it that simple? I wish it were. To be successful in the field it is good to have a list of tasks to complete before you head out—a plan for your outing, an itinerary.

The artist Henry Hartman said, "Success always comes when preparation meets opportunity." I try to approach all of my photographic trips this way: methodical, detail oriented, and repetitive. This allows me to be as ready as I can be photographically.

Then comes safety. Nature is wild, unpredictable, powerful, and dangerous. Being well prepared and having a healthy respect for the outdoors is undoubtedly the best approach. The unprecedented access we have to nature today allows us to document wonderful scenes not far from our vehicles; unfortunately, this can also provide a false sense of security. Venture deep into the wilderness without forethought and your risks increase dramatically. We, as nature photographers, time and time again find ourselves traveling alone, an activity that offers great peace and focus to our art, but also creates an added threat. Numerous photographers have been injured or killed in the attempt to come away with a few beautiful scenes to share.

This chapter provides knowledge I have gained and used in my trips, and information I obtained by consulting rangers and outdoor experts that could save your life and protect you while out taking pictures.

THE FIRST STEP

Nature photography may be about recording beauty, grandeur, form, and light, but the most difficult part of creating a great shot is all the effort before the capture. A good majority of the time is spent in preparation, whether researching an area, packing your outdoor gear and photo equipment, choosing your planned route and schedule, or simply making the physical effort to get to a location. When the scene is finally in front of you, the execution is usually the shortest and possibly the easiest part of the equation. My nature photography teacher in college said something I will never forget, and I paraphrase: "You can talk all you want about a photo of a bald eagle in a magazine, telling people you could capture a better shot if you were there and had the gear to do so. The fact is, you don't have any images of bald eagles; you've never traveled to that location to fight off mosquitoes, black flies, and the exhaustion that comes with carrying all your heavy gear and camping out in the elements. So you can't say you could have done better, because you didn't." Simply put, half the battle is getting there.

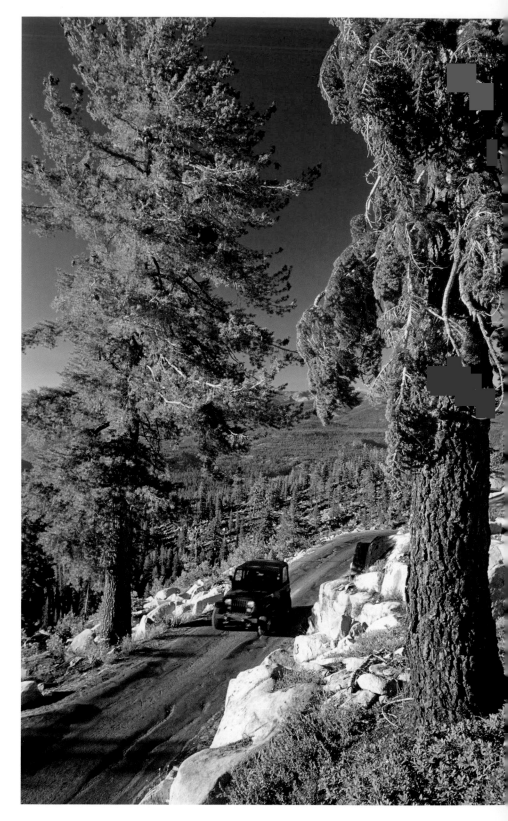

Whenever I travel into the mountains on assignment, I carefully assess everything I need so as to capture the images I want, while remaining safe and sound for days in the backcountry. Shot with a 24mm lens and a polarizer, $f/8$ for 1/100 sec. using ISO 100.

Respecting Nature

I don't travel the backcountry with a sense of foreboding, but instead with preparation and caution. Ed Viesturs, an American mountaineer who climbed all 14 peaks over 8,000 meters without supplemental oxygen, is one adventurer I admire. His mountaineering accomplishments are extraordinary, but it is his approach to climbing that I appreciate the most. Methodical preparation for each expedition and his respect for nature has helped him stay alive into his early fifties. He would tell you that climbing is just as much about proper decision-making skills as it is about technique. Nature may be beautiful and inspiring, but it is also unforgiving. Be deliberate and aware of your surroundings. Although a 2-mile walk back to camp is relatively easy, by being careless, unobservant, or just unlucky, that 2-mile walk could turn into a painful, life-threatening crawl if you run out of water, get lost, or become injured. You must be aware that any decision you make can lead to a multitude of outcomes.

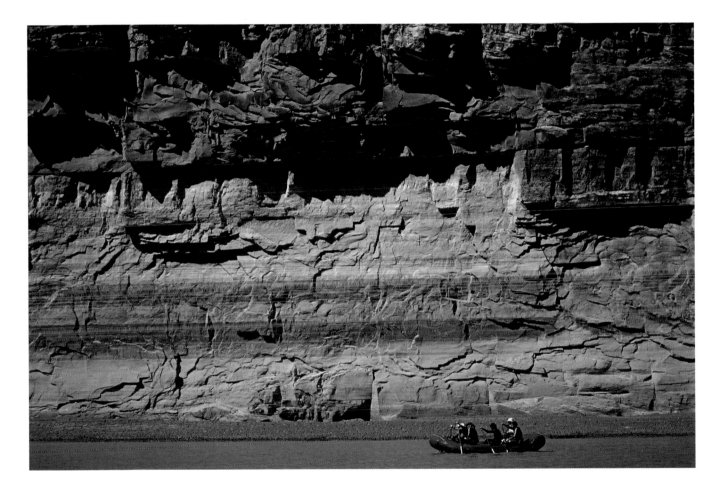

Goals in the Outdoors

Whenever I go photographing, I always have a few goals in mind. Some are part of my personal philosophy, but most should be universal:

- Let people know where I am going—specific roads, trails, and destinations.
- Make safety a first priority in all my decisions.
- Expect to be 100% self-sufficient; smart hikers are the ones who return under their own power.
- Challenge myself to capture great images.
- Leave no mark on the areas I travel through, and leave nothing behind.
- Enjoy the process. Stuck filters on lenses, a scraped knee, or a small unimportant mistake may get me a little frustrated, but if I don't take in all I can while in nature, there is little reason for me to be there in the first place.

Documenting a dramatic scene, such as this one captured along the Colorado River can appear fun, but rafting the rapids of Cataract Canyon in order to get into position for this shot adds that danger factor. Taken with a 50mm F1.8 lens, f/11 for 1/200 sec. using ISO 100.

SAFETY IN NATURE

Any wilderness area can include a mix of environments that challenge you and your equipment. As passionate photographers we find ourselves pushing the limits of safety to get the angle or composition we desire. Yet we cannot be reckless in our methods. Here are a few things to keep in mind when out and about.

Roads and Trails

Trails are not only a source of passage to and from one location to another, they also make for nice leading foregrounds—a topic discussed in chapter 3. Move off a trail and you might be able to hide it completely to produce a pristine-looking landscape, yet you might also step on a snake, twist your ankle on an uneven surface, or even lose the trail. If you have ever traversed a rain forest you know how easy it can be to get disoriented only a few feet from the trail. The same goes for roads. If you leave the road, you can get your tires stuck, start a fire from your exhaust pipe, or lose the path back to the road. Going off-road or off-trail can also trample and damage sensitive areas, especially in desert environments, where vegetation can take years to return.

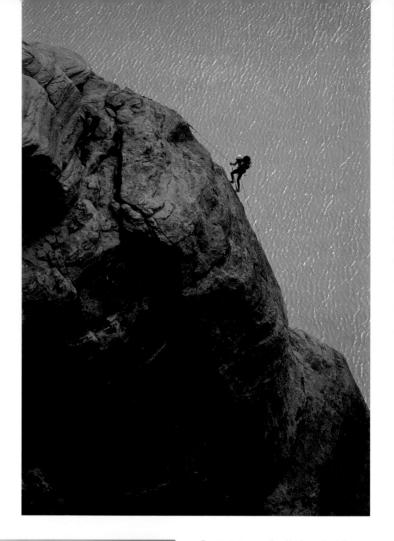

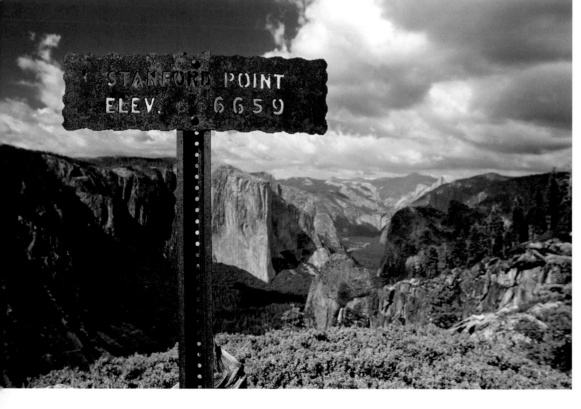

I am not a rock climber, but I had to position myself to capture images of these amazing athletes, while avoiding becoming a casualty myself. Shot using a 200mm F2.8 lens set to f/4 for 1/250 sec. using ISO 100.

Following a trail does not mean you can't get lost. Some trails become overgrown if used infrequently, making them harder to follow. As a dirt path traverses a rocky area, it is easy to lose the trail unless, of course, it is clearly marked. I shot this image of a trail sign overlooking Yosemite Valley. Taken with a 24mm F2.8 lens, f/5.6 for 1/1000 sec. using ISO 100.

Mountains

"An awful power, clad in beauty" is how climber Bailey Willis described Mount Rainier upon visiting the mountain in 1883. As stunning as they are to photograph, mountains provide another whole set of safety concerns. They can create their own weather and have microclimates rarely found in weather reports. As a storm rolls in, temperatures can drop from 100 to 40 degrees in a matter of minutes, so carry extra clothing as well as a waterproof cover for your backpack or photo bag. I recently experienced a wild summer storm in California's Sierra Nevada, the sunny, 90-degree day turning to rain, hail, thunder, and lightning as I walked through a small stream. Higher altitudes rob you of sea-level oxygen and, when combined with steep trails, make for tough hiking. Going cross-country and off trail to hike a few hundred yards through a choked forest can take you hours.

Deserts

Heat-related issues and exposure are repeatedly mentioned when it comes to desert climates. The first priority is having enough water, but knowing where you are and where you are going, and staying covered to avoid sunburn, are other major concerns. Get lost shooting images and 24 hours later you could be in a whole world of trouble. Desert canyons should also be traveled with caution, as flash floods from storms miles away can catch unsuspecting hikers off guard.

Sand

After water, sand has to be the next most common element to get into every piece of equipment, wreaking havoc on the inner workings of your cameras, tripod leg thread locks, glass filters, and lens focusing rings. Make sure to clean your gear and bags thoroughly using canned air and a soft brush. Sand is also hot on bare knees or feet, and when wet it can shift, toppling tripods into oncoming surf.

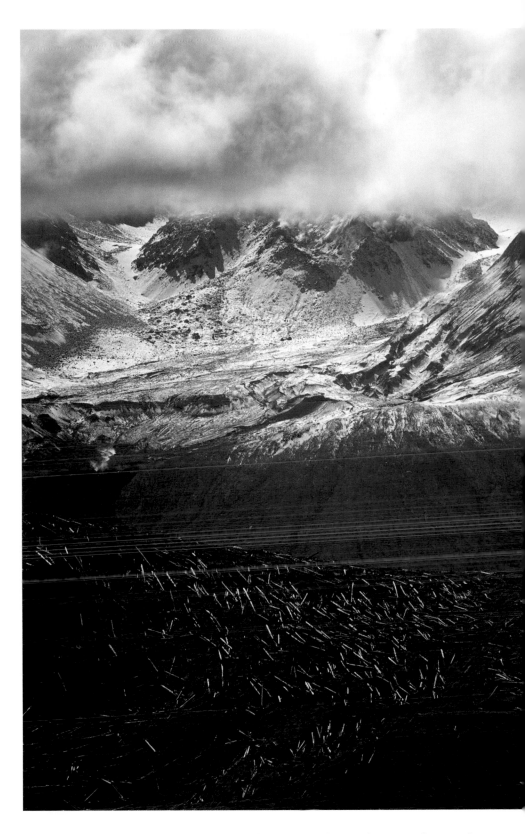

Mount Saint Helens's summit remained hidden for 4 days as the massive mountain created its own weather. I captured this view looking into the crater with a 300mm F4 lens, exposing it at f/8 for 1/125 sec. using ISO 100.

Cliffs

Many times I've found myself inching closer to a cliff to procure a more dynamic composition, but I never forget that these areas are precarious and can erode without warning. If you walk next to a cliff and catch a bootlace, trip, or make any mistake at all, serious injury or even death is a possibility.

Water

As one of the most powerful forces in nature, water offers a mix of hazards. I'm extremely careful around rivers, lakes, and oceans. You can slip and fall in a number of ways, exposing yourself to major injury or hypothermia. Frigid rivers that appear to be slow flowing may hide a powerful current that can sweep you or your equipment downstream. Animals are attracted to water as a drinking source, which is good for wildlife photography, yet a reason to be cautious. Often, positioning yourself for the best shot can be exceedingly hazardous. I knew a man in college who went on to be a top-notch river rafting expedition photographer. Well versed in the powerful ways of water and a class V river guide, he rose in the ranks as an extreme adventure photographer able to capture images most could not due of his knowledge of and access to the water. He navigated some of the world's toughest rivers, some that only few could handle, yet one morning near his home he ventured out on a still lake to kayak, a routine he had performed hundreds of times, and never returned. They found his kayak later that day and his body a month later. If this could happen to him in a place he knew well, it could happen to anyone.

We backpacked up the Yosemite Falls trail and came across countless day hikers struggling to make the top while running out of water. We handed out water pills to some and informed others that they might not make it or may succumb to dehydration if they tried. Most felt the 3-½-mile trail would be short, but nothing is short when it is 3,000 vertical feet straight up. I shot this at the top, where Yosemite Creek turns into Yosemite Falls, with my 24mm F2.8 lens, set to f/22 for 1/15 sec. using ISO 100.

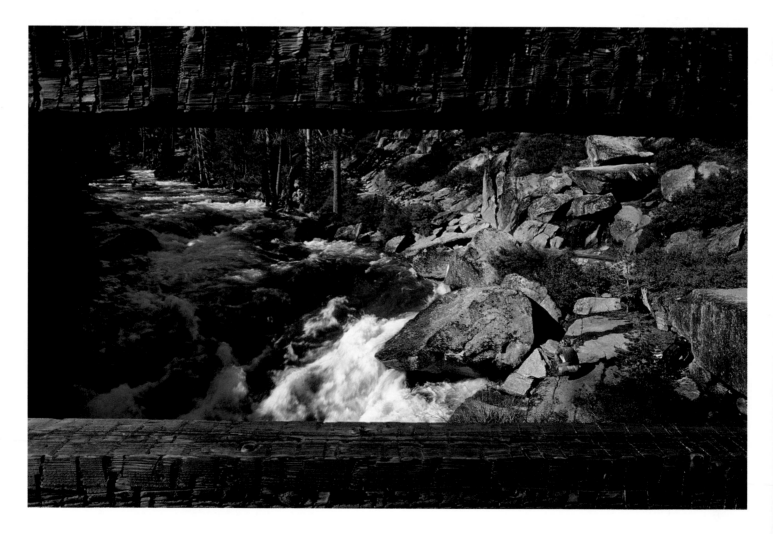

THE COMPLETE GUIDE TO NATURE PHOTOGRAPHY

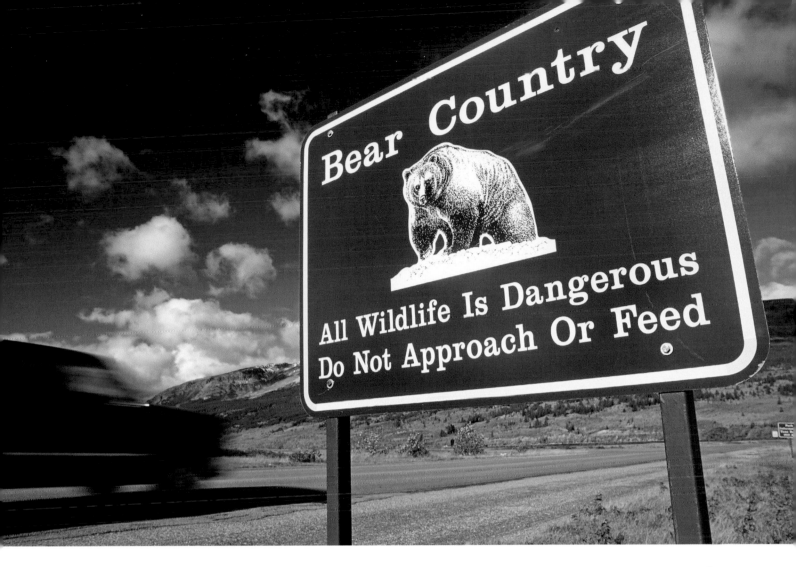

Forest Fires

Forest fires are a huge danger. Avoid driving or hiking toward areas where fires may be occurring. Some photographers gravitate toward fires, hoping to capture an image, but forest fires can grow extremely quickly, travel at high speeds (much faster than a hiker), and roads and trails can become blocked. Know your exit points and leave the area immediately if you smell or sense fire.

Wildlife

Before entering any wilderness, one of the first pieces of information you should obtain is what species of wildlife you may encounter. In all my solo hikes around the West I've never encountered a mountain lion, yet I'm acutely aware that I'm traveling through their terrain and may see one at any point. Even animals such as deer can attack if surprised, provoked, or trapped. Once you set foot into the territory of bears, alligators, or wild boars, if you do not take time to understand the hazards of photographing there, you are underestimating the dangers you may come across. Most animals prefer fleeing to attacking, but a little knowledge and a few extra items (such as pepper spray or a bear canister to protect your food) can lessen the risks. Some studies claim that wildlife attacks on humans have increased dramatically In the last 25 years, partially because of our encroachment on natural lands combined with our population increase, and the lack of knowledge people have about wild animals. We, as nature photographers, are often alone during times of the day when most other humans are back at their campsites, in their tents, or at home—when animals venture out for water or food. Therefore, being keenly aware of your surroundings and what animals may inhabit the area where you are shooting is very important.

Traveling through places like Glacier National Park in Montana, signs like this one on the eastern border make everyone aware that powerful wild animals are present. Heed these warnings, especially if you are lucky enough to spot a bear in the wild. Photographed using my 24mm F2.8 lens, set to f/6 for 1/25 sec. using ISO 100 (with a polarizing filter).

PACKING AND PLANNING

As a methodical packer, I have built different packing lists over the years, depending on the kind of trip or assignment I'm taking. I have specific places for each piece of equipment and timelines I try to follow. Your list may not need to be as detailed, but the more organized you are, the easier and faster you can find what you need and the less weight you have to carry—and those two details alone are worth the effort.

Safety Gear

Your lists may vary, but some essential items should always be a part of your pack.

Headlamp

Hike in the dark without a flashlight and you understand the impediment. A headlamp is a great way of keeping both hands free, useful for night photography, and just as effective for dawn or sunrise shoots, as well as dusk and twilight.

Cell Phone

With new cell towers sprouting every year, cell phones continue to save people in wilderness situations. Make sure yours is fully charged and turned on only for emergencies. Outdoor camping stores like REI even carry a solar-powered battery charger for phones and other devices.

Water

Potable water pills or a filter to make clean drinking water can be lifesavers. Small and lightweight, they are worth more than their weight in gold. Carry extra water regardless, whether to drink or to use in an overheating vehicle. Having more water than you need is smart. Even though I follow this rule, I have had a few borderline cases of heatstroke, one where I was literally within a couple hundred yards of my car in Mexico. When dealing with the elements, anything can happen, so do not stretch your resources too thin, at least until you become more experienced and better understand your limitations as well as the environment around you.

Emergency Blanket

Lightweight and cheap, an emergency blanket packs tightly and can perform many tasks, such as providing lifesaving warmth, becoming a makeshift tent, and protecting your photo equipment in a rainstorm.

Emergency Beacon

This is most critical to carry in areas where you can truly get lost—in backcountry snow with avalanche warnings or cross-country hiking off main trails, to name just two. Beacons allow search and rescue teams to find you faster and more easily. These items add extra security, but having them doesn't mean you should take more risks, believing you could be easily rescued. Instead, they ensure that in any emergency situation, you have a fighting chance.

Photo Equipment

Before you pack your equipment, consider reading your camera's manual. Manuals may not read all that clearly, but having a grasp of your gear and referencing sections from time to time can help. Then, prep your photo equipment before you shoot. Recharging batteries, cleaning lenses, and packing gear in an orderly fashion can make you more efficient in the field. These steps may sound silly, but I find that most workshop students unfamiliar with their cameras are unable to change settings or to locate specific gear in their bag as critical moments pass. By knowing where all of your camera's features and functions are and how to change them, you move faster in the field, eliminating that frustration factor.

We all shoot in different ways, so when someone asks what I carry into the field, I tell them it is all about their personal goals and preferences. Some photographers carry a small shoulder bag with limited gear, others the kitchen sink. I use three factors to determine the equipment I bring on any trip: speed versus weight versus the essential tools needed for the journey. Long lenses usually mean heavy weight and require extra effort. A tripod may provide exposure flexibility but it, too, adds weight. Prime lenses (lenses with fixed focal lengths) offer crisper renditions and a wider maximum aperture for faster exposures, but more lenses are needed to cover the range of one zoom lens. When I backpack, I carry as little as I can since the extra weight of camera equipment adds to my pack. On occasion, I use makeshift straps to attach tripods, or wrap a bandana or a pair of socks around a lens for protection. Choose your equipment carefully, and pack that camera manual just in case.

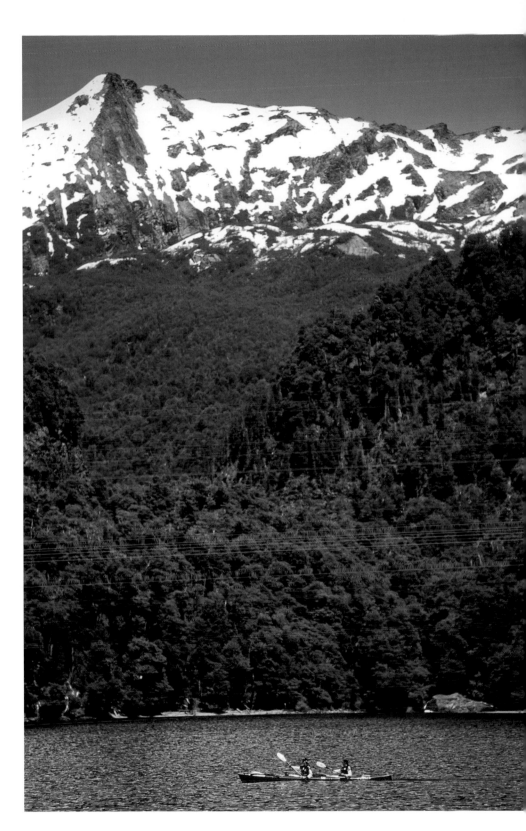

While on assignment in Argentina, one of my tasks was to document kayakers. I had to decide what equipment I would need to allow me to kayak, hike, and swim, so zooms took precedence over fixed lenses. As the kayakers passed an area of lush forests and snow-capped peaks, I directed my 80–200mm F2.8 lens toward them and shot at f/5.6 for 1/500 sec. using ISO 100.

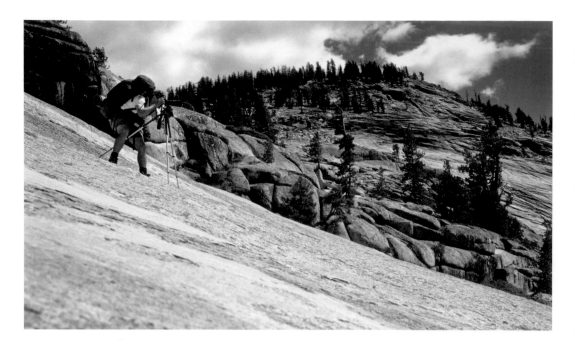

Students who attend my workshops without a tripod miss at least half of the potential scenes they can capture. Here I am shooting a scene in Yosemite's Tenaya Canyon with my trusty Gitzo steadying my 300mm F4 lens.

» tip

Whether using a backpack or a photo bag, I repack all equipment and accessories in the same spot, allowing me a systematic way to grab gear faster.

Protecting Your Gear in the Outdoors

Keeping your camera gear intact and in working shape when shooting outdoors is crucial. Blue skies are not always in the forecast, so on every shoot one big concern is damaging something—whether dropping a lens, breaking a filter, ruining a memory card, or soaking a camera. Consider some of the following information to help you avoid this.

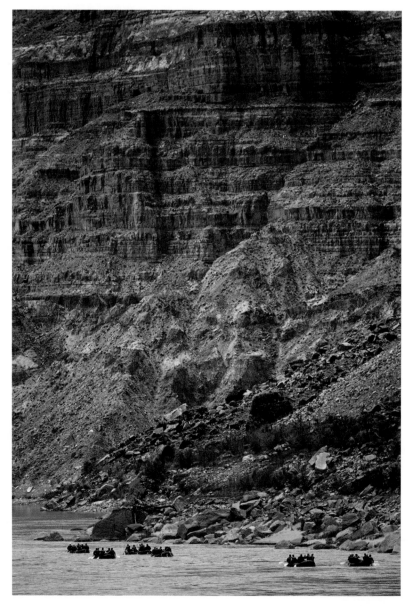

Rafting down the Colorado River in southern Utah required packing my gear into a dry bag to keep it protected from water damage. Using my long 300mm F4 telephoto lens, I captured this shot of rafts passing high cliff walls in the distance, exposed at $f/4$ for 1/1000 sec. using ISO 100.

Water

Water wreaks havoc on photo equipment. Kata and other companies produce rain covers for SLRs and lenses, but I also like to pack a dry bag, large Ziploc bags, and a parka or a backpack with a water-resistant rain cover. Use a four-season waterproof tent or a nearby vehicle to keep your equipment dry during non-shooting times.

Whenever on water, whether in a boat, canoe, raft, or kayak, your first piece of equipment should be a Pelican case or a dry bag—a waterproof rubber bag most often used in paddle sports. Load all your gear into the watertight bag, and if it gets submerged or goes overboard, the bag will float and keep your gear safe. Today's versions offer easier access, and some are even transparent.

Heat

An ice chest is a great way to protect your equipment in extreme heat. It is difficult to carry, however, so is best for vehicles and close campsites. I used one when shooting in Death Valley in mid-July's 126-degree heat, saving my LCD screens from burning up. For the most part, exposing your gear to normal heat will not damage it so long as you don't store it in a place where heat builds up.

Snow

As in any cold weather condition, battery life and condensation are big concerns. When you store your camera or a lens under a parka or coat, your body heat warms it, and then when it is exposed to colder temperatures, condensation is created that normally takes a few minutes to dissipate. I usually carry my camera on the outside of my jacket when it is not snowing or raining, and the batteries inside my coat.

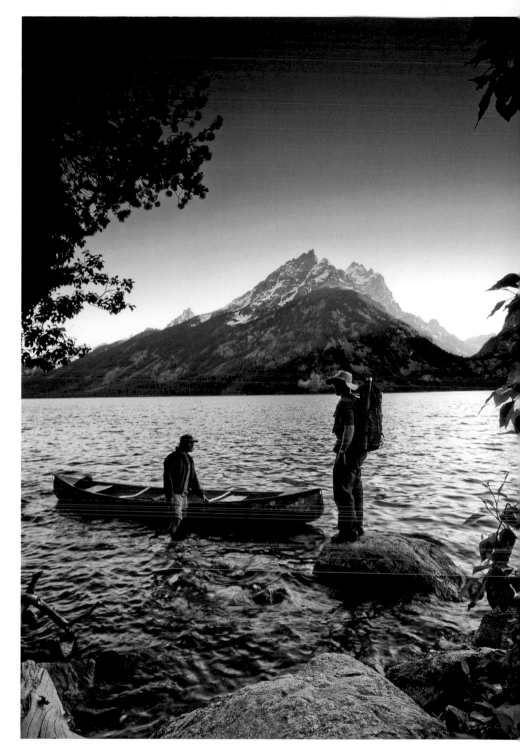

Before heading out across Wyoming's Jenny Lake, I placed my gear into a dry bag to protect it from water damage, whether from incoming waves or the chance of capsizing. I shot this last frame at *f*/16 for 1/4 sec., ISO 100, using my wide-angle lens and a tripod to steady my camera while using a slow shutter speed.

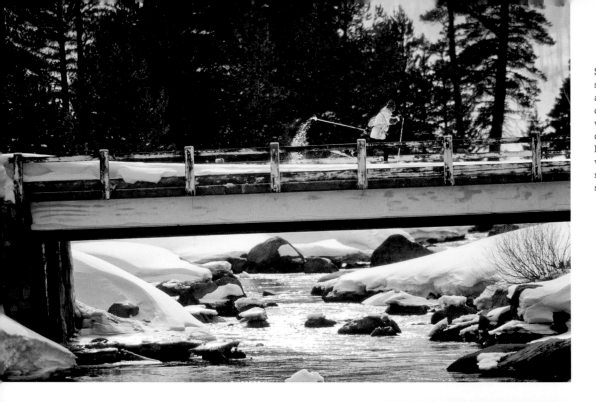

Shooting cross-country skiing south of Lake Tahoe presented a mix of laborious tasks, from dealing with batteries in cold weather, to trudging through difficult terrain, to being engulfed by a winter storm. I shot this with my 300mm F4 lens as the snow began to fall, *f*/4 for 1/250 sec. using ISO 100.

Avoiding Accidents

A slip while crossing a river resulting in a camera smashing onto a boulder or into the water; a tripod with a camera attached slowly being dragged into the ocean as sand softens from the receding tide; a dropped lens rolling and bouncing off the side of Yosemite's Half Dome. I have seen all of these happen to photographers. I had a similar experience when squatting down to snap a photo, only to feel my 50mm lens slip out of my pocket, hit the ground, head over a cliff, and bounce down the hillside. Switching lenses with full hands can result in one slipping out of your grasp. Placing your camera or lens on the ground, not using your camera strap, or simply forgetting you do not have your camera strap around your neck as you let go can result in loss of your precious investments. To avoid mishaps, take time to think about your every move as you rush to capture that great light in front of you.

Cliffs are not for the faint of heart, and mistakes cannot be made when perched on perilous sections, such as this spot on the top of Cloud's Rest in Yosemite National Park. I made sure I was clear of the 5,000-foot drop-off to my right before firing off the scene. Photographed using a tripod with a 24mm F2.8 wide-angle lens and a polarizing filter, the exposure set to *f*/16 for 1/80 sec. using ISO 100.

Clothing and Shoes

I wear comfortable, functional, and lightweight clothing. I carry less on multiple-day backcountry trips. I am willing to wear the same shirt or pair of pants from time to time, yet never skimp on layers for warmth. I always bring a jacket, whether left in the car for close-by shooting, or stowed in my daypack on a hot day. You never know when the weather might turn, and being hot with the chance to strip down is better than being cold without the option to layer up.

Since up to 80% of your body heat escapes through your head, another key piece of clothing is a warm hat. I usually pack a baseball cap to shade the sun and a wool hat for the evenings.

Dry socks and broken-in hiking boots with solid support are some of the most important items of nonphoto gear you can bring. Anyone who has experienced blisters and has had to hike any considerable distance would agree. Bandages and moleskin are also nice for covering hot spots quickly before they turn into blisters. Another option for water shots is wearing Teva-style sandals or fishing waders with felt soles—not only do you stay dry in waders, but your feet stick to slippery lake bottoms and riverbeds.

Maps

The more you know about the terrain, the less likely you are to get lost, which is why I love to study topographical maps. With a great north-east-south-west lay of the land, you can review trail elevation gain or loss, find water sources (depending on the season), locate boundaries, and caption your images with more detail. Topographical maps now come in digital and paper form, and are accessible by cell phone. However, one misconception about topographical maps is the perception of distance. Increases in elevation combined with the weight of a 25 to 50 pound pack can make a 2 mile jaunt an extremely strenuous hike; elevation changes that seem small on maps can be quite daunting in person. Prepare for the extra time to cover distances contingent on the type of terrain, lack of oxygen, the weight being carried, and any weather you may encounter.

» tip

To minimize the chances of theft, hand carry your most expensive photo gear when traveling through airports, preferably in a nondescript bag that won't draw attention. If you must check your camera equipment, use extra protection to ensure less damage in transport.

Having a topographical map can be your lifeline in the outdoors when trails end, directions get confusing along forest trails, or alternate routes are needed. Taken with a 24mm F2.8 lens, f/22 for 1/8 sec. using ISO 100.

Weather

One modern benefit taken for granted is 24-hour access to weather reports, from daily updates to 7-day forecasts on television and the Web, and even full live Doppler radar on my iPhone. Although these reports are not 100% accurate, having an idea of the expected weather can help you determine what to pack according to high and low daily temperature forecasts and potential atmospheric conditions. Regardless, you should always be prepared for Mother Nature's unpredictability factor.

Research

Researching areas you plan to photograph gives you a leg up on time efficiency. Besides wilderness guidebooks and outdoor magazines, access to information online on such reliable sites as the National Park Service (nps.gov) can provide important phone numbers, safety tips, trail information, and more. Rangers are also a great source for information on geography, weather, and wildlife. Had I heard "Highway 120 is now closed for the season," for example, I could have planned for what became an 8-hour overnight drive to Yosemite Valley versus the 90-minute ride at dusk I had counted on. "Please avoid the area due to the likelihood of a bear encounter" could have saved the life of a field botanist near Yellowstone in 2010.

For more about dealing with the weather photographically, see chapter 5.

As the continental divide rises (part of two mountain ranges in Montana's Glacier National Park), incoming weather created by the surrounding landscape can catch visitors and photographers off guard. Shot with a 180mm F2.8 lens, exposed at $f/8$ for 1/125 sec. using ISO 100.

PHOTOGRAPHING IN STATE AND NATIONAL PARKS

I'm often in awe of my surroundings when I shoot in these protected areas, places where past Native American chiefs governed and led battles, presidents formed unions with environmentalists, and artists and photographers were inspired to produce magnificent works. State and national parks are magnificent sources for photographs and have been intertwined with photography since their inception. It is often said that places such as Yellowstone are overrun with tourists during peak months, but hike a mile off the main road or get up for a sunrise shoot and you often find yourself clear of 99.9% of the visitors.

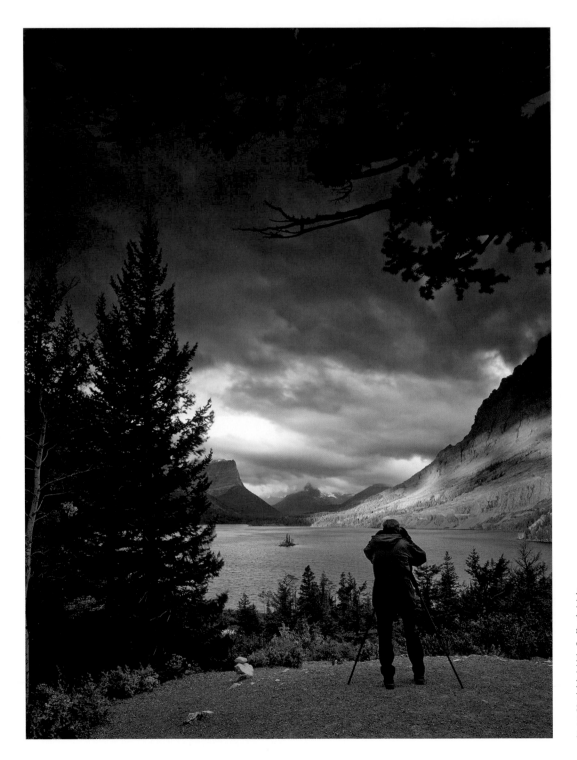

After shooting in Glacier National Park for more than a week, waiting for the rain to stop, my persistence finally paid off when an amazing sunrise took place overlooking Saint Mary Lake. As I set up, other passersby joined me to record the wild light that lasted only a few minutes. Shot using a medium-format 125mm F3.2 lens, captured at f/32 for 1/2 sec. using ISO 100.

Following the Rules

When visiting any regional, state, or national park, as long as you follow general visitor rules, you are not required to obtain special permission or a permit to photograph unless you plan to use your images for commercial purposes. There are no restrictions against using tripods or photographing wildlife, although it should be known that restricted areas or closures are off-limits, and any wildlife or marine mammal photography taken from closer than 100 yards can be a fineable offense. As long as an animal approaches you, and if you are not altering its behavior in any way, most rangers will not ticket you. I personally believe I represent all photographers when out and about, so my behavior and respect for all rules is vital. Having a new restriction put in place for future photographers because of my lack of respect for park rules is hardly what I wish for. Represent yourself as if you are the face of all photographers—because you are.

Photographing in places like Yosemite National Park may not require a photography permit for nonprofessionals, but a backcountry permit is needed to camp overnight. Backpacking into Little Yosemite Valley did require one of these forms. Documented with an 85mm lens at f/4 for 1/60 sec. using ISO 100.

PRE-VISUALIZING YOUR SHOOT

Once I organize my gear I am ready to mentally prepare for my shoot. This does not need to be a major undertaking. The process is mainly to give my mind time to think about where I am traveling and wonder what kinds of images I may capture, what type of weather I may come up against, which gear or camera functions I may use, and how much time I have. If I have to hike, drive, or catch a flight, whether for an hour or a day, I always find time to mentally prepare. Pre-visualization places me in a solid photographic state of mind.

Artist Paul Gauguin described his preparation by saying, "I shut my eyes in order to see." A *National Geographic* wildlife photographer once said he needed at least 3 days to get into the right frame of mind to photograph. Could he walk out of his home and still produce great images? I am sure he could, but using the extra time to draw his focus makes perfect sense. You may not have 3 days to prepare, but if you find time to hone your thoughts it may help you convey your photographic messages a little better. I also delve into this concept a bit more in chapter 3.

LEARNING HOW TO CAPTURE SOMETHING UNIQUE

Now that you are physically and mentally prepared, you may be itching to ask how to create a great outdoor image. Making a pleasing composition, recording great light or bold color, revealing tonal differences, creating mystery or mood, documenting a unique perspective, or capturing an astonishing moment—these techniques all help to add quality to your photos, and I discuss them more in chapters 2 through 10. Yet the steps to finding these scenes are just as confusing, whether you search for them or just happen across them. The ability to find something unique in the wilderness is an innate skill, not a tangible thing you can put into words.

In studying how I see over the years, I find that I first scan a landscape in search of interesting views. I decide which lens I may use and if I need a tripod, consider if I need to move in a certain direction for a better angle, and determine how much time I have before the scene is gone. I also think about my exposure and how it may affect the scene. Then I follow my gut, which is part technical experience, part creative knowledge, part feel, and part emotion—the melding of body, eye, and mind leading me to the best images I can create. It may sound strange, but it is true, and it is not something you can pick up in a week or two, but over a number of years.

I can't tell you how to see; you must study the way you look at things, how you interpret them into a frame, and what you may find interesting to chronicle. Much of art can be taught, but a large portion is intuitive, and every situation is different. Many actions we take as photographers are subconscious, so rules and guidelines are only a start to help you create. You can learn technique, technical aspects, and theory, but putting them into practice is another level. There is no cookie-cutter method for great nature photography. Traits such as patience, the flexibility to roll with change, learning from mistakes, and being persistent are just as much a part of nature photography as learning exposure. This is where you move away from what you have learned and begin to train your eye, trust your gut, and combine all you know into creating a scene you find interesting.

Once you do capture that image and get home safely, the point is not necessarily to let others know how hard it was to get. The goal is to tap into another's emotions, for someone to look at your photograph and say, "Wow, that's beautiful!" or "Where was that taken?" or "I've never seen anything like that before."

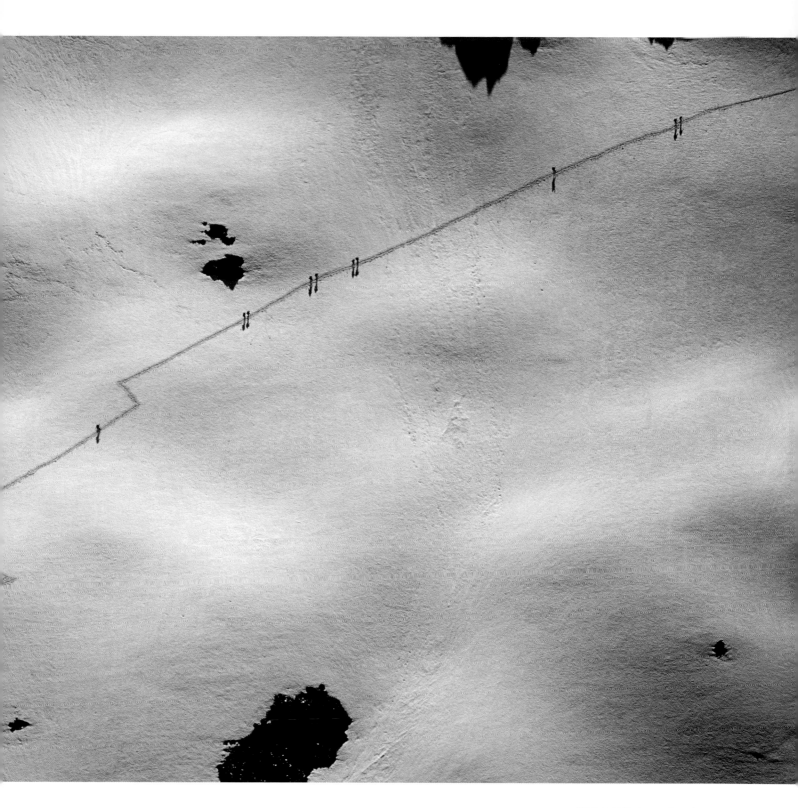

Documenting an adventure race in northern Patagonia, I noticed the row of climbers hiking up a snowy ridge and knew the zigzag pattern combined with their shadows would make a unique image. Shot with a 300mm F4 lens combined with a 1.4× tele-converter at f/5.6 for 1/500 sec. using ISO 100.

Nature Assignment #1:

Pack and plan an outing with all the necessary gear

It may sound basic, but I cannot tell you how many workshop students were late for a sunrise or missed a shot because they couldn't locate a headlamp, a quick-release plate for their tripod, or a rain jacket. For this assignment, create a to-do list, an equipment list, and your personal goals for an imaginary (or real) trip. Pack your photo bag with all the essentials you may need in such a way that you can locate each piece of gear quickly.

For our first assignment, I ventured into California's High Sierra, backpacking to the top of Cloud's Rest in Yosemite National Park. I packed a poncho, my self-standing tent (for dome camping), and all my food and photo gear. Using a tripod with a 24mm F2.8 wide-angle lens and a two-stop graduated neutral density filter, I set the exposure to f/22 for 1/4 sec. using ISO 100, and made sure I was clear of the 2,000-foot cliff to my left and the 5,000-foot drop-off to my right before firing off this sunset scene.

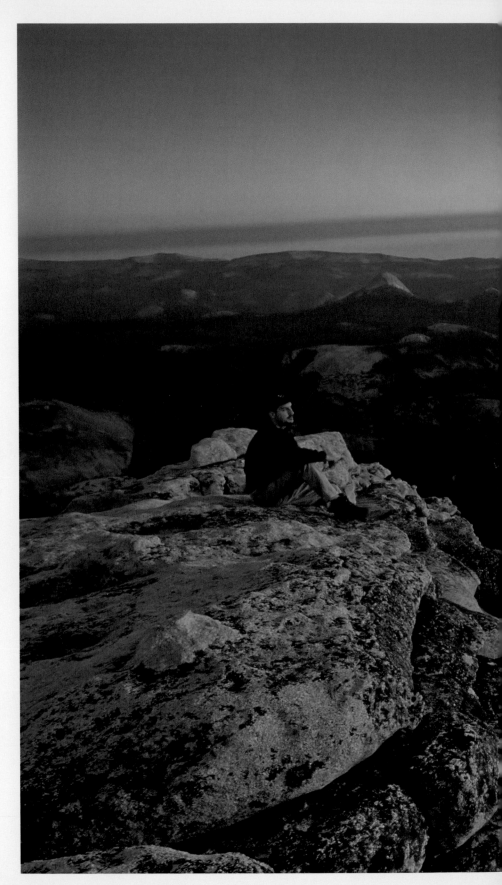

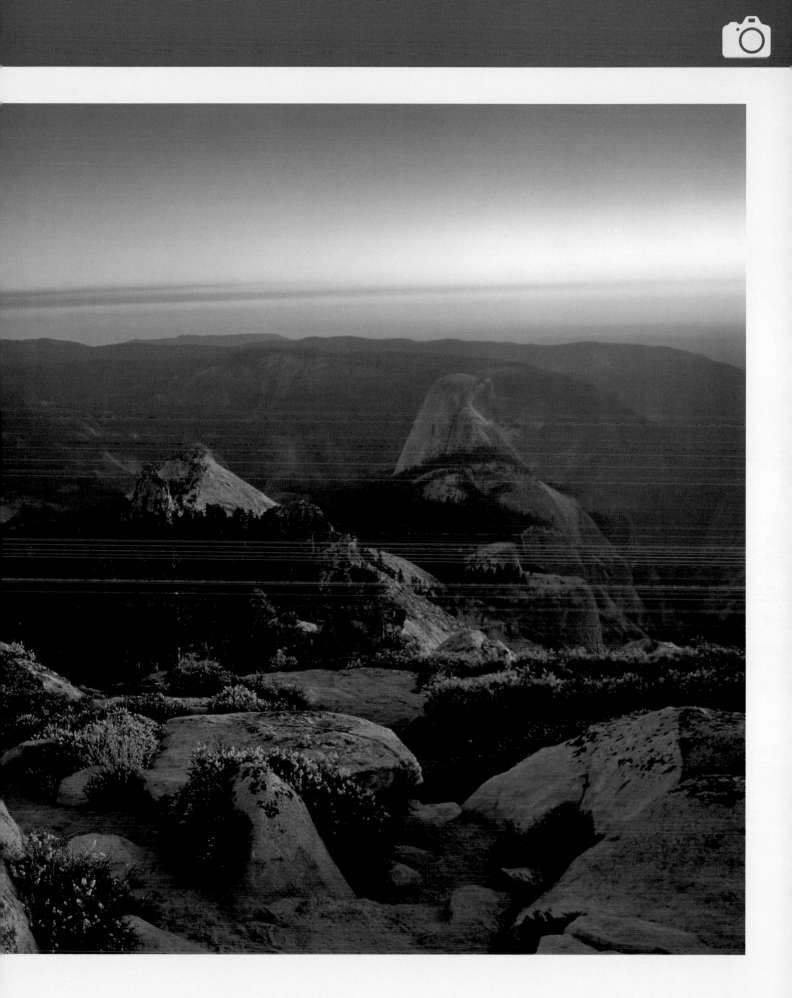

NATURE IN THE DIGITAL AGE

Innovative digital technology has opened doors to many wonderful hands-on aspects of photography, though creating a better photographer is not necessarily one of them. Arnold Newman, an American photographer noted for his environmental portraits, once said, "We do not take pictures with our cameras but with our hearts and minds." It is your creativity and communication of emotions that makes a great photograph, and not the one-eyed metal and plastic box we call a camera. Digital cameras are great, but they do not create dynamic images; your trained eye, education, and knowledge of photography do.

That said, being unfamiliar with your camera functions could leave you disabled in the field. If you understand how to operate your equipment, you can use this knowledge to guide your creativity and progress as an image maker. In this chapter, I cover some features applicable only to digital photography, things today's digital photographer must know, such as the differences between file formats, how to pick a color space, and which white balance to select in the outdoors; these elements do not apply to film-based cameras.

HOW DIGITAL BENEFITS OUTDOOR PHOTOGRAPHY

Most photographers who have made the switch know how rewarding digital can be. Now you have the ability to edit images and color correct scenes, to store EXIF metadata and internal GPS (global positioning system) data that provide exposure and location information, and to take advantage of new features like high dynamic range imagery and panorama stitching that allow you to capture a wider range of light and landscape in one single image file. In post-processing, you can do minor retouching of elements, such as contrails in a clear blue sky, and process raw files, pulling out more information and detail in any given scene; these are just two aspects that have stretched the medium of outdoor photography. One of the biggest benefits of going digital is the instant access to and gratification in reviewing images taken seconds earlier.

Instant Previews

The LCD screen (or monitor) on the back of your 35mm DSLR is a fantastic tool for reviewing your shots; it means you don't have to wait hours or days to process film to see if you nailed the shots. But LCD screens can be misleading—a subject I touch on later in this chapter. Nevertheless, having a monitor to review your images offers a variety of benefits, and one is the ability to learn on the spot.

When shooting river details near Lake Tahoe using a slow shutter speed, reviewing each frame in my LCD screen was of great benefit for checking my colorful composition. Photographed with a 35mm lens at *f*/5 for 1/15 sec. using ISO 100.

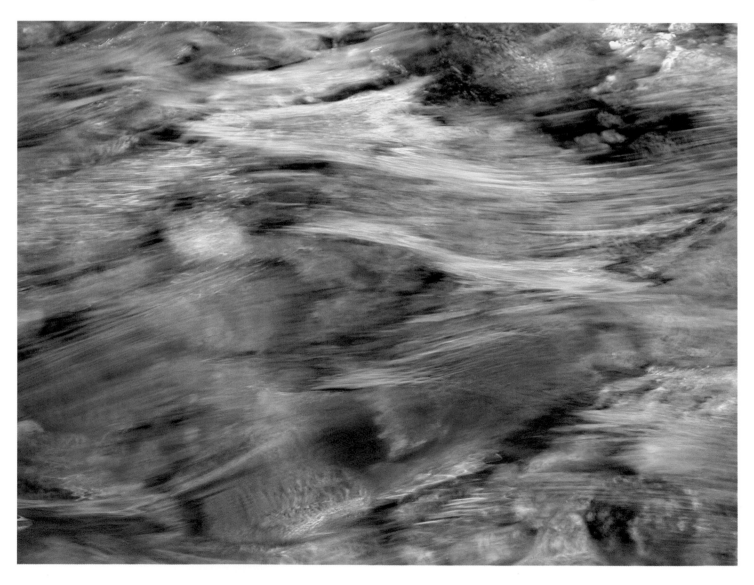

A Learning Tool

Having an LCD screen in the field can help or hinder a photographer's progress. One big issue is the increased speed at which you can capture photos. Photographers quickly review images instead of truly working a scene. Giving more thought to the content of each capture, taking your time to focus and frame your subject, and then reviewing your images can be a learning process. LCD monitors are great for checking framing, to see if you captured a specific moment, or for scanning facial expressions or reactions to see if someone blinked. You can even check an image's focus by enlarging it on the LCD, though it will never appear tack sharp. You can review the shot's histogram, but unless you are an expert at reading histograms and know exactly what you want in regard to exposure, I do not recommend this method (see this chapter's section on histograms on page 51). Another great feature is the ability to study the EXIF metadata, which provides information embedded into each image file, listing the settings at which the photo was taken—your personal exposure assistant. (More information on EXIF metadata is covered in chapter 10.)

Exposure Benefits with Contrasty Scenes

Digital has a slight advantage to film in regard to a scene's contrast. The latitude is wider with image sensors—6 to 7 stops of light from highlight to shadow, while film's range is around 5-1/2 to 6 stops of light. I expand on this topic in chapter 4.

FILM VERSUS DIGITAL

People often say that shooting digital is cheaper than shooting film, but I look at it a bit differently. When you consider only the number of images you want to shoot, digital can be more affordable, but when you add up all the equipment costs over time, film and digital probably come out closer to the same cost. Film cameras and equipment were often investments that would not lose much value and would last years and years. With digital, I buy new equipment more often since the cameras become obsolete within a few years, the latest computers and software are often needed or desired, and hard drives to store images and backups are required—all of which offset the cost of film and processing. But even so, the benefits of digital these days far outweigh film in my opinion: to be able to fix exposures, manipulate shots, remove dust, or make an infinite number of copies without any generational loss. Film has a wonderful quality, but as we move into 20+ megapixel 35mm systems, digital has definitely caught up to film.

To not to have to carry so much film, or reload every 36 frames (especially in freezing cold conditions), or wait hours or days to see if you captured the moment you spent so much time on is quite nice. With outdoor treks, rolls of film add weight, whereas memory cards are lighter and hold a greater number of images; however, they are also expensive and potentially more at risk in the elements.

If you still shoot the "old-fashioned" film way, you are not alone, nor will your images suffer in any way. I captured photos for more than 30 years using my nondigital cameras, some of which are in this book. Sure, digital offers a mix of features that film cannot, but I always say that film is only one step from digital, and that is a high-quality scan. Table 2-1 on the following page gives you an idea of the quality of film as compared to digital megapixels.

» **tip**

I always carry and use a Hoodman hood loupe to view my back LCD monitor. Similar to a loupe for viewing slides on a light box, the enclosed device blocks outdoor light that can create problems when trying to view images in the field, allowing me to review my composition more clearly.

Table 2-1

Film versus Digital

Type	Size	Conversion to digital megapixels
35mm DSLR full format	24x36mm	12–24 megapixels
35mm film	24x36mm	20 megapixels
645 medium format	45x60mm	48 megapixels
6x9cm film	60x90mm	62 megapixels
4x5 inch film	101x127mm	149 megapixels

Then compare megapixels when it comes to print output in Table 2-2.

Table 2-2

Megapixels versus Maximum Print Sizes

Megapixels	Pixel resolution	Print size at 300ppi
10	3872x2592	13x8 inches
16	4920x3264	16.5x11 inches
35mm film scanned	5380x3620	18x12 inches
21	5616x3744	19x12.5 inches
56	9288x6000	31x20 inches

FILE FORMATS

Current digital camera systems offer two types of file formats: raw (.nef files with Nikon, or .cr2 files with Canon) and JPEG (Joint Photographic Experts Group). If you're not currently shooting in raw, you should be. Some feel the additional post-capture time required for raw files does not warrant its use, but the benefits far outweigh the disadvantages. Raw's superiority comes from the unprocessed data it retains, not compressed or converted, with no original information lost, thus obtaining the most data and in the purest form. It captures the highest quality in color range, detail, and contrast ratio (the widest of all formats at 12 or 14 bit, as compared to 8 bit in JPEG). This optimal format also provides up to 2,000 times more archival information than a JPEG file, and the pure data gives you more flexibility to manipulate photos when preparing the final digital image in your computer—exposure corrections, white balance, and recovering detail—all with few or no visible digital artifacts (less noticeable degradation in your final digital file); this is critical when it comes to the range of light in outdoor scenes. Raw is also beneficial because the original file can never be overwritten. It may store changes you made and allow you to save it as a .psd (Photoshop format) or TIFF file, but the original is always available for future use. The only negative of raw is the larger file size; it occupies more card or disk space, as well as the aforementioned additional computer time.

JPEG is a file version compressed by your camera's built-in raw converter, broken down into high-, medium-, and low-quality file sizes. JPEG Fine or JPEG High compresses to a ratio of roughly 1:4 (a quarter of the size of the normal file); JPEG Normal, the middle quality setting, compresses to a ratio of 1:8; and JPEG Basic or JPEG Low, to a ratio of 1:16. It may be the smallest digital file your camera produces and the most popular format used in digital (a universal format able to transfer and open quickly for easy manipulation and adjustments), but JPEGs are not archival. If you produce an 8-bit file (limiting your scene in color and detail, and exhibiting higher contrast), make any adjustments, and resave the file, you begin to lose information by recompressing the file over and over—what is known as a "lossy" compression. The file begins to suffer in quality through generational loss of information.

I shoot in RAW+JPEG Fine mode exclusively. This dual format offers the best of both worlds by producing two files with each capture. This gives me the raw archival file I need, with the option of a smaller jpeg file to quickly review, e-mail, share, or post online. (JPEG Fine gives me a high enough quality on screen, yet is small enough to transfer quickly.) This takes up more memory card space, so I carry a few additional memory cards to cover me in the field.

Converting Raw Outdoor Images

Through raw conversion software like Photoshop, the potential to extract more color, detail, and tonal range from your files provides a major benefit for outdoor photographers dealing with such a diverse array of subject matter and lighting contrast when in the field. Working with raw files can be time consuming, but no more so than the time it takes to get film processed, reviewed, edited, and filed away. My goal is to render a raw image that matches the scene I saw. I will elaborate on a few of my techniques in chapter 10.

Correcting Exposures after the Capture

Another advantage of digital is the capability to make post-capture exposure alterations. Even so, it should be noted that there are a few negative aspects of depending on post-processing: it can be quite time consuming, there can be irrecoverable loss of information in the most under- or overexposed areas, and artifacts can build up in your digital file. This is why I always say that learning exposure is better in the long run. I share more information on how to expose in chapter 4 and discuss post-processing exposure corrections in chapter 10.

IMAGE SENSORS

Image sensors are to digital cameras what film is to traditional cameras. An image sensor is a silicon chip containing millions of photosensitive diodes called photosites that convert light into an electrical signal. The image file stores the recorded light data as a set of numbers that correspond to the color and brightness of each pixel on a screen.

The larger and higher-quality your image sensor is, the greater dynamic range it can capture in an image file. The large LCD screen and the overall look of a digital camera is the flashy exterior, whereas the image sensor is the engine. This is why it is usually one of the main deciding factors when I purchase a camera.

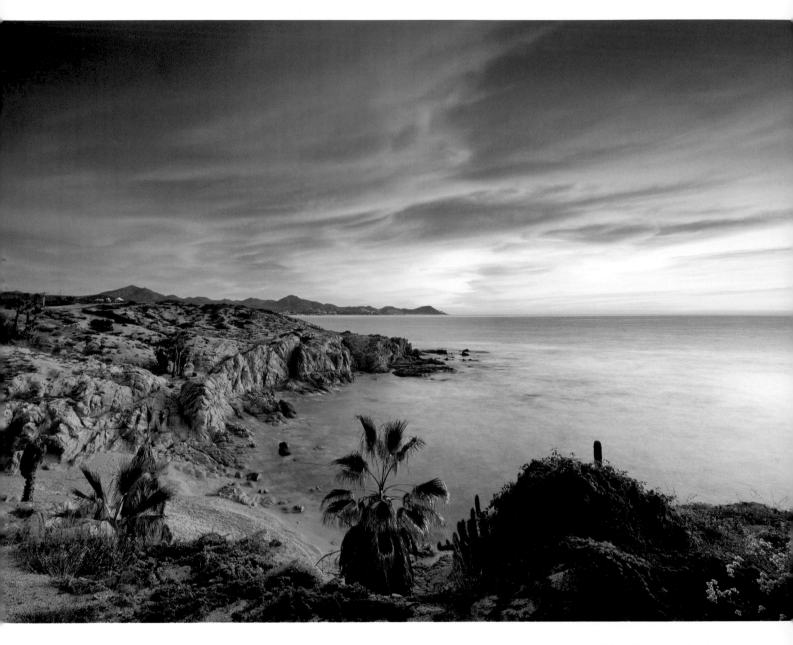

Originally captured using my medium-format Fuji 680 III camera system, I was able to scan in my 6×8cm negative, producing a 300MB file that was large enough to retain all the detail in the original film, as well as create a large high-resolution fine art print. Exposed at *f*/32 for 2 seconds using ISO 100.

How Sensor Size Affects Your Final Print Output

Since nature photographers often use a print as their final art form, knowing how the size of your sensor affects the size and quality of prints is important. Point-and-shoot cameras may be lightweight and compact, and offer the same megapixels as a 35mm DSLR, but they use smaller image sensors and produce lower-quality enlargements. Many consumer-level SLRs use larger APS sensors, slightly smaller than 35mm film size, giving you better results yet resulting in a crop factor ranging from 1.3 to 1.6 (check your camera's manual to confirm yours). This affects the length of your lenses, depending on the lens type you may have purchased; some Nikon DSLRs allow you to switch between DX (24x16mm) and FX (36x24mm) modes to accommodate different lens formats.

Pro-level DSLRs use full-frame sensors, equal to the size of 35mm film (36x24mm)—high in quality, high in price. Jump up to a medium-format digital system and you will find the largest image sensors with the highest-quality image files; however, you lose mobility in the way you shoot, the added weight can be a problem for some types of outings, and the price matches the cost of a new car.

Image sensor size also affects digital noise: the larger your sensor, the less noise you obtain. This is most notable at higher ISO settings. A smooth, noiseless image gives much higher quality for large fine-art prints.

TRAVELING WITH DIGITAL MEDIA

Outdoor photographers have always had concerns when it comes to traveling with their equipment, film, and digital media. After 9/11, numerous changes came down the pike in regard to what you could transport, how your baggage was scanned, and how these limitations might affect your photos.

Airport Protection

According to the Transportation Safety Administration (TSA), their screening equipment will not affect digital cameras and electronic image storage cards. I have yet to have any problems with losing digital media on my memory cards, portable hard drives, or laptops. But I always recommend backing up your images to a secondary storage device. I never had problems with film, but then I always hand-checked my film, because traveling through multiple airports on a trip could result in X-ray problems. The TSA also allows electronic devices powered by lithium batteries, such as digital cameras and laptops, as carry-on baggage, since the Federal Aviation Administration deemed them to be nonexplosive. Nevertheless, because equipment and travel regulations change on a regular basis, always check the TSA's website (tsa. gov) for the most updated information.

Portable Hard Drives

As essential travel equipment, portable hard drives are affordable, have large storage capacity, and allow me to download and back up memory cards, giving me the security of not losing any image files. I often copy my images to my laptop and to a portable hard drive, while keeping the original image files on my memory cards until I return to my office. I have yet to lose an image file and believe this is due to the consistent way I back up my files.

COLOR SPACE

Choosing the right color space, an option found in your digital camera's menu, for nature photography is no different than for any other type of photography. There are two main color spaces used in most DSLRs: sRGB and Adobe RGB. A color space establishes the gamut of hues available in your image file for viewing or print reproduction. sRGB offers the least amount of color space, whereas Adobe RGB incorporates a wider range. sRGB was created for monitor viewing, but Adobe RGB seems to be the standard these days, while Profoto RGB is best for printing. I see no purpose in using sRGB since obtaining the widest range of color and information in your image is one goal in nature photography. This is why I set my camera to Adobe RGB.

One nice aspect of shooting in raw format is that the unprocessed image file is not locked into a specific color space set in camera, unlike JPEG files.

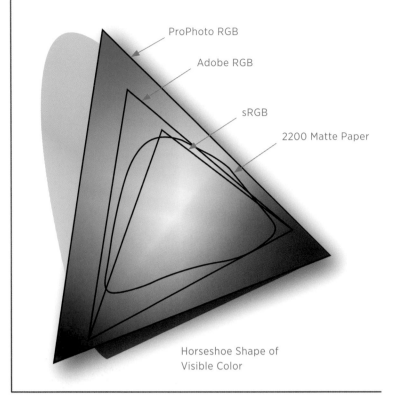

ProPhoto RGB

Adobe RGB

sRGB

2200 Matte Paper

Horseshoe Shape of Visible Color

Chart showing the various color spaces available and the hues they cover.

Tonal Values in Digital Files

Color information in digital image files is also obtained through bit depth—usually 8, 12, 14, or 16 bit. Bit depth determines the number of tonal values to be recorded. JPEG files record at 8 bit (with 256 tonal values available); raw files record at 12 or 14 bit (16,384 tonal values), with the ability to open at 16 bit (giving you 65,536 tonal values in a single file).

REFERRING TO YOUR LCD SCREEN IN THE FIELD

Having immediate access to your photos in the field is great, and with recent additions like LiveView, looking through your viewfinder is not even necessary. But if you rely completely on your LCD screen previews, problems can arise.

Limiting Your Reviews

A trend I see with digital photography is students incessantly analyzing their images when in the field. I believe this can create distraction when shooting; you pay less attention to detail, making you lax with your captures. You end up losing touch with the method of working a scene in front of you. I recommend limiting the reviewing process when shooting. It's not easy to do, especially for those who started in photography using digital, but this method tends to help photographers focus on the task at hand and creates better final images.

Understanding the LCD's Limits

Taking refuge in your LCD screen is not the best technique, because what you see on the LCD will not necessarily be what shows up on your computer screen. Bright outdoor conditions can reflect on the screen; the LCD screen is much smaller than a computer monitor; and your camera's LCD screen is simply lower quality than your computer monitor. Exposure anomalies and camera or subject movement are the two biggest factors that regularly differ from camera to computer.

Flip-up caps or loupes can keep out some reflections but not all, and trusting your LCD to show an accurate depiction can lead to less-than-satisfying images back at home.

Many photographers use their LCD screens in combination with the histogram to judge exposure when other basic options are better, such as understanding how your meter works or how light affects exposures. Although your screen will give you a ballpark idea of the exposure, knowing how it converts to your computer is important. Imagine watching your high-definition television atop a mountain on a sunny day, then at night in a darkened tent. Even though you hadn't adjusted the brightness, contrast, or color, there would be a drastic change in the way the TV screen looked to your eye. Relying on your LCD screen for all of your exposures not only will give you a false sense of proper exposure but may stifle your progress.

What *can* your LCD confirm? It can confirm composition, if you captured a moment, and possibly focus (if you zoom in on the focused area and understand that it will not tell you if it is tack sharp, but will give you an idea if you were close).

SETTING A PROPER WHITE BALANCE

White balance (WB) is a feature added in digital photography that allows you to correct for shifts in light, measured through Kelvin color temperatures. These numbers do not refer to heat but to color (see the scale below). Setting the proper white balance in the field is not as easy or accurate as it is made out to be since color shifts occur as time and weather changes throughout the day. However, one huge advantage of shooting in raw is that your white balance isn't processed in the image file, and you can easily correct for any color temperature shifts in post-processing using programs such as Apple's Aperture, Adobe's Lightroom, or Photoshop's Adobe Camera Raw (ACR). (For more about this, see page 226.)

This chart gives you an idea of how specific sources of light shift in a certain direction. Color temperatures in the Kelvin scale represent certain types of lighting conditions, and white balance helps neutralize these shifts by producing opposite colors, correcting the overall hues in a given scene.

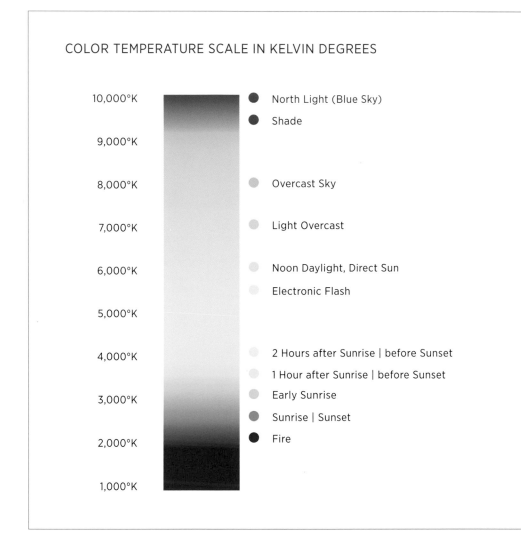

COLOR TEMPERATURE SCALE IN KELVIN DEGREES

10,000°K	● North Light (Blue Sky)
	● Shade
9,000°K	
8,000°K	● Overcast Sky
7,000°K	● Light Overcast
6,000°K	● Noon Daylight, Direct Sun
	● Electronic Flash
5,000°K	
4,000°K	● 2 Hours after Sunrise \| before Sunset
	● 1 Hour after Sunrise \| before Sunset
3,000°K	● Early Sunrise
	● Sunrise \| Sunset
2,000°K	● Fire
1,000°K	

How White Balance Affects Color

Color shifts come from change in the balance of white light, and whenever one hue is dominant over another, often through atmospheric conditions, a shift occurs. Sometimes it is aesthetically pleasing, such as a sunset; other times is it not, such as a heavy blue shift in a face in shade. Film photographers use filters to correct for these shifts, but with the advent of digital, white balance has taken on this role. Our eyes and minds tend to adapt and correct for these shifts, making it more difficult to notice, but our image sensors and film take them at face value. Begin to pay attention and you will notice these subtle changes. As you do so, you'll learn where and how to implement white balance into your arsenal of photographic choices to create more accurate color renditions—warm up the cool tones captured in overcast light, or lessen the extreme orange tones of a campfire.

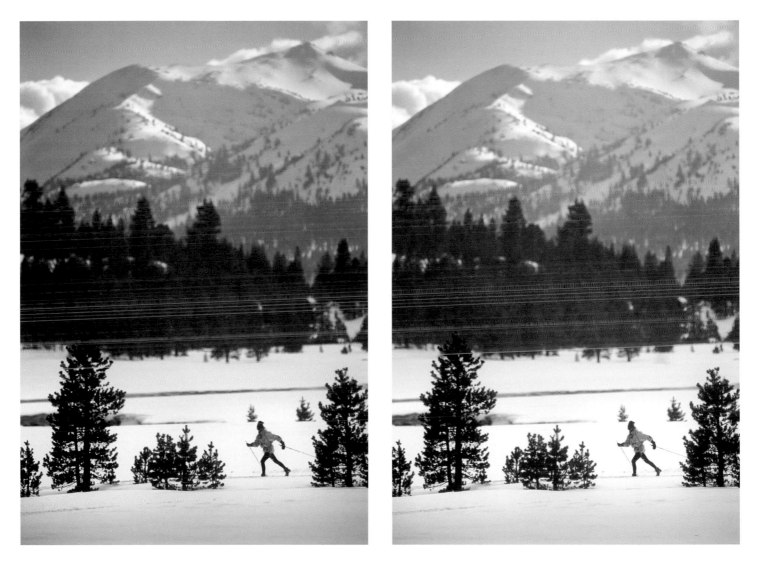

While photographing this skier, the sun was blocked by the clouds, which caused a shift in color. My white balance was set to Direct Sunlight, causing a blue shift in the image. The left photograph is the original file, and the one on the right is the color-corrected image.

Using White Balance Presets

Digital cameras provide a number of presets that give you a choice of basic shooting conditions to obtain proper white balance. In many cases, the color may be fairly accurate, but not altogether dead on. If the situation you are photographing fits into one of these presets, you can set the white balance to it and watch the color adjust automatically. General menu settings vary from camera to camera, but most include:

- Auto: Using a best-guess algorithm, Auto decides which color temperature to use by measuring the light.
- Tungsten/Incandescent (3,000 K): This is rarely used in nature; it is mostly for warm shifts under incandescent light such as household lamps and candlelight.
- Fluorescent (4,000–4,500 K): Set to correct for fluorescent lighting; seldom used in outdoor photography.
- Direct Sunlight (5,000–5,500 K): Used in most general conditions where direct sunlight is available, such as a blue-sky day. Best set for shooting sunrises and sunsets to allow the natural color to occur without being corrected or neutralized.
- Flash (5,400 K): Use when you employ your flash for any scenes. See chapter 6 for more on this.
- Cloudy (7,500 K): Used in situations where the sun is blocked by clouds, such as an overcast sky. Light overcast is close to 7,500 K, while heavy overcast is upward of 9,000–10,000 K; in the latter situation you can consider using the Shade setting, or some post-capture corrections may be needed.
- Shade (10,000 K): Adjusts for the heavy blue shifts with subjects in ambient or indirect sunlight. Used when your whole scene is in shade.
- Choose Color Temperature: A preset allowing you to choose any specific color temperature, from 2,500 to 10,000 K, to correct a shift or create a certain feel.
- White Balance Preset: Using a neutral gray or white object as a reference for white balance, a WhiBal card (offered through RawWorkflow.com), or white balance lens cap (through Photojojo.com), you can set your white balance manually, procuring the most accurate color.

Comparing Auto to Manual White Balance

When it comes to white balance and outdoor photography, I either shoot in Auto white balance or Daylight white balance. Some do not believe in using Auto, and although I agree it can't give you perfectly accurate white balanced images every time, neither can any other preset. If set correctly, manual WB, and maybe most presets, will beat auto in the accuracy test every time, but then again, how often do you want to disrupt the flow of your photography by adjusting your white balance over and over? What happens if you move from a sunny situation to shade, or if a cloud suddenly blocks the sun and you forget to change your white balance?

This series compares a scene shot in shade using the WhiBal gray card, the first image using Auto WB, the second Daylight, and the third Shade. You can see that Auto does fairly well, although it is still slightly cool; Daylight shows the strong blue effects of shade; while Shade gives the most accurate representation of color.

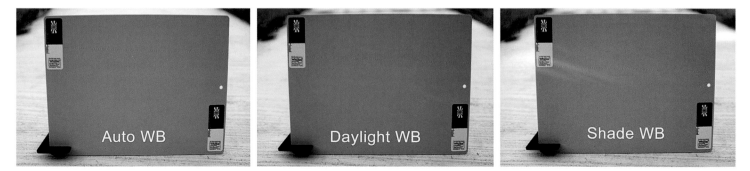

Auto WB Daylight WB Shade WB

I recommend using Auto at the start, slowly integrating a white balance preset from time to time. Then shoot in raw. The unprocessed file does not convert white balance regardless of your settings; only JPEG formats do. For more on how I prep my image files and correct white balance in post-processing, see page 226.

One last scenario to consider is white balance correction on images you may not want to correct—cool-toned scenes of snow, shade, or ice, or the warm tones of sunrise or sunset. Sometimes a slight blue shift adds to the frigid feeling, and once corrected the image loses a bit of its message. "Perfect" white balance may be preferred for many scenes, but in other situations, color shifts may create a desired feeling or mood.

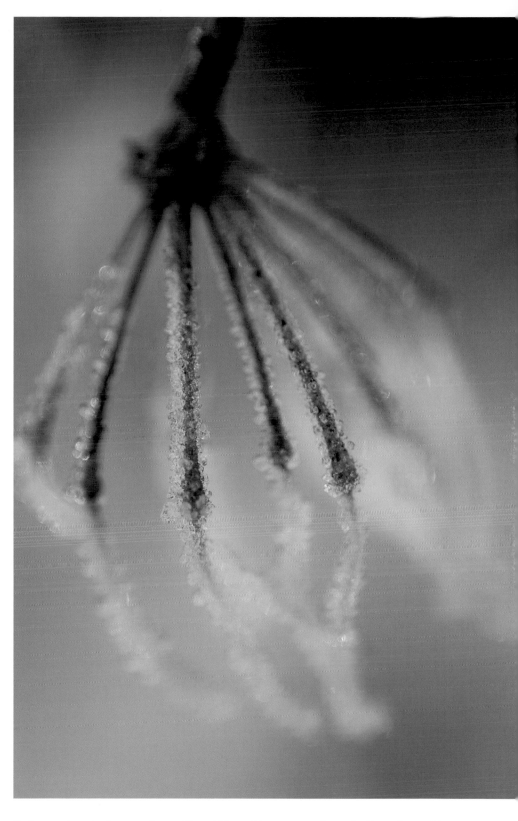

Early morning shade cast a heavy blue shift on this cow parsnip, so I adjusted my white balance from Direct Sunlight to Shade, bringing neutral tones to the scene. Upon doing so, however, I lost the icy cold feeling I'd wanted, so I adjusted the white balance back to my original setting of Direct Sunlight. Shot using a 60mm F2.8 macro lens at f/5 for 1/160 sec. using ISO 100.

USING DIGITAL ISO WISELY

Digital ISO (known as ISO or ASA with film) refers to the sensitivity of your image sensor to light, and it plays an important role with regard to exposure and digital noise with your image files. Newcomers to digital photography may not be aware that with film, ISO was constant throughout the roll you were using. Today, digital ISO is one of the best tools in your exposure arsenal.

Many misuse ISO, cranking it up unnecessarily, thereby increasing their digital noise while losing nice color and detail in outdoor images. Others use the Auto ISO setting, which to me is one of the worst camera functions available. It's true that Auto ISO allows you to shoot without worrying about setting your ISO, but in many cases the adjustments are extreme, and the need for ISO is really dependent on your subject matter, the lighting conditions, and the equipment. To review more about how to use ISO effectively, see page 97.

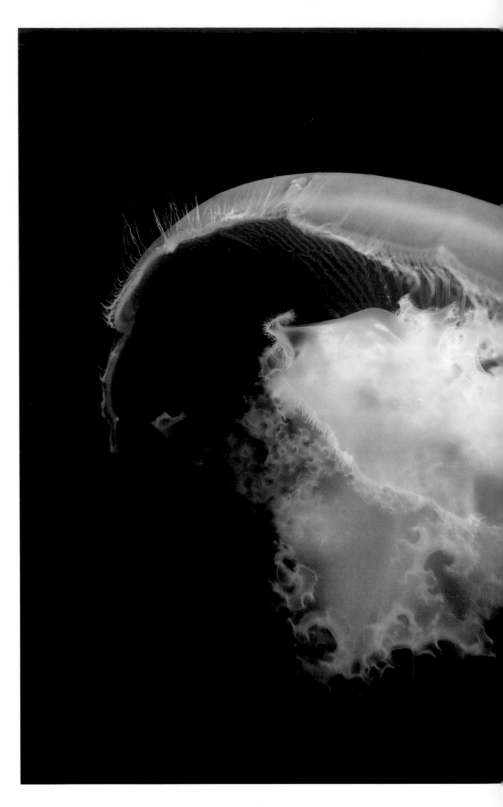

This jellyfish was in such low light that, although it was moving slowly, I was required to increase my ISO to 800 in order to handhold my camera for 1/40 sec., and stop its motion. Captured at *f*/4 for 1/40 sec. using a 12–24mm F4 lens, set at 24mm.

UNDERSTANDING YOUR HISTOGRAM

The statement I routinely hear In my outdoor photo workshops is "I don't know why my image wasn't well exposed; I used my histogram." Two of the biggest misconceptions of digital photography are that you have to use your histogram and that the histogram gives you the proper exposure in each scene. Deciphering a histogram is critical to understanding its real purpose, and, as with camera meters, histograms are often misunderstood and misused. The fallacy of a histogram being your exposure solution has tricked most photographers into believing that digital has solved the difficulties of exposure. Working in tandem with the LCD screen, many use the histogram to judge exposure. Histograms may help you determine certain aspects of exposure, but I rarely review them in the field, and neither do dozens of seasoned pros I have interviewed.

Study the important components of exposure, like your meter, because it is a better way to judge exposure—and also because there is no such thing as a correct histogram. Having a perfect bell curve to your histogram does not create a perfect exposure; it only tells you that you have an abundance of middle tones in your shot. I have thousands of well-exposed photos that would produce awful-looking histograms. These are images in which the histogram is all the way to the left or right, maybe even cutting off highlights or shadows. Look at the image itself, however, and it works as far as the exposure is concerned. This is because capturing every detail in every shot is impossible given the limitations of our image sensors.

Other photographers rely on "blinkies," those blinking areas on your LCD screen that indicate overexposed highlights, to determine exposure. The simple fact is that your image sensor's dynamic range cannot cover certain areas within many contrasty scenes. If you shoot based on your histogram, allowing it to control your exposure, or darken your exposure until the blinkies go away, you might underexpose the most important part of the scene: your main subject. The histogram is a better tool to use in post-capture processing (as described on page 227) to help study the range of your image sensors and ensure specific highlight or shadow detail you may not want to lose.

When should you use the histogram in the field? When you first learn about exposure and how to meter light, the histogram might be a nice backup tool. At that point, if you want to retain detail in a subject whose tone is close to white or black, you would meter your subject, expose the scene, and check the histogram to ensure no loss of detail in the critical areas.

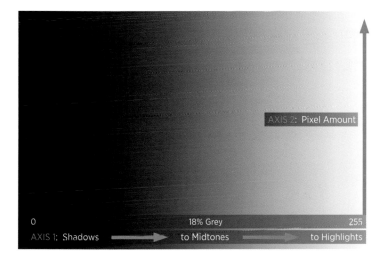

A chart illustrating the range of light and color recorded in a histogram along both axes.

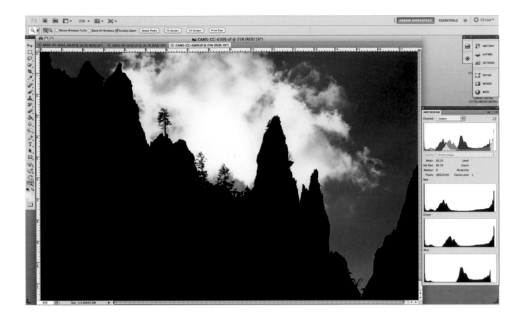

Here are three examples of scenes where histograms could negatively influence the photographer to create different exposures.

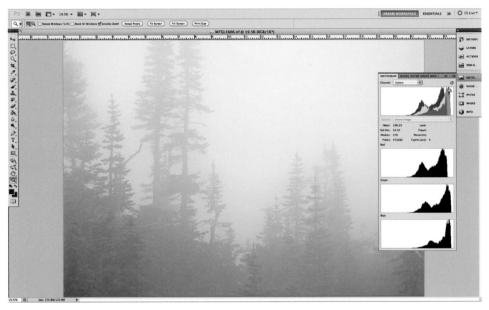

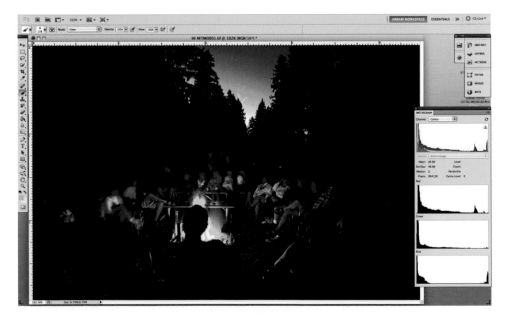

Nature Assignment #2:

Set your white balance in nature

Find a scene where white balance might be a challenge, such as shade or overcast, and, using a preset, reference point, or WhiBal card, attempt to correct for the color shift. Instead of using Auto WB, consider one of the white balance presets, and make a before and after comparison.

Record as many specifications and details of your photo not included in your EXIF metadata as you can. You can find most of your exposure settings through the metadata, including your white balance preset, but not the filter type or the direction you were shooting, should you wish to share this information later.

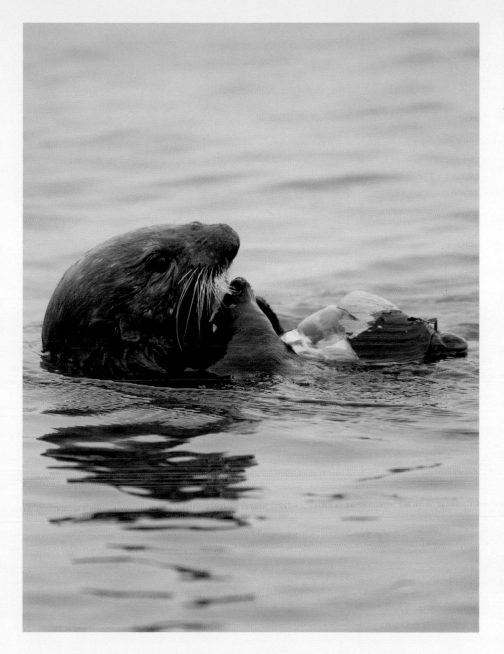

While working on this assignment near Monterey, California, I set my white balance to Cloudy to adjust for the morning overcast. This helped cut the blue shift of light, bringing back the real tones I saw with my own eye: the otter's fur, the shell it was eating, and the slough water it was feeding in. Captured at f/4 for 1/640 sec. using ISO 200.

FRAMING YOUR OUTDOOR SCENES

Noticing a few cameras around my neck and my geeky-yet-functional photo vest, a man once asked me, "What are you doing?" When I explained that I was a nature-travel photographer, he smirked—a reaction I don't often get. I asked him why, and his response was, "All you nature-travel photographers make everything look so beautiful—and it's never like that." I agree and also disagree with his statement. My goal as a photographer is making the places I photograph look as beautiful as possible. It's what my client and I desire and expect. I also believe that all it takes is a keen eye and a positive mind to see the beauty everywhere.

In a nutshell, I look for interesting images wherever I go, and that is why I am able to find this beauty—because I seek it out. I may search for the most stunning locales I can capture, but these views are not created by hand or through Photoshop. They are right in front of me. All I'm doing is finding the best light and angle, and then organizing the subject matter to produce stunning versions of nature. As Ralph Waldo Emerson wrote, "Though we travel the world over to find the beautiful, we must carry it with us or we find it not."

THE RULES OF COMPOSITION

Composition can be thought of as *creatively editing the world around you*, choosing the elements you wish to keep in your final rendition. As I work, I consider which subject matter to include and which to remove. The French Post-Impressionist painter Paul Cézanne once wrote, "All art is selected detail"—so true for the structure of any photograph of nature. With a chaotic mix of lines and patterns in skies, mountains, water, trees, and plants, you must find ways to compose where all the elements flow well for the viewer. The distance of your subjects, the locations you choose to shoot from, and the lens used have a big influence on the kind of arrangement of elements you can create.

In running photo workshops since the late 1990s, I have discovered that one of the toughest, most intangible aspects to teach is simply how to *see*. Learning how to recognize what you are searching for, to find it, and then how to capture it in a way that conveys what you are hoping to communicate isn't easy. Like anything in life, seeing beyond the basics comes naturally to some, as it has for me, whereas others work arduously to connect with that part of their mind. I assume there is a scientific reason for this, but it is nothing I can explain except to say we all see in different ways.

One of the methods I used was to show students examples of how I frame outdoor scenes while offering a set of rules: "The first rule of composition is . . . ," and so forth. Although this way worked, I was never completely comfortable with it since it felt as if I was locking students into a set way of photographing. Then I read an article describing compositional tools as *guidelines* instead of rules. This description fit better in the context of teaching, because in art, there shouldn't be any rules. Art is all about the interpretation of the artist. Nevertheless, you do need to learn basic methods to figure out why something works, or why it does not, and compositional guidelines help.

Composition is a big part of any successful image, but hopefully the viewer sees and connects emotionally with the scene without consciously noticing how it was framed. Captured with a 24mm F2.8 lens, *f*/22 for 1/8 sec. using ISO 100.

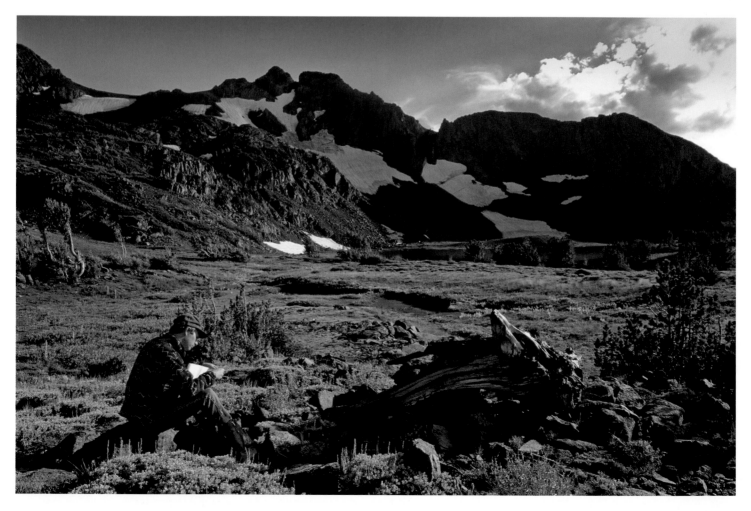

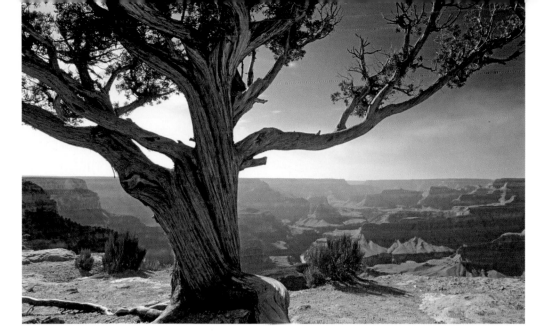

This tree near the edge of the Grand Canyon caught my eye from a quarter mile away. Knowing I could use it to frame the location while also blocking the harsh afternoon sun made it a great compositional addition to the landscape. Taken with a 24mm F2.8 lens, f/22 for 1/15 sec. using ISO 100.

Visualizing the Final Capture

One critical step in learning how to see is the art of visualization—or, as I call it, *previsualization*—whether it's when you're daydreaming of great scenes days before, or as you emerge from your tent to shoot the sunrise, or when you happen upon on a beautiful scene and try to decide how to document it. It's crucial to consider your framing, and visualizing the final scene is a start. Visualization is forming a mental image, imagining what you hope to capture, whether it deals with shape, form, lighting, weather, color, or composition.

When asked if what I capture always fits what I visualize, the answer is no, whether due to the boundaries of the camera's frame, the lack of proper light, or the inability to find the right perspective. However, I believe pre-visualization can get you into the right mind-set—to imagine what an area may look like, to think about the possible scenes, to dream a bit about a particular place. As unachievable as it may sound to have your vision come to fruition, it is possible, and regardless, these thoughts help you become more visually creative, pushing you closer to your goal of capturing a great image.

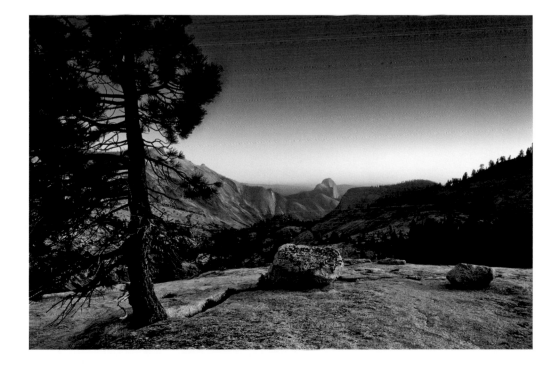

This view of Half Dome in Yosemite is one of my favorites, and I wanted to include the elements that make the location what it is: a big sky, a granite landscape, a mix of pines, a few glacier erratics, and the wild light of an alpine sunset. Taken with a 24mm F2.8 lens, f/22 for 1/15 sec. using ISO 100.

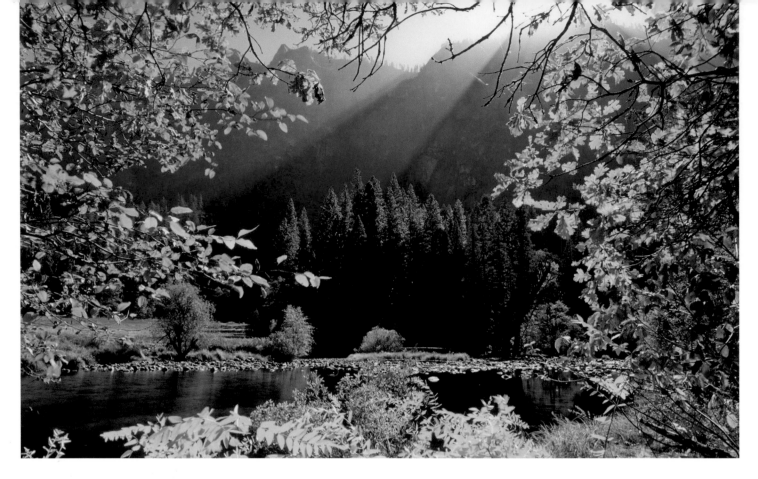

Visualization can also help with technical decisions. Recognizing what type of scene you're searching for can help you decide which lens to choose, what gear to bring, what weather to hope for, what time of day to venture out, and what season to visit a location. Whether you want to create a mood or feeling, emphasize light or form, or show color or the separation of tones, thinking about it beforehand is a good initial step.

The *National Geographic Photographer's Field Guide* says it perfectly: "An image doesn't start with a camera—it ends there." This describes so much about the cerebral methods you use before you pull the camera up to your eye—using your best tool, your eye, to frame a scene, and then knowing what photographic techniques will be needed to make it a successful image. Attempting to replicate this vision in camera is not always easy. Another step I apply is to picture the whole scene as a corner-to-corner photo already hanging on a wall, printed on a magazine page, or displayed on a computer screen. By doing so, you tend to consider the entire frame, which can lead to a better layout. Some make the mistake of ignoring the corner-to-corner composition and are fixated on their main subject, to the photograph's detriment. When I look through the camera I am not looking at an outdoor scene to document; I am looking at a composition that will create a complete photograph.

Finding Angles

In my workshops I teach that outdoor photography is all about angles. By visualizing scenes, I often find myself in positions I may not have otherwise thought of. To re-create what I have in mind forces me to find the necessary perspective to capture it, whether horizontally, vertically, or diagonally. Finding the best point of view also helps a viewer step into the setting or see something they might not have seen had you not placed it so predominantly in your photo. Great angles can negate poor lighting by placing simpler subject matter in the background to block elements like the sun, and create visual dominance by emphasizing foreground subject matter.

Finding the best angle became crucial toward documenting this dramatic scene in Yosemite National Park. I searched for a window-like opening to frame Yosemite Valley in the fall colors that lined the banks of the Merced River. When the beams of light appeared over the south wall, I metered the landscape with my 24mm F2.8 lens, and exposed at *f*/22 for 1/15 sec. using ISO 100.

There is no specific way to find the best angle, whether bending down low to separate a tree from a ridgeline, photographing through one animal to capture another, or hiking higher on a mountain to catch a better view of a lake. Moving into the right position is part of what creates a visually pleasing image.

On occasion, locating the optimal angle is difficult or even impossible. *I'd like to be standing right there, but I can't since there's a massive cactus bush, or I wish I could move 10 feet farther out, but the edge of the cliff won't allow me to do so.* Someday I look forward to walking on air or growing wings. However, finding a way to look over, under, or down on something to obtain the best angle is of prime importance when creating consistently strong re-creations of nature.

Change Your Point of View

Moving out of our normal and potentially boring 5- to 6-foot eye-level range can give the viewer a different perspective on a subject, provide your images with cleaner backgrounds, and offer a better way to frame a scene. In the example at right, I positioned my camera much closer to the ground to find the best framing. For some shots, it may appear as if I am holding the camera at standing eye level, but this is rarely the case.

In the image of the backlit tree roots at sunset at right, I knew capturing it at an extremely low angle would help separate the roots from the water and sky, yet I could not fit into the tight space to look through the viewfinder at the angle desired. So instead I shot it without looking through the back of the camera—the beauty of digital allowed me to place the camera where I wanted and check the composition after the capture.

When you stand tall, you stretch a landscape horizontally. Crouch lower to the ground and the landscape becomes compact, elements squish together, and the scene appears flatter. Somewhere between the high spot and low point is the perfect angle for any landscape.

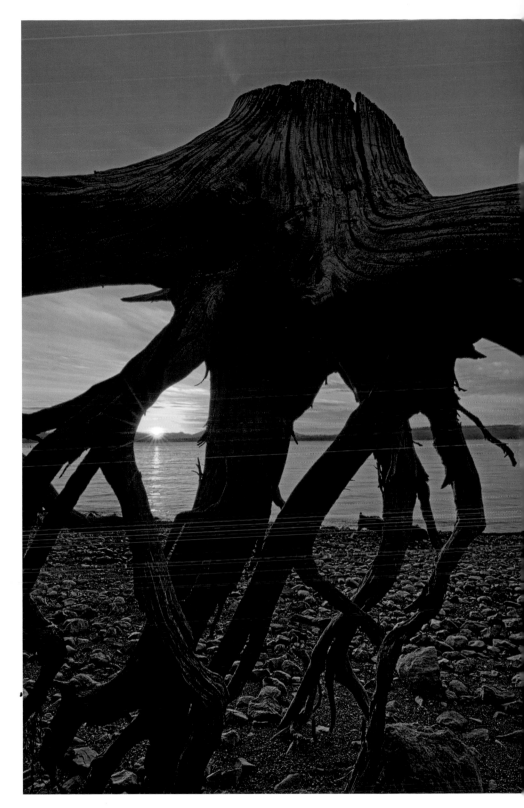

Because of the extreme angle, I was unable to look through the viewfinder once my camera was in place, so I metered the scene first, before finding the right composition. Once in position, I mounted my camera on my lowered tripod and continued to fire off shots until I had a composition I preferred with the sun peering through the roots. Photographed with a 18mm F2.8 lens, *f*/22 for 1/2 sec. using ISO 100.

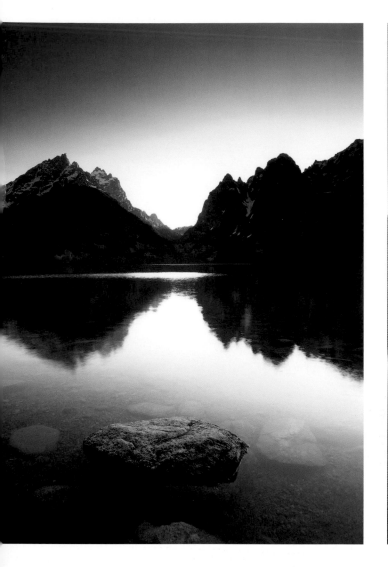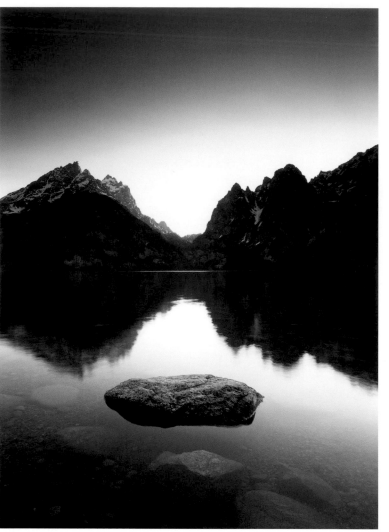

These two images of Jenny Lake in Wyoming illustrate the change in perspective as you change the level of your view. By lowering my camera, I was finally able to place the rock against the lighting reflection of the sky (right). Both were captured using a 24mm lens, *f*/32 for 1 second using ISO 100.

Macro photography also deals with finding unique perspectives to illustrate small details in nature. I'll talk about the critical aspects of positioning yourself for macro in chapter 8.

Whether moving up a ridge, standing on a rock, or peering over a bridge or cliff, getting the best point of view may require a search for higher perspectives. Often dramatic in nature, these angles give your viewer a bird's-eye view of a landscape. Higher positions can separate subject matter, produce grand views, and even place you into different lighting and weather situations.

This scene overlooking Yosemite Valley was exposed at *f*/11 for 1/60 sec. using ISO 100.

I drove up a fire trail to get above the morning clouds in Montana's Swan Valley. Exposed with a 125mm F2.8 lens at *f*/8 for 1/30 sec. using ISO 100.

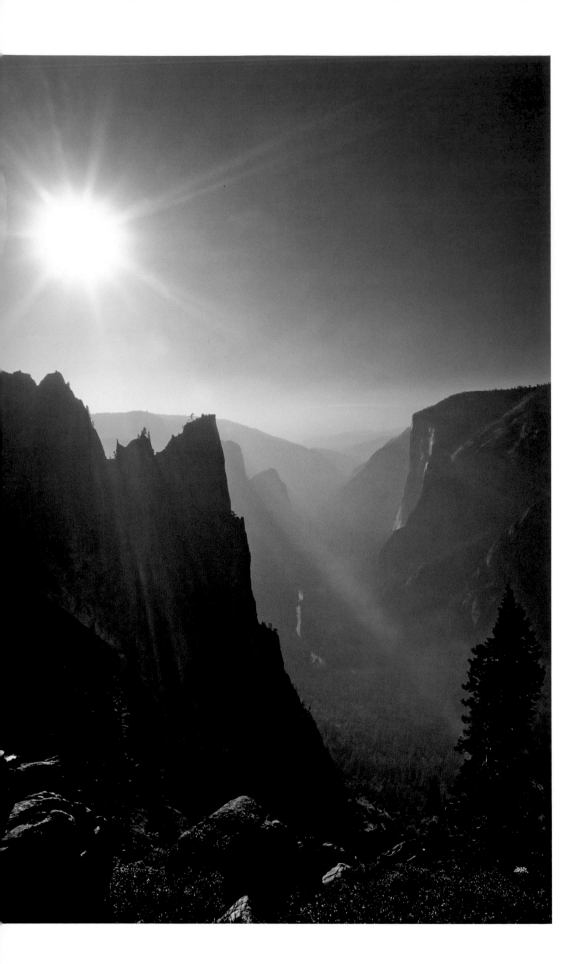

Vista views for these images of California and Montana gave me unique perspectives on the landscapes below me. Exposed at *f*/22 for 1/40 sec. using ISO 100. Some places of interest are easy to get to; others are not, as was the case for this location along the Four-mile Trail high above Yosemite Valley.

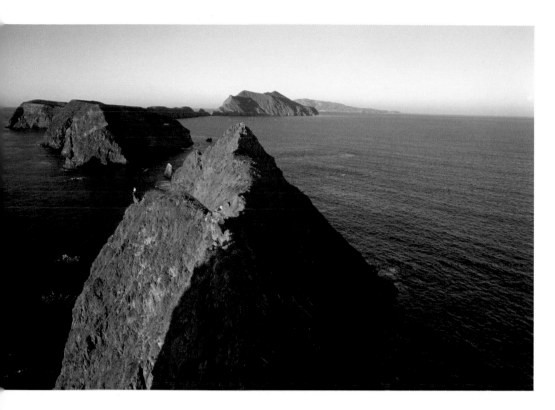

Sometimes just moving side to side, 1 inch to the left or 3 feet to the right, can put your camera into a better place, allowing you to remove distracting elements and create a nicer result. My shot of the Channel Islands at sunrise is a perfect example. In order to separate the first two islands in the foreground, I moved closer to a precarious cliff and then walked to my left. Both movements gave me the stepping-stone pattern in the second island landscape.

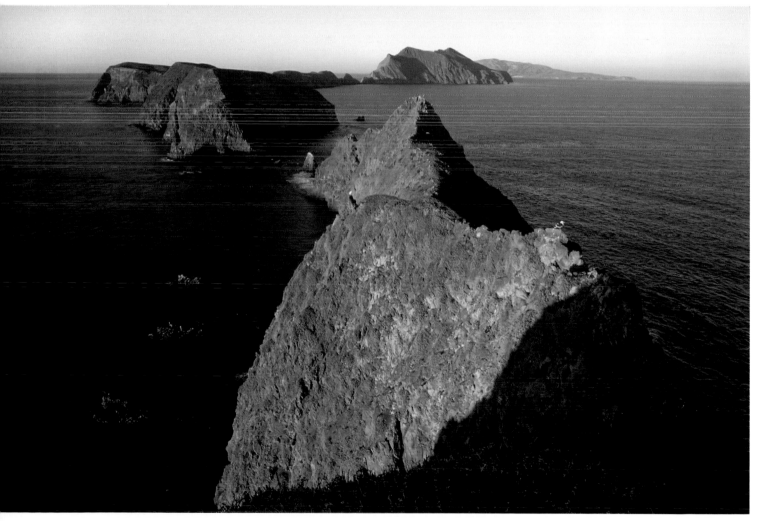

Compositional Guidelines

Composition in art has been around ever since humans painted on cave walls. Elements of design can encompass color, symmetry, balance, shape, size, pattern, texture, and line. Part mathematics, part art theory, these parameters have been applied as far back as Ancient Egypt and Greece, as well as in modern art and architecture. In photography, however, the basic principles of organizing your scene are confined to the parameters of a camera's frame—whether the 2x3 format used in 35mm film or digital, the 3x4 format common in many compact cameras, or the square format some medium-format cameras offer. Note that these guidelines are nothing more than that—guidelines. Don't create cookie-cutter images by following these rules rigidly; use them when you can, mixing in your intuition for what feels right.

In-camera Editing

As you compose, it is vital to study the whole frame from edge to edge. Some refer to this method as "filling the frame"—making certain what you include in your picture has a necessary role and removing any unwanted detail. On occasion we all miss details—small branches coming in the frame, part of a sign obstructing the nice view in front of us—but practice this awareness, fill your frame boundaries with essential material, and your compositions will be more pleasing and hold fewer distracting features.

» **tip**

Avoid tangents: Defined as "a straight line or plane that touches a curve or curved surface at a point, but if extended does not cross it at that point," a tangent is where subject matter intersects, just touching but not necessarily overlapping. When your compositions include tangents, these points can be an eyesore, distracting the viewer away from your main subject.

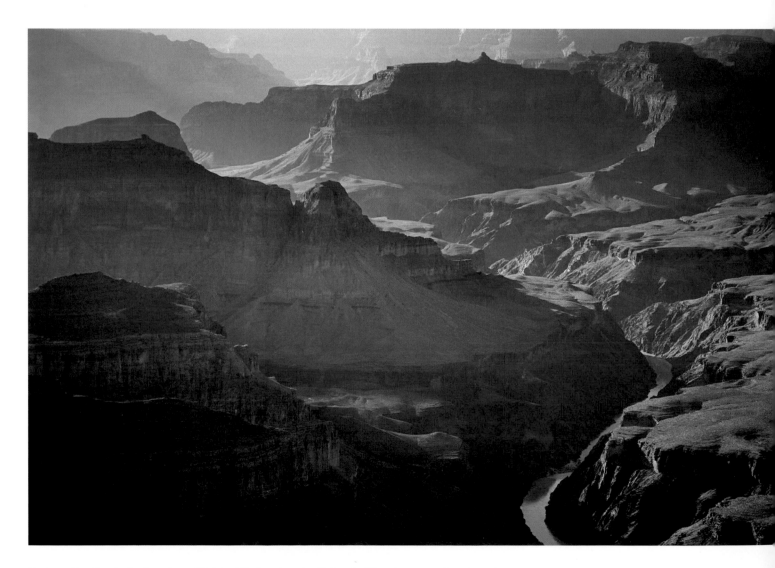

Paying attention to the layering of light while framing the Colorado River juxtaposed against the canyon walls, helped give me the strong composition for this late afternoon scene in Arizona's Grand Canyon. Captured using a 300mm F4 lens, at f/8 for 1/30 sec. using ISO 100.

The Rule of Thirds

Keeping your subject out of dead center is a big general rule of photography that is not restricted to images of nature. Getting caught up in our subjects too much can create tunnel vision, leading to subjects smack in the center of our compositions and resulting in less-than-interesting captures—too much sky, lack of balance, limited flow. Only if you feel it adds strength to your final shot should you place your main subject in the middle of your frame. How far off center should you place subjects? The rule of thirds can help guide you.

This common compositional tool first defined in a 1797 painter's book states that your "canvas" should be imagined as being divided into nine equal parts by two equally spaced horizontal and vertical lines, similar to a tic-tac-toe layout. These imaginary lines divide a scene into thirds horizontally and again vertically. Placing important compositional elements or "points of interest" along or close to the lines or their intersections helps you consider more interesting artistic layouts, such as including a foreground, middle ground, and background for landscapes using the horizontal lines, or using subjects like trees or waterfalls to cross the vertical lines. Following the rule to a T by placing your subject exactly in these areas isn't necessary or even possible, since all outdoor scenes have some fudge factor in balancing subject matter.

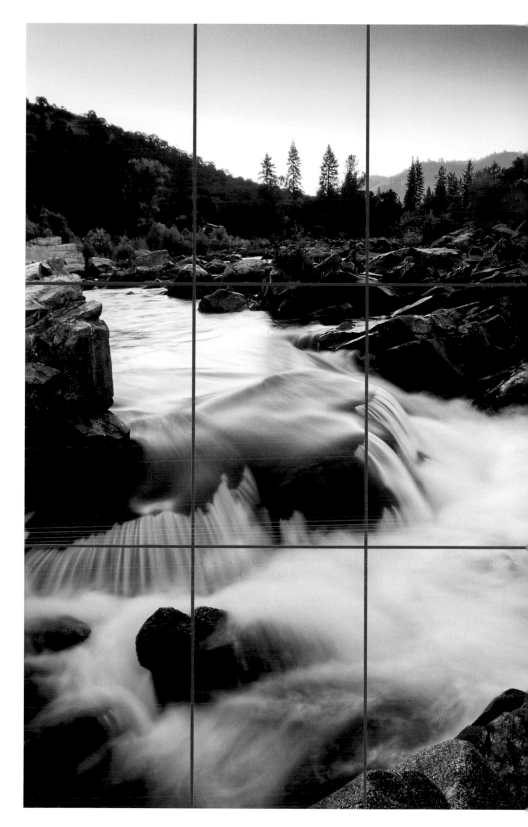

While on assignment, I came upon this scene in California's American River and composed it to include a foreground, middle ground, and background, breaking the image into thirds. Shot using a 24mm F2.8 lens, I exposed the landscape scene at f/22 for 8 seconds using ISO 100.

Along the Merced River in Yosemite National Park, I framed these fall trees following the rule of thirds. Photographed using a 24mm F2.8 lens, captured at *f*/22 for 1/30 sec. using ISO 100.

The points where these two sets of lines meet are powerful anchors for image composition—focal points for the subjects in your composition. Some camera viewfinders have rule-of-thirds grids in camera; if yours does not, imagining the lines may be a bit challenging. This is where I tie in my own personal guideline, called the "four corners" rule.

Locating a vantage point to illustrate the views of the Pacific Ocean from Point Reyes, I framed this image to what felt right at the time. Looking back, I realize it fit well into the rule of thirds. Shot with a 6×8cm medium-format Fuji 680III camera, using a 125mm F3.2 lens, captured at *f*/4 for 1/250 sec. using ISO 100.

Similar to the rule of thirds, yet possibly easier to follow, the four corners rule says to place your subject away from dead center using the four corners of the frame, near where the lines of the rule of thirds intersect: upper left, upper right, bottom left, bottom right. These are your power points. Whether it is a bird flying in the sky, a flower blooming in the foreground, a person sightseeing, or a tree rising up in front of a lake, this adaptation of the rule of thirds gives you four quick places to consider when initially framing a photograph.

I framed this photo of an immature bald eagle following the rule of thirds and the four corners rule. Shot with a 400mm F2.8 lens, exposed at $f/4$ for 1/500 sec. using ISO 100.

Symmetry

Symmetry, the quality of similar parts facing each other or around an axis, is frequently used in images of flora and fauna. Found in lake reflections mimicking the topside landscape, in the uniformity of a flower, and in isolated patterns found in nature, symmetry can generate wondrous and graphic captures.

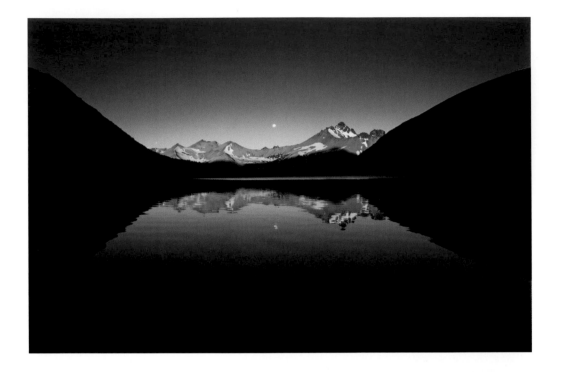

Symmetry wasn't evident when I arrived at this northern Patagonian lake, but as the light passed over the hillsides, the wind died down, the water became still, and the full moon rose above the Andes, a beautiful pattern in the landscape emerged. Captured with a 24mm F2.8 lens, at f/22 for 1/4 sec. using ISO 100, with a two-stop graduated neutral density filter.

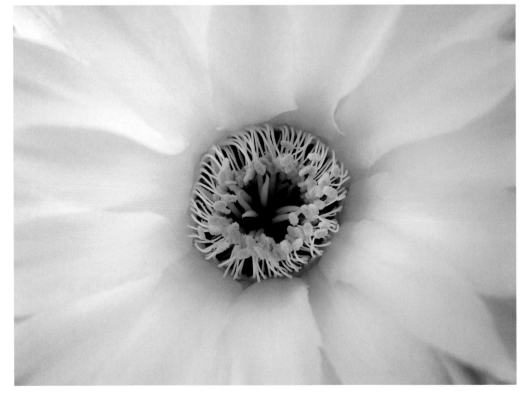

When photographing a barrel cactus in bloom, the symmetry of its delicate flower stood out, forcing me to break the guideline of avoiding dead center. Captured with a F2.8 macro lens, at f/4 for 1/250 sec. at ISO 64.

Balance

Balance in nature comes in many different forms: the coordination of colors or tones, the similarity of shapes or repeating patterns, or the weight of contrasting elements. However it appears, finding this even dispersal of color, design, and weight can give you better image structure.

Traveling through the boulder-laden Alabama Hills in California's Owens Valley, I noticed this egg-shaped weathered granite formation. The circular shape alone created balance, and the distribution of color—the opposing hues of yellow and blue—also added to the framework of the final scene. Taken with a 24mm F2.8 lens, at f/16 for 1/30 sec., ISO 100, using a polarizing filter.

Finding similar tones that match or comploment, whether in color or black and white, brings balance. View n color wheel and you soon realize that opposing hues, like red and cyan, and green and purple, are revealed in nature. Put these colors to use and they counterbalance each other well. Switch your mindset to black and white and divide a dark tone on the left side of your composition with a dark tone on the right, and you end up creating uniform balance as well.

Nature is full of repeating shapes—rippling waves on a body of water, identical shells strewn on a beach, or a blanket of leaves on a forest floor—and compositions that capture these textures can tie the forms together to create a feel of balance with the weight of the elements.

Walking back and forth in front of this grove of trees helped me find the best place to separate enough trees from others, resulting in a nice balance of shapes and tones throughout the composition. Taken with a 50mm F1.8 lens, at f/22 for 1/2 sec. at ISO 100.

Up early for sunrise along the Lee Island Coast in Florida, I came across sections of beach on Sanibel Island covered in shells. I fired off numerous frames, but the one I felt worked best was of the shells themselves, the pattern producing a balanced composition. Using a macro lens on my medium format camera, I exposed this delicate scene at *f*/32 for 1 second, ISO 100.

At 17, I first saw the word "juxtapose" while reading Galen Rowell's *Mountain Light*, when he referred to compositional balance. Juxtapose is defined as "placing objects close together or side-by-side, especially for comparison or contrasting effect." I learned early on that juxtaposing subjects meant more interesting photos. You can juxtapose textures and patterns, shapes and sizes, contrasting light and form—soft clouds above rugged cliffs, a person dwarfed by a large Sequoia tree, or warm sunlight reflecting off of the cool tones of a shaded lake.

Photographing Yosemite Valley landscapes in the dead of winter, I noticed a pine covered in moss next to a large piece of granite covered in lichen. The contrast made for a nice balance of textures and tones. Shot at *f*/32 with a 2 second exposure, using a 70–200mm F2.8 lens at 92mm and ISO 100.

Leading Lines

Foraging for leading lines in the environment—straight or curved, leading to or from a location, strong or subtle—can be a great way to take the viewer through your scene and create a visual journey with the eye. What do I mean? If you can arrange a composition where the eye moves fluidly from bottom to top, left to right, or any easy flowing direction, then you have it. Whether done with the shape of a windblown tree, a winding trail, a meandering river, a pier leading off into the distance, or the petals of a flower, if that journey starts or ends with your main subject, all the better.

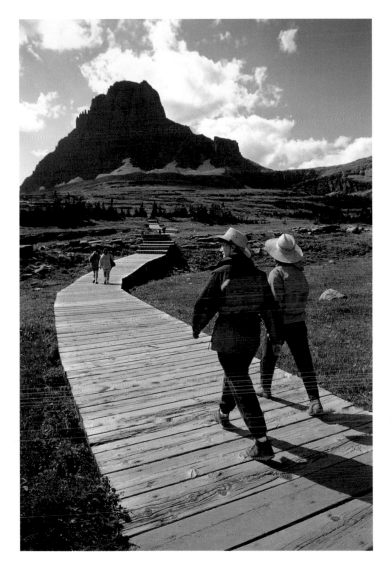

This wooden walkway created a great visual line leading from the hikers to the peak in the distance. Photographed at f/22 for 1/2 sec. using ISO 100.

Zion National Park's Virgin River snakes up through this landscape, creating a nice connection between the foreground boulders and the sun-drenched mountains above. Shot with my 24mm wide-angle lens, exposed for 1/125 sec. at f/11, ISO 100.

Here, the water runoff added a subtle leading line to help the viewer through the vertical composition, from the foreground pine needles to the foggy forest above, or visa-versa. Captured with a 24mm F2.8 wide-angle lens, at f/22 for 2 seconds using ISO 100.

This winding trail in Northern California provided a perfect visual conduit between where the hikers were, and where they were going. Photographed with a 70–200mm F2.8 lens at f/8 for 1/60 sec. using ISO 100.

Keeping Your Lines Straight

Angling your horizons can create a nice effect, but unless you have a specific compositional reason for doing so, it can instantly degrade the photograph. Horizons can be straightened in post-capture edits, but information can be cut off, so attention to horizons in camera will not only give you larger files and better quality, but more detail as well. How can you get horizons consistently straight? Bubble levels attached to the flash hot shoe or tripod can be effective, but with practice and attention to your horizons, one of the best (and free) tools is your eye. Curvy subjects, such as lakes, can make horizons look crooked, and when photographing from a boat or any moving object, securing straight horizon lines is more difficult. Avoid placing your lens on the side of a boat since the shake and movement cause compositional problems as well.

Horizontals versus Verticals

Most students of photography start off capturing horizontal compositions, but when you place yourself in nature, there are verticals everywhere. Some even believe we see in a vertical way, top to bottom or bottom to top, whether looking at books and magazines or at a live subject such as an animal or a landscape. Even when a scene dictates a horizontal or vertical composition, consider trying the other one to see what happens.

Some may prefer the horizontal of this Yellowstone scene, and others may like the vertical. I may choose one over another depending on its final use, whether for a magazine cover, a fine art gallery print, or a slide show. Either way, I have both compositions. Both images were captured at f/22 for 1/8 sec., ISO 100, using a 24mm F2.8 lens with a polarizing filter.

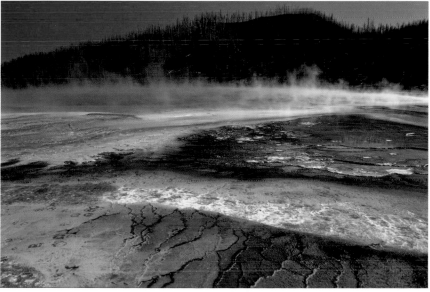

» tip

If you have a great foreground for your landscape, consider a vertical composition. If your foreground isn't anything to write home about, go with a horizontal composition to include less of it.

Order in Chaos

The complex mathematical theory known as chaos theory originally stemmed from the prediction of nature, weather, and even the future, and it actually plays a part in photographic composition. With an innumerable mix of what seem to be disorderly elements in nature, documenting any assemblage of order can appear to be quite complicated. Regardless, if there is structure to your image, appropriate subject placement, and patterns that blend well together, then your composition works. Asymmetry, the lack of equality or equivalence between parts or aspects of something, is a welcome part of nature and should be embraced in our images. We should not look to make perfect outdoor scenes, but visually striking ones. Benoît Mandelbrot, a French mathematician who pioneered the study of fractal geometry and authored the book *The Fractal Geometry of Nature*, wrote that nature mimics math in many forms. These are quite complicated methods of seeing, but take a close look at a fern, a snowflake, a series of mountain ranges, or the design of a coastline, and you may begin to understand the concept. When you bring together a variety of textures, colors, forms, and patterns, they do not always have to line up or balance perfectly to make a good photograph.

Two completely different scenes from Point Reyes National Seashore: one of a forest on Mount Vision, and another of elephant seals below Chimney Rock. With a mix of lines and forms, textures and colors, they show how even disparate elements can go together nicely if a proper balance is found in all of the hullabaloo. The forest scene above was shot at $f/22$ for 13 seconds using ISO 200 with a 18mm F4 lens. The image of elephant seals was exposed at $f/5.6$ for 1/125 sec., ISO 100, using a 180mm F2.8 lens.

People in Nature

This may not be a book about portraits, but it is important to discuss capturing people in their surroundings, as illustrated in many chapter 1 images. One of the best ways to document people in nature is to place them in their environment, capturing the feeling of what it was like to be there. Here are two compositional techniques to capture people in nature.

Giving a Scene a Sense of Scale

Placing people in their environment is one of my favorite ways to show scale. To show what type of geology and/or light a person is traveling through gives some perspective to what it felt like in real life. Depending on how close or faraway you are in relation to your subjects, any lens can be used, and the effect is often grand and impressive.

From the forests of northern Vancouver to the desert outside of Las Vegas, giving space around the people I photograph in nature gives a sense of the amazing landscapes they're traveling through. The forest scene above was captured with a 24mm F2.8 lens and a two-stop graduated neutral density filter, at $f/16$ for 1/8 sec. using ISO 100. The rock-climbing image below was photographed at $f/3.2$ for 1/1600 sec., ISO 100, using a 70-200mm F2.8 lens set to 200mm.

Illustrating Your Point of View

When you participate in any outdoor activity, the thrill of being there is obvious, but if you can record part of this feeling through your point of view, another unique composition can be had: freezing whitewater as it crashes over your raft, peering over a cliff into a deep valley, or capturing your shadows as you stand arm in arm at the top of a mountain. Today, access to helmet cams like GoPro's Helmet Hero Wide HD and affordable accessories like a remote trigger or Bogen's Super Clamp make these views possible.

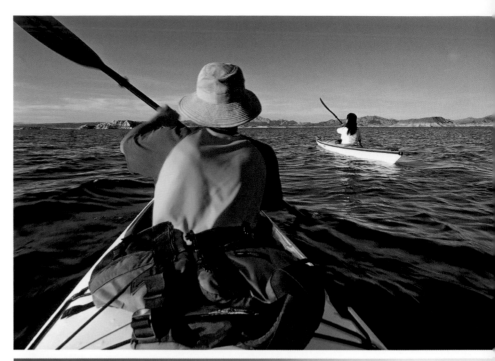

To give the feeling of kayaking on Lake Mead in Nevada, I strapped my camera tightly around my chest, firing off images using my self-timer. In the past, I have attached cameras to a helmet, my mountain bike, and a raft to give the feeling of being there. The top kayaking image was shot at $f/11$ for 1/50 sec., ISO 100, using a 24mm F2.8 lens. The bottom kayak shot was documented at $f/16$ for 1/40 sec., ISO 100 using the same 24mm F2.8 lens.

CHOOSING THE RIGHT LENS

A fundamental part of becoming a better image maker is knowing your equipment —what it does, what it's good for, how to use it, and how to change it when in the field. Understanding the strength of each lens and how it reacts differently to your surroundings can help bring your vision to fruition.

Whether using a superwide lens or a long telephoto, choosing the proper lens takes experience. Practice with each lens you own to figure out which would fill the frame with the key elements you desire. I'm often asked, "What lens would you use for this scene?" My initial reaction is to say that the *scene* dictates which lens to select, but only because I already know what my students do not—what type of coverage and effect each lens gives me. Once you have this knowledge, how certain lenses work for specific settings and why, it is easier to pick an appropriate one to document your vision.

Wide Angles and Superwides: 12–35mm

Superwides and wide angles cover the broadest views of any lenses (44 to 100-degree coverage). Landscape compositions are routinely captured with these lenses as they offer an almost panoramic view of any scene, incorporating detailed foregrounds while including distant horizons. In addition, these lenses provide the most depth of field, keeping detail throughout a scene, from inches to infinity, tack sharp.

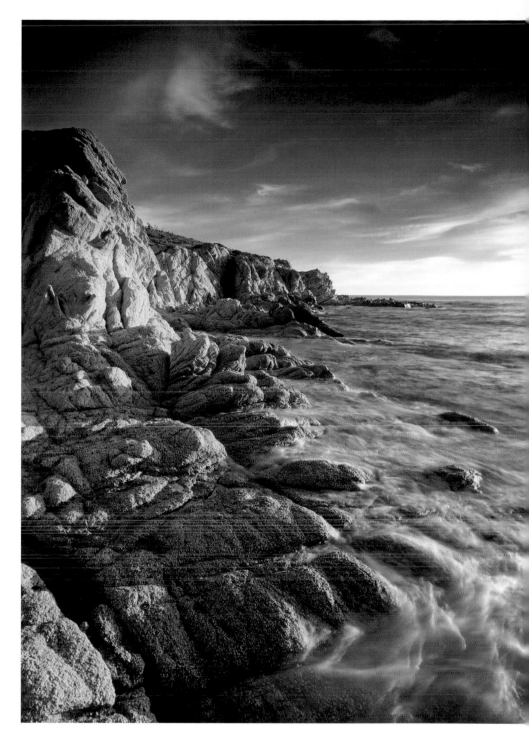

I arose early to capture the sunrise along the Los Cabos coastline in Baja, Mexico. By using a 24mm lens held vertically, I gave the viewer a sense of standing there. Exposed at *f*/32 for 2 seconds using ISO 100.

Eye-catching foregrounds are essential to landscapes, and although it is easy to say "find compelling foregrounds," applying these techniques to real life can be a bit more difficult. So here is a list of environments or climate zones, and what I search for when using wide-angle lenses:

- Deserts: Blooming wildflowers, sand formations, distinctive rock formations, washes/dry riverbeds.
- Snow: Protruding rocks, frozen streams, interesting snow patterns.
- Mountains: Flowing rivers, rocks or plants along riverbanks, wildflower beds, pines framing distant mountain ranges.
- Coastlines: Tidal pools, rock outcroppings, any subject that lies in the line where surf meets sand.

» **tip**

If you want to avoid having footprints in your photos when photographing in sand dunes, plan your shoot carefully, stepping and placing tripod legs only where you have to.

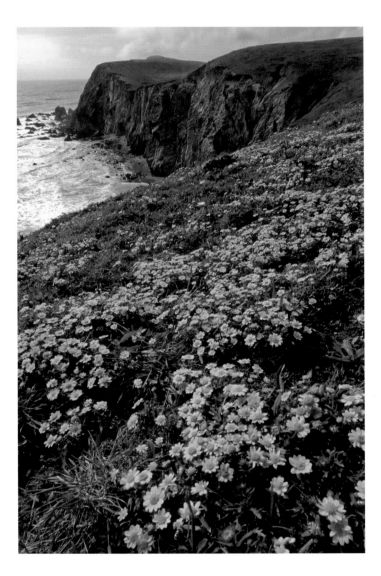

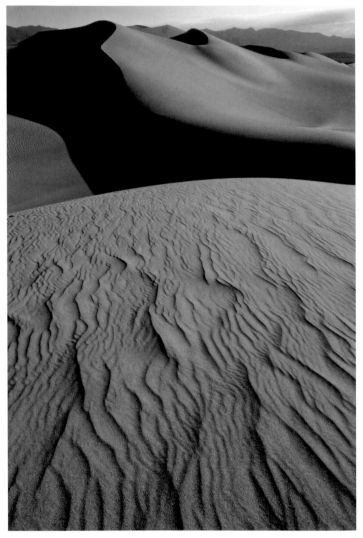

While teaching a wildflower workshop along the California coast, I used my 12–24mm zoom lens to frame a scene of blooming goldfields overlooking the Pacific Ocean. The superwide-angle perspective and colorful foreground resulted in a strong final shot. Photographed at f/22 for 1/15 sec. using ISO 100.

I located these sand patterns hiking into Death Valley National Park's Mesquite Sand Dunes at sunrise. Using my 24mm lens and applying a vertical composition with the horizon close to the top, I created a strong landscape in the early morning light. I exposed the scene at f/22 for 1/2 sec. using ISO 100.

Standard/Portrait and Macro: 50–105mm

Often called "portrait" lenses because of the nice perspective the length gives a person, these lenses range around the perspective of our own vision and work well in a variety of situations. Including less angle of view (15–30 degrees) than wide angles, yet less exaggerated views than telephotos, standard lenses create wonderful vignettes of nature, isolating certain sections of the terrain—a tree against a wall of granite, a detail along a riverbank, a small section of forest. Macro lenses fall into this category, something I address in chapter 8.

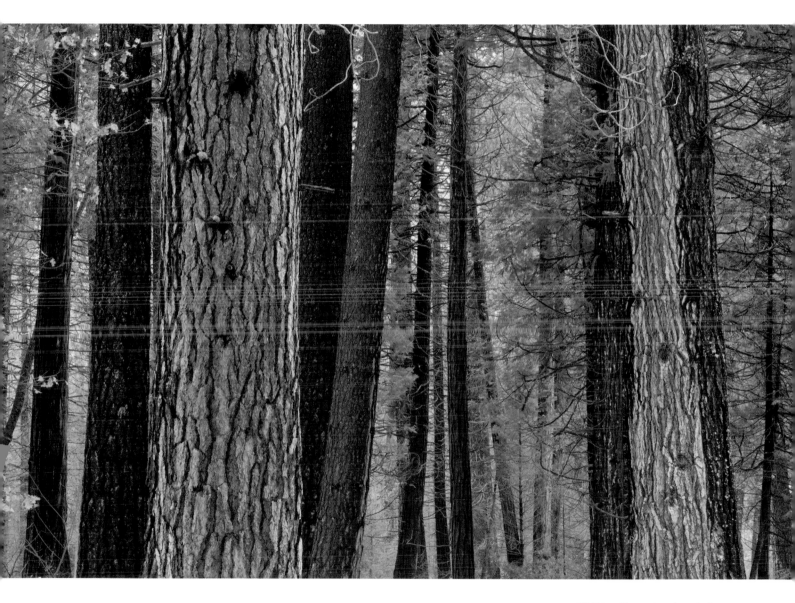

Walking through a forested area in Yosemite Valley, I noticed the mosaic pattern of the pines that stood in front of me. My 85mm lens edited out most of the surrounding area, allowing me to focus on a nice section of woods. Exposed at f/22 for 1/15 sec. using ISO 100.

Telephoto Lenses: 135–600mm

I regularly use telephoto lenses to bring focus and provide detail for scenes a bit farther away. Covering limited areas of your surrounding (3–14 degrees), telephotos tend to compact the land and bring natural elements closer together—ridges appear as if they were right next to each other instead of miles apart. Telephotos have limited depth of field, so they help eliminate distracting elements such as foreground branches and background foliage, giving you cleaner compositions. However, they need stability in the form of a fast shutter speed, a tripod, a mirror lock, a cable release, or the use of image stabilization (also known as vibration reduction). They are great for wildlife photography (see chapter 7).

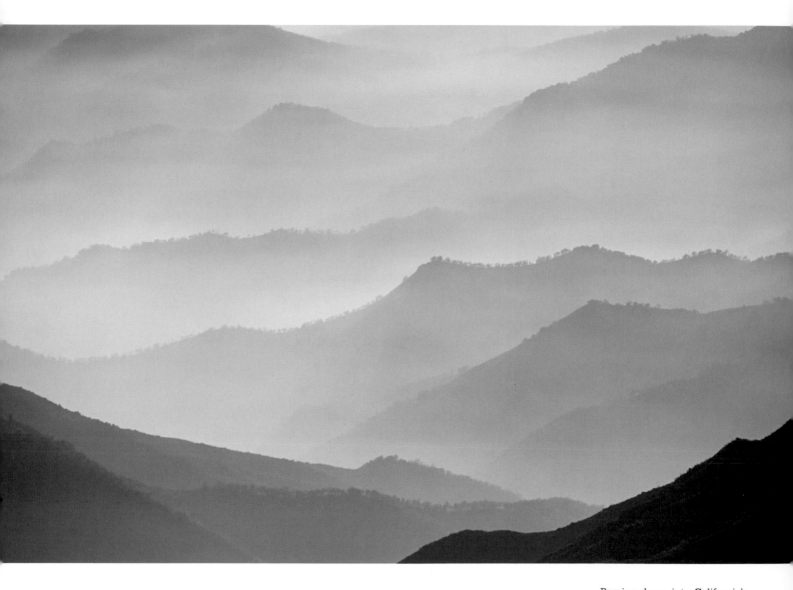

Peering down into California's Sierra foothills, I noticed the winter haze setting just below a set of ridges. Using my 300mm F4 lens, I focused in on a section and documented the wavelike patterns using a relatively open aperture of f/8, a fast shutter speed of 1/1000 sec. and ISO 100.

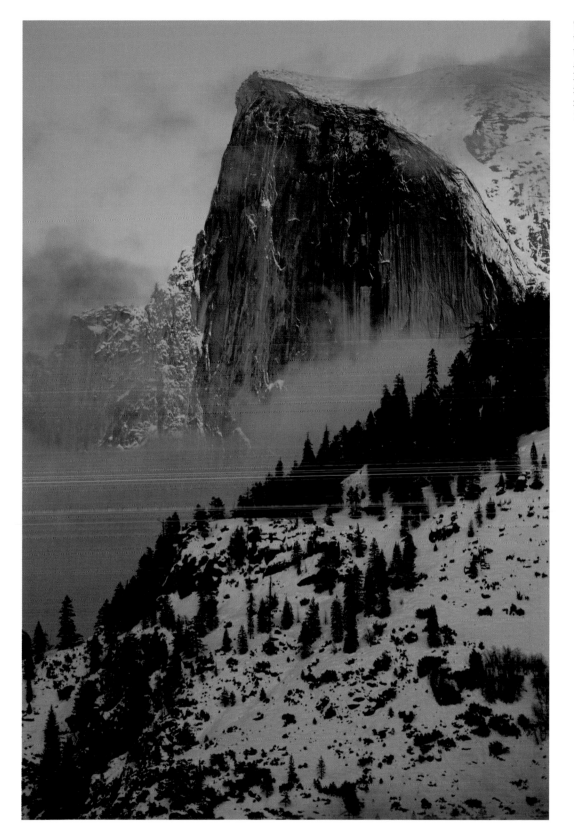

The winter light filtering through storm clouds cast a wonderful hue on Half Dome. A 500mm lens helped to isolate its amber-colored granite face from the rest of the environment. Exposed at f/5.6 for 1/125 sec. using ISO 200.

Zoom Lenses

Unlike prime or fixed focal length lenses, which have only one locked millimeter length, zoom lenses cover a range of distances: wide-angle to standard (35–70mm), standard to telephoto (70–210mm), or high-powered wide-angle to telephoto (28–200mm). The beauty of these zoom lenses is their capacity to help you creatively crop scenes without moving from your original position. I use my zooms to edit specific elements that sit on the edge of the frame—parts of a scene that may sidetrack a viewer from my main subject. Remember, however, that even with a zoom lens, you should never rely solely on your original position to be the best vantage point to capture a moment.

I recently photographed a flamingo preening itself, zooming in and out to find the best composition as it bobbed its head up and down. Nailing focus on its eye while creating a tight composition as it moved in and out of frame was a very difficult task, but I knew if I accomplished this, the image would be strong. Some may choose to simply zoom out to a shorter length, get the shot, and crop it in Photoshop after the fact; however, you end up cutting detail, as well as megapixels. Crop a photo by a third and you decrease the number of megapixels by a third as well—a 15-megapixel file becomes a 10-megapixel file.

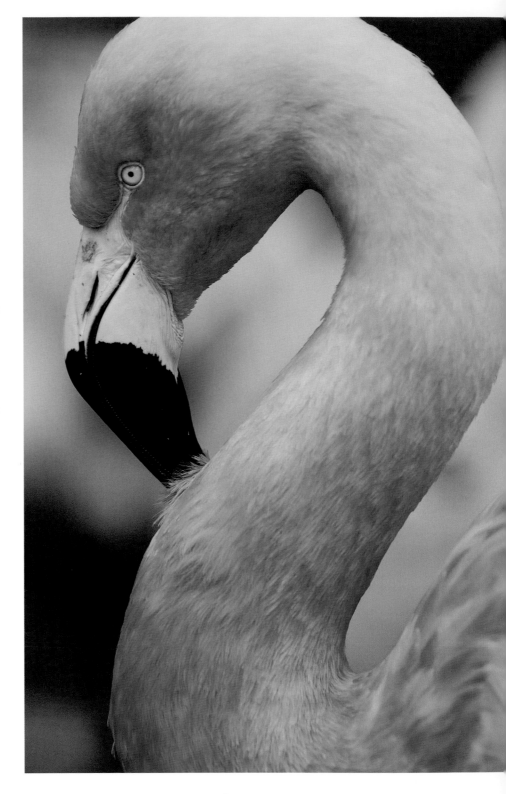

Filling the frame with my 300mm F4 lens, I waited patiently until this flamingo sat perfectly in frame, giving me the nice S-curve composition I was hoping for. Exposed at f/4 for 1/1000 sec. using ISO 200.

THINKING OUTSIDE THE VIEWFINDER BOX

Some say the first rule of composition is following no rules, but I disagree. Artistic license is one of the most important parts to defining a style or stretching a medium, but in order to capture great outdoor images, you have to first recognize what works and what may not.

Once you have this general knowledge and put it to the test, you can slowly step outside the box to design one-of-a-kind compositions. As Ansel Adams once stated, "There are no rules for good photographs; there are only good photographs."

Breaking the Rules in Your Favor

Ignoring the rules, or guidelines, is okay as long as it works for your final shot; recognizing why a composition may work is key to knowing when to break these rules. This stretching of the medium can give your images strong emotional impact and separate them from the pack. Although digital isn't more affordable than film when it comes to photo and computer equipment and software costs, it is most cost-effective when dealing with frame count. Without the processing costs, you can experiment with all kinds of compositions, extreme subject placements, and unusual crops—all you risk is a little more time in reviewing your images.

Breaking the Rule of Thirds

Some feel that when you apply the rule of thirds or my four corners rule, your subjects should face inward—that is, if you place an animal on the left side of your frame, it should look to the right, and vice versa. This can be applied and work fine in many situations, but breaking this rule can create visual tension as well as create better balance, depending on the other subject matter.

Some may have placed this Belding ground squirrel on the right to look into the shot, but to me it worked better with it looking out. Shot with a 300mm F4 lens, at f/4 for 1/1000 sec. using ISO 100.

Another exception to the rule is when dead center works. Centering your subject in nature can break all the rules; just make sure it benefits your image and plays an important part in the composition.

When my brother picked this pacific tree frog off of his boot, I wanted to photograph it to identify later. When he held it in his hand and it looked at me, I felt a dead-center composition would work best. Documented with a 60mm F2.8 macro lens using fill flash.

Negative Space

The use of negative space is another compositional strategy, one in which you place your main subject way up in one corner or far to the left or right. This can give you a forced composition with more tension for the viewer. The unusual, mood-driven framing can illustrate large bodies of water, vast skies, or immense forests.

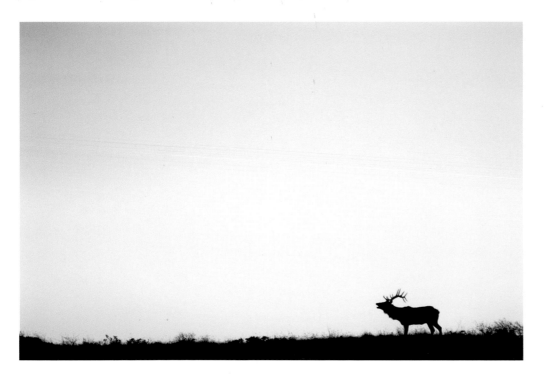

Photographing tule elk along the California coast at Point Reyes at sunset, I was not able to get as close to the herd as I wished to. I adapted to my circumstances and created a more artistic shot using the sky as negative space instead of a closer documentary-style image. Captured with a 300mm F4 lens at f/8 for 1/1000 sec. using ISO 100.

Nature Assignment #3:
Create an outdoor image following the rule of thirds

Visually breaking your frame into thirds often gives a viewer a better journey to follow through your photograph. Search for a scene and chose an appropriate lens that gives you a foreground, middle ground, and background, then position yourself to split those areas into thirds. You may also place your subject in one of the areas of your frame following my four corners extension of this rule.

While working on this assignment, attempt to record as many specifications and details of your selected image not included in your EXIF metadata, such as filter type, direction, and location.

I ventured up the Snake River in Jackson Hole, Wyoming, and came across moose feeding in a beaver dam. I captured a mix of images that afternoon, but when two moose came together in front of me, I positioned my camera to include the Grand Tetons and fired off this shot. I may have framed a scene following the rule of thirds, but this composition also created balance through its symmetrical elements: the two moose, the two sections of trees, and the centered mountain range above. Using my medium-format Fuji 680 III and a 125mm F3.2 lens (equivalent to a 58mm lens on a 35mm SLR or DSLR camera), I set my aperture to f/8 and shot for 1/250 sec. using ISO 100 film.

METERING THE OUTDOORS

The primary function of your camera is to collect and record light. Exposure, in photographic terms, is recognized as the total amount of light permitted to enter a camera and received by the image sensor (or film plane) through the course of capturing an image. Capturing a proper exposure can help to create mood, emphasize light, enhance color, and add subtly to detail. Proper exposure is critical in nature since environments, and their lighting, weather, and tonal values are difficult to control.

If you read my first book, *The Better Photo Guide to Exposure*, you know exposure is a book in itself. Exposure is the foundation for all great images, and without knowledge of exposure you cannot fully express your creativity—you miss moments, lose subtle colors, and spend more time in post-capture editing. Unless you understand how your meter works, capturing a good nature shot becomes hit or miss. The resulting image may not be what you expected, and if it is, you may not understand how to repeat it.

LEARNING EXPOSURE

Using slide film, I learned early on that my photos would not hold up with less-than-perfect exposures. Regardless of the composition or light I waited for, if the exposure was not dead on, the image lost its impact. Metering systems today have advanced and improved in many ways, yet the general concepts still remain the same. Get as much detail, light, and exposure as you can in camera, and your images will shine.

Another justification for learning exposure comes when you try to capture a fleeting moment in nature and have to react quickly to document the scene with as much quality and detail as possible. Knowing how to choose the most beneficial settings and to expose the moment well and quickly becomes crucial. Get good at exposure and you can pick your settings in seconds. In addition, when you learn exposure, you learn about your camera functions, lighting, composition, and how to convey a message.

In this digital age, some photographers feel they can fix everything in post-capture editing, and although these software-editing programs are robust, with many tools to adjust exposure, proper in camera captures can save you hours of computer work. A better exposure will also add more detail to your image file, and the more information you have to work with, the better final image you produce. The camera's exposure is both the recipe and the items you carefully select and mix together, and Photoshop is the oven you cook it all in. You need both to generate a high-quality final creation.

My goal for this chapter is to give you a basic understanding of the components of exposure as well as your meter so you are able to apply these technical aspects when you're out in the field. There are no easy ways to capture consistent solid exposures outside of learning the fundamentals, understanding the process, and following a step-by-step method. Then the final step is to practice, play, and practice some more. Recognize that learning exposure can take years, but if you master it, it can give you the ability to create the images you have in mind or replicate what you see in nature in a powerful way.

SETTINGS AND FUNCTIONS THAT AFFECT SCENES

The painter Georgia O'Keeffe once wrote, "Creativity is not a work of art; it is the art of work," a statement I believe in and a good example when it comes to exposing scenes. Shooting six or seven images and checking your LCD screen every frame, using the guessing game strategy until you obtain a decent exposure, is not the way to go. By learning the technical aspects of metering, your image-making abilities increase. Apply the knowledge of how to wield your photographic tools in the right way and you will only become more creative in your approach to nature.

Proper exposure has just as much to do with picking the right camera settings as it does with metering correctly. Shutter speed, aperture, ISO, metering mode, exposure mode, exposure compensation, composition, and lens choice affect how your final image appears and what your meter recommends in regard to exposure. The three main components of exposure are the combination of shutter speed, aperture, and ISO. They work together in a give-and-take way to balance the amount of light entering the camera. Note that photographic settings, especially with regard to exposure, can seem backward and cause confusion. Instead of just thinking about the numbers, consider what they do and how they will affect the final scene to help eliminate confusion.

Aperture

A main component of exposure, aperture is defined as an adjustable iris (circle, hole, or opening) inside your lens that changes depending on your setting (called the *f*-stop). It controls two aspects of exposure:

- The amount of light entering the camera through the lens. The *f*-stop is the measurement used for the size of the lens opening. The larger the aperture, the more light; the smaller the aperture, the less light.
- The depth of field in the scene, measured in inches, feet, or meters. This is the range of distance within an image that is sharp when the camera is focused.

F-stops range from *f*/1.4 to *f*/32 on most 35mm camera lenses. "Faster" lenses have wider apertures (smaller number *f*-stops); they are considered faster because a wider aperture, and thus more light, allow you to use a faster shutter speed. *F*-stops run in 1-, 1/2-, or 1/3-stop increments, depending on what your Exposure Value (EV) steps are set in your camera's menu (for more on stops of light, see page 93). EV steps set your aperture increments and coordinate with your shutter speed and ISO increments, so if you set it for one, it is usually set for all three.

Your aperture setting, the *f*-stop you choose, can be a huge factor when it comes to conveying messages through exposure. It helps you direct the viewer, give the image a certain feel, and can creatively edit or eliminate elements. By controlling the amount of light, your *f*-stop affects your shutter speed and vice versa.

» tip

Even though the aperture is physically inside your lens, DSLRs control the function from a knob near your LCD screen on the front or back of your camera.

A comparison of a large ("wide open") aperture (left) that allows more light in but lessens depth of field, and a small ("closed down") aperture (right) that allows less light but produces more depth of field.

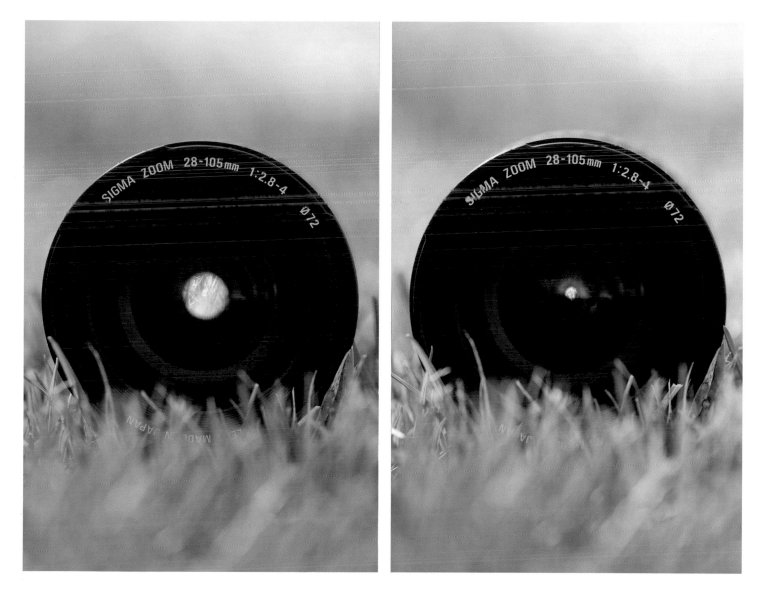

Depth of Field

Depth of field (DOF) is not only affected by the size of your aperture, the lens you choose, and the distance from your subject, but also by the image sensor format (or size). The larger your aperture (the lower the *f*-stop number), the less depth of field you have. The smaller your aperture (the higher the *f*-stop number), the more depth of field you retain. With lenses, the shorter the lens, the more depth of field it provides; the longer it is, the less depth of field it allows. For distance, the closer you are to your subject (a coyote, a tree, a flower), the less depth of field you have. Minimum depth of field can help eliminate backgrounds and even foregrounds, creating a less distracting image, which is great when working with wildlife. It can direct the viewer's eye to a specific place within a scene since our eyes are often first drawn to the parts of an image in focus. Maximum depth of field can bring more into focus, creating sharp, detailed scenes, which works well for landscapes. In addition, a smaller aperture creates less dimension, producing a flatter-looking scene by blending subject matter in the foreground and background. However, there is a trade-off since larger apertures allow more light into the camera, giving you faster shutter speeds than with smaller apertures. Unless you desire a faster shutter speed, the advantage goes to the smaller aperture.

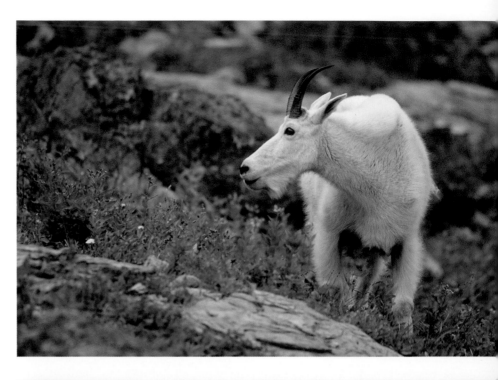

Two examples of using minimal depth of field with a low number f-stop to soften the background and draw focus to the animal. The mountain goat was documented in Glacier National Park, Montana, and the bird in California. Both images were captured using a 200mm F2.8 lens at ISO 100, the goat for 1/250 sec. at *f*/4 and the bird for 1/500 sec. at *f*/2.8.

Hyperfocal Distance

The purpose of hyperfocal distance is to maximize your depth of field, guaranteeing sharpness throughout a landscape. In theory, it can be used with any lens and any *f*-stop, but is usually applied using wide-angle lenses since they offer the most depth of field coverage. To attain hyperfocal distance, instead of focusing at the farthest distance of infinity (∞) or the closest distance, the minimal focal point of the lens, set your lens to a certain distance where the depth-of-field extends from half that distance to infinity. This means your focus may not be on your main subject at first, but once applied, that subject will come into focus in the final rendering.

» tip

When you look through your viewfinder, regardless of the lens or *f*-stop used, you always see through your camera at the largest aperture setting of the lens. This is set up by manufacturers to allow you to see through your camera with the most light possible. In order to review your *f*-stop setting, you must use a depth-of-field preview button on your camera (if your camera has one). When you do, the scene through your viewfinder may get dark, depending on your *f*-stop, owing to the decrease in the amount of light entering the camera. However, this DOF button helps you to see what your final image will look like in regard to focus.

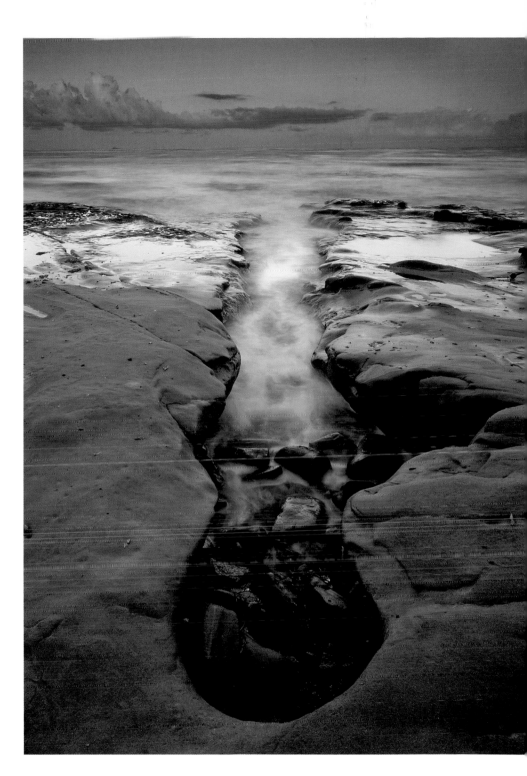

Capturing the California coast near La Jolla at sunrise, I used my medium-format camera and a 50mm F5.6 wide-angle lens, along with a tiny aperture of *f*/45, and exposed for 8 seconds using ISO 100, giving me maximum DOF using hyperfocal distance, as well as some nice motion to the incoming waves.

This chart illustrates the optimal distances to obtain hyperfocal distance and how shorter lenses offer more depth of field.

HYPERFOCAL DISTANCE / LENS COMPARISON FOR 35MM CAMERA SYSTEMS
Scale below is in feet, a place to focus giving you 1/2 that distance, to infinity (∞), in focus

Lens (length)	f/8	f/11	f/16	f/22	f/32
14mm	3.2'	2.4'	1.6'	1.2'	0.8'
16mm	4.3'	3.0'	2.1'	1.5'	1.0'
18mm	5.5'	4.0'	2.8'	2.0'	1.4'
20mm	7.0'	5.0'	3.5'	2.5'	1.7'
24mm	10'	7.0'	5.0'	3.5'	2.5'
28mm	13'	10'	7.0'	5.0'	4.0'
35mm	20'	15'	10'	8.0'	5.0'

» **tip**

If you prefer to calculate hyperfocal distance and have depth-of-field charts at your fingertips, you can download an easy-to-use free application for the iPhone called Bokeh. The term "bokeh" means the visual quality of the out-of-focus areas of a photograph as rendered by a particular lens, hence the name of the application.

Shutter Speeds

Halves	Whole	Thirds
	1 / 8000	
1/6000		1/6400
		1/5000
	1 / 4000	
1/3000		1/3200
		1/2500
	1 / 2000	
1/1500		1/1600
		1/1250
	1 / 1000	
1/750		1/800
		1/640
	1 / 500	
1/350		1/400
		1/320
	1 / 250	
1/180		1/200
		1/160
	1 / 125	
1/90		1/100
		1/80
	1 / 60	
1/45		1/50
		1/40
	1 / 30	
1/20		1/25
		1/20
	1 / 15	
1/10		1/13
		1/10
	1 / 8	
1/6		1/6
		1/5
	1 / 4	
1/3		1/3
		1/2.5
	1 / 2	
1/1.5		1/.6
		1/.3
	1 sec.	
1.5		1.3"
		1.6"
	2 sec.	
3		2.5"
		3"
	4 sec.	
6		5"
		6"
	8 sec.	
12		10"
		13"
	16 sec.	

F-Stops

Halves	Whole	Thirds
	1.0	
1.2		1.1
		1.2
	1.4	
1.7		1.6
		1.8
	2.0	
2.4		2.2
		2.4
	2.8	
3.3		3.2
		3.5
	4.0	
4.8		4.5
		5.0
	5.6	
6.7		6.3
		7.1
	8	
9.5		9
		10
	11	
13		13
		14
	16	
19		18
		20
	22	
27		25
		29
	32	
38		36
		42
	45	
		50
		57
	64	

ISO Sensitivity

Whole	Thirds
12	
	16
	20
25	
	32
	40
50	
	64
	80
100	
	125
	160
200	
	250
	320
400	
	500
	640
800	
	1000
	1250
1600	
	2000
	2500
3200	
	4000
	5000
6400	
	8000
	10000
12500	

Shutter speeds, f-stops, and ISOs in 1-, 1/2-, and 1/3-stop increments. Most numbers apply to most systems, yet the range available depends on the camera and lens you own.

Shutter Speed

Shutter speed is another main ingredient of exposure. The basic definition of shutter speed is "the rate at which the shutter, a mechanism inside the camera, opens and closes to expose a scene"—whether on film or onto a digital image sensor. Shutter speed also controls two aspects of exposure:

- The amount of light entering the camera and lens: measured by your meter
- The speed at which the scene is shot: measured in time (seconds, minutes, hours)

Shutter speed is measured in seconds or fractions thereof, and also plays a part when conveying a feeling. Shutter speeds usually range from a screaming fast 1/8000 sec. to a slow 30 seconds; by using the B setting (which stands for "bulb"), you can lock the shutter open as long as you wish, to create exposures minutes or hours long (great for exposures of star trails).

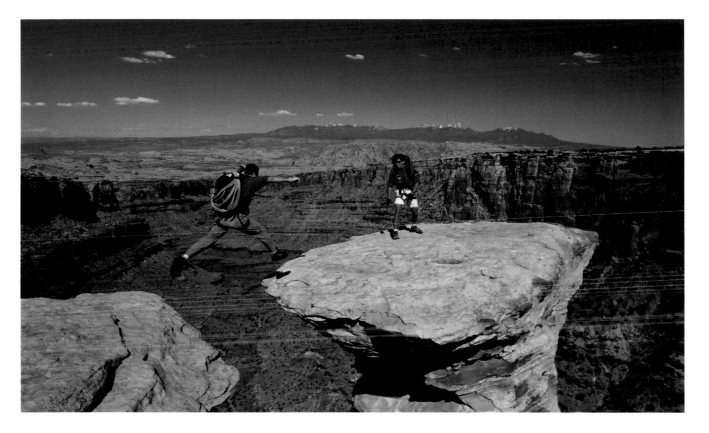

The F-Stop Formula

"Stops of light" is a measurement of the amount of light entering the camera. One stop will halve or double the amount of light, depending on the shutter speed, aperture, or ISO changes you make. With shutter speeds and ISO, the change is easy to remember since the number usually halves or doubles every 1 stop (from 1/1000 to 1/500 second or from ISO 200 to 400 is doubling the amount of light, for example). Apertures are more confusing since the f-stop number halves or doubles every 2 stops: f/4 to f/8 is 2 stops, f/32 to f/16 is 2 stops, and so on. However, the amount of light halves or doubles every 1 stop—f/4 to f/5.6 is 1 stop less light, f/32 to f/22 is 1 stop more light—so memorizing the 1-stop increments with f-stops can help in this process.

The examples of freezing movement shown above and on page 94 were captured using three different shutter speeds. Depending on the lens, how close you are to your subject, the speed at which the subject is traveling, and the angle, the best shutter speed varies. The jumper above was captured using a 1/500 sec. exposure. The pelicans on page 94 a 1/250 sec. exposure, and the bursting wave a 1/640 sec. exposure.

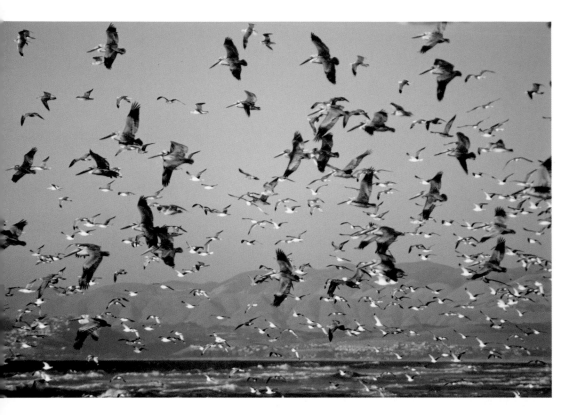

Two examples of freezing movement, captured using different shutter speeds. Depending on the lens, how close you are to your subject, the speed at which the subject is traveling, and the angle, the best shutter speed varies. The pelicans (left) were captured at a 1/250 sec. exposure, while the bursting wave (below) was exposed at a 1/640 sec. exposure.

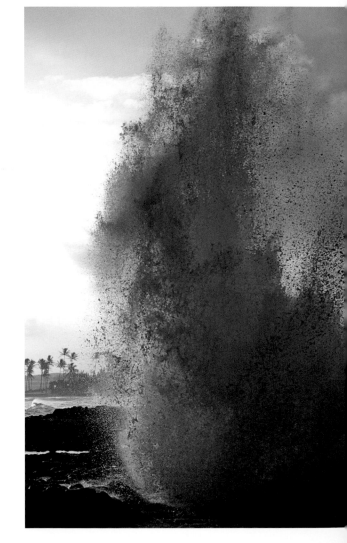

Shutter speeds come in 1-, 1/2-, or 1/3-stop increments as well; once again, check the adjustment in your camera's EV step menu. As with aperture, shutter speed controls the amount of light falling onto your image sensor or film, and therefore it affects your exposure decisions. This is the trade-off that comes with exposure, especially with shutter speed, aperture, and ISO settings. Figuring out how to work around the negatives to find the best combination of settings for a specific scene is tough.

In addition to its effect on exposure, shutter speed changes the way movement appears in your picture, which in turn alters the overall feel. Fast shutter speeds are used to expose more brightly lit scenes, and to freeze fast-moving subjects like birds, water, or wildlife. Stopping something in motion depends on the speed of the subject, the direction it is going (side to side, or moving away from or toward you), the distance from you, and the lens chosen. When used effectively, frozen motion can illustrate expressive moments of power and strength. Slow shutter speeds are used to intentionally blur moving subjects for artistic effect, such as groups of animals or a flowing river, or to give the feeling of speed, movement, flow, or motion. One example of this is with water. The faster your shutter speed, the more powerful the water usually appears. With a slower shutter speed, water can appear to be moving faster. Slow shutter speeds tend to smooth water, creating more distinguishable reflections. This also allows you to see into the water more clearly. Your LCD screen really comes in handy here, giving you the chance to compare the motion of the water. Long shutter speeds are also used for low-light situations when flash is not an option and more light is needed to expose the scene, such as sunrises, sunsets, dawn, dusk, deep shade, or nighttime.

When it comes to photographing without a tripod, the handheld shutter rule is an important guideline. The general rule of thumb is that the slowest shutter speed you can use when handholding your camera is a fraction of the number matching the focal length of your lens. For example, handhold a 300mm lens and you should not go below 1/300 sec. Handhold a 20mm lens and your lowest speed should be 1/20 sec. Any shutter speed used below the length of your lens without a tripod can result in camera shake—a slight blur throughout your scene where nothing is in focus, caused by the slow shutter. Many think there is something wrong with their lens or camera, or that they just missed the focus, but it is usually a slower exposure combined with an unsteadied camera.

However, when using the technique of panning—when you follow a moving subject with your camera while using a slower shutter speed to capture the subject's motion— the handheld shutter rule goes out the door.

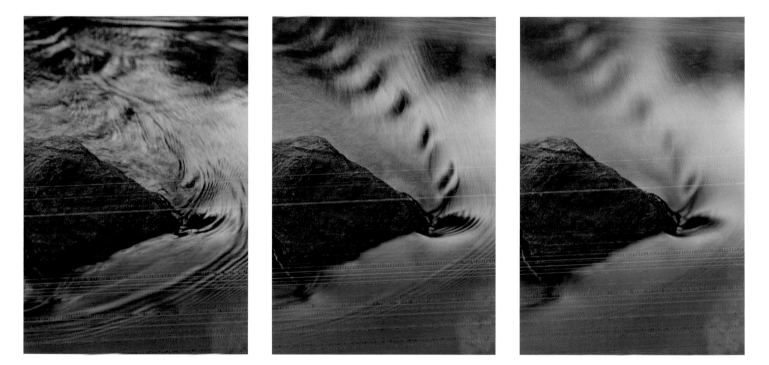

This series shows the undulations in the Feather River through the comparison of shutter speeds. The faster the shutter speed, the sharper the ripples. Captured at ISO 100 with a 60mm F2.8 lens, and exposed at (from left to right) $f/2.8$ for 1/10 sec., $f/11$ for 1.6 seconds, and $f/32$ for 13 seconds, respectively.

» tip

A big issue for nature photographers working with exposure is securing tack sharpness—seeing feather detail, the hairs on an animal, a sharp eye; it all makes a difference. You can capture soft or blurry images even with a tripod. Most think using a high ISO is required, but this isn't always necessary. Besides following the handheld shutter rule, here are a few ways to get sharp images:

- Mount your camera to a tripod.
- Use a cable release or a remote trigger (or your self-timer if you don't have one).
- Use mirror lock.
- Weigh your tripod down with something heavy.
- Use an IS/VR lens. Important note: Turn off your IS/VR lens (see page 96) when using a tripod.
- Check your ball head to make sure it is not slipping, especially with vertical compositions and heavier gear.
- Check the diopter on the viewfinder to make sure it is set to zero or properly set to your eye prescription.
- Make sure you nailed focus using auto or manual focus.
- Consider using a shorter lens if you have to handhold your camera in low light, since you can use a slower shutter speed.
- Check your lens to make sure it is not damaged. Test one scene with a few lenses.

Vibration Reduction/Image Stabilization Lenses

Image stabilization (IS) or vibration reduction (VR) lenses counterbalance movement to lessen camera shake when handholding a camera, which is most noticeable with longer, heavier lenses. Not all lenses have IS/VR, but if they do, when turned on, the handheld shutter rule can be stretched a bit, allowing you to use slower shutter speeds by 2 additional stops. For example, with a 400mm lens, instead of handholding it no lower than 1/400 sec., you can now go down to 1/100 sec. with IS or VR. For a 100mm lens, instead of 1/100 sec. being the bar, 1/25 sec. is the new rule with IS/VR. New VRII lenses claim up to 4 stops below the handheld shutter rule. But when it comes to IS/VR lenses being used in conjunction with tripods, or another piece of equipment to steady it such as a beanbag, it's critical you turn IS/VR off. If you don't, the internal mechanism counteracts the tripod, searching for movement, resulting in shake itself.

Unable to mount my camera on a tripod while shooting from a boat, I turned on vibration reduction to ensure sharpness while handholding below the handheld shutter rule. Photographed with a 300mm F4 lens at f/4 for 1/1250 sec. using ISO 100.

ISO

The third factor in exposure, and one that gives you more choices with your settings, is your digital ISO (ISO or ASA for film). Since you can control shutter speed and aperture through ISO, the number you choose can greatly affect the final outcome.

ISO determines the sensitivity of your image sensor (or film) to light. The higher the number, the more sensitive it is; the lower the number, the less sensitive it is. As with any aspect in exposure, there are trade-offs. The "faster" or higher the ISO (e.g., 400, 800, 1000), the less light is required (a shorter time is needed to expose the scene onto the image sensor). The lower the number, the more light is needed (a longer exposure). The belief that a higher ISO is always best since you can acquire more depth of field as well as a faster shutter speed is wrong. Higher ISOs produce more digital noise (randomly spaced, brightly colored pixels that can replace detail and proper color), and they should be considered only when you have no other choice. A lower digital ISO setting (or slower speed film) may need more time to expose a scene, but it provides a better result. If you want to achieve minimal noise with rich black shadows and smooth optimal color and detail in your outdoor scenes, chose a lower ISO. The capability to switch ISOs in mid-shoot, without having to finish a roll of film, is one great aspect of digital, allowing you to capture a scene at a moment's notice. If you need to shoot faster shots, using a higher ISO is fine; just be aware of the added noise and loss of rich detail and accurate color the higher you go.

When would you want to switch your ISO? One example is from a recent photo shoot I was on in a slough, photographing from a boat as sunset approached. Being on water, I could not steady my camera as the light diminished, so I had no choice but to bump up to a higher ISO to compensate for the movement, avoiding the camera shake caused with slow shutter speeds—sharpness taking precedence over noise. Another example is when wind is swaying the wildflowers in the foreground of a landscape. I'll want tons of depth of field for that scene, requiring a small aperture and thus slower shutter speed. A higher ISO helps raise my shutter speed to freeze the flowers in place.

Exposure Modes

Most cameras have three automatic exposure modes (Aperture Priority, Shutter Priority, and Program/Automatic) and one Manual mode that control how you decide to expose, some giving you greater control than others. For all automatic exposure modes, the camera's meter will determine the final exposure (unless you use exposure compensation). Each mode acts slightly differently, letting you control one or two settings while it does the rest—with the exception of Manual, which gives you more artistic freedom to create and alter from the meter.

Aperture Priority (Av): Usually abbreviated Av or A, Aperture Priority allows you to set your aperture while the camera calculates the appropriate shutter speed. Av is a nice option when depth of field is central to the photograph and is great for a hurried situation or fast-moving event that does not allow time to meter. This helps you focus on your aperture alone and concentrate on the scene at hand.

Shutter Priority (Tv): Conversely, Shutter Priority (Tv or S for short) lets you select the shutter and have the camera calculate the corresponding aperture. Tv is often used for scenes dealing with time, whether fast or slow, allowing you to focus on the speed of your capture without having to meter or select the exposure. When might I use Tv? In situations where light is changing quickly, or my subject is moving in and out of alternating light levels, not allowing me to meter manually—such as a horse running through shade and sunlight. Tv is great for panning situations, allowing me to pick a shutter speed appropriate for my subject, while it sets the aperture according to the light available.

See chapter 2 for more about noise and image sensor size, and chapter 10 for software plug-ins that reduce digital noise.

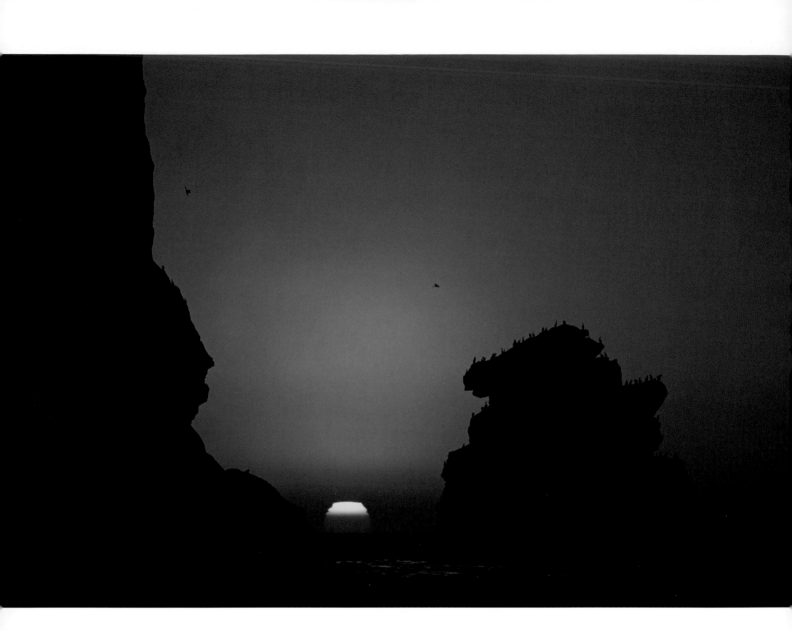

To guarantee proper exposure for this scene, I shot in Manual, judging the tone of the sunset sky and choosing the exposure I desired. Shot with a 300mm F4 lens, at *f*/4 for 1/250 sec. using ISO 100.

» **tip**

Aperture Priority is great to practice with when learning how *f*-stops work; it shows you what comes into focus using the various apertures and how they alter a scene. By concentrating on one aspect of your camera at a time, you can learn about a feature much more easily. The same goes for Shutter Priority when you want to compare shutter speeds and subject matter.

Program (P)/Automatic (A): Current DSLRs refer to this mode as Program, while older models use Automatic. In this exposure mode, my least favorite, the camera sets both the aperture and shutter speed based on the meter's recommended exposure for a specific scene. All you have to do is compose, focus, and shoot. Many cameras offer a selection of Program modes; one type allows you to rotate the dial to change the aperture and shutter speed combinations—Nikon refers to this as Flexible Program and Canon calls it Program Shiftable. There are also program preset combinations for specific shooting situations, such as Landscape, Night, and Action.

My main problem with all of these automatic exposure modes is that they rely on the camera's internal reflective meter to judge the light and set the exposure. Meters are getting better these days, but they're still wrong in many instances. Yes, exposure control is not lost completely with automatic exposure modes and exposure compensation, but more on that later.

Manual (M): Manual is the only exposure mode that gives you complete control of your exposure; it is my personal favorite and the one I use almost exclusively. You can set the *f*-stop, shutter speed, ISO, and other functions of exposure without your camera making the decision for you. In my book on exposure, I make the analogy that auto-pilot may be able to fly a plane, but you still need a pilot to make critical decisions that control the aircraft. This mode takes time to learn, but when you become competent in metering and understanding the myriad lighting conditions you come across in nature, you will begin to realize that having full control of a scene gives you the greatest flexibility and creativity. In Manual mode, I can take my meter's recommendation of a proper exposure and decide if the setting would create the best exposure for what I have in mind. I may wish to create moods by under- or overexposing on purpose, or fix potential metering issues or miscalculations (see page 102).

Exposure Value (EV)/Exposure Compensation (EC): Exposure Value (EV) is the value or measurement of light (what your meter does) and Exposure Compensation (EC), often seen as a +/− symbol on one of your camera buttons, alters this recommendation. This is why EC is used in automatic exposure modes like Av, Tv, or P, and not in Manual (where you alter the recommended exposure on your own). Measured in 1/3-, 1/2-, or 1 stop increments, EC changes your aperture, shutter speed, or ISO setting (depending on which exposure mode you are in) to fix any exposure mistakes your meter may make. I do not use EC since I work in Manual mode most of the time. It should also be noted that if you use EC with Av, Tv, or P, you may tend to rely on your LCD screen, which, as mentioned in chapter 2, is not the greatest judge of exposure.

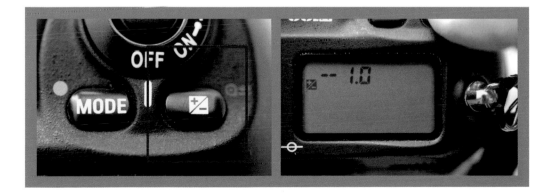

The Exposure Compensation button is often found on top of your 35mm DSLR camera, as well as in your top LCD screen.

Metering Modes

Spot, Partial, Center-Weighted, and Pattern (called Evaluative with Canon and Matrix with Nikon) modes are the main metering modes available in most camera systems. Understanding your meter reading is extremely important to metering any scene. Here is a brief description of each and how they meter certain scenes.

Spot or Partial metering: My favorite mode of metering, yet probably the toughest to use, Spot metering reads the light from a small section, defaulted in the center of the frame (usually between 1 and 5%), whereas Partial meters a slightly larger area (5–9%). I like to select a small subject or part of the scene I want perfectly exposed, meter it directly without the influence of any other area, and judge the tone. Having studied exposure for years, I use a more advanced method of reading various parts of a scene, similar to the way Ansel Adams used the zone system (a method of finding the best exposure to generate black blacks, white whites, and everything in between). A bit more knowledge of exposure is required, as well as doing math in your head, which adds some time to your setup when in the field.

 Spot metering

 Partial metering

Center-Weighted metering

 Evaluative / Matrix / Pattern metering

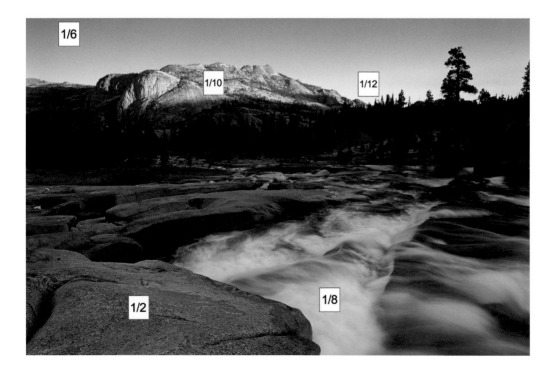

Spot metering different tones and light can give you conflicting recommendations from your meter. Knowing how to decipher the information to choose the best exposure takes a lot of field experience as well as some math. In the river scene here, with my aperture set at $f/22$, spot metering gave me different recommended shutter speeds, and I ended up choosing 1/6 sec. (using a two-stop graduated neutral density filter to cut the contrast). For the climber shown opposite, I kept my shutter speed at 1/25 sec., and spot metering gave me a mix of different aperture recommendations. I finally decided on $f/16$. Both were shot using my 24mm F2.8 wide-angle lens and ISO 100.

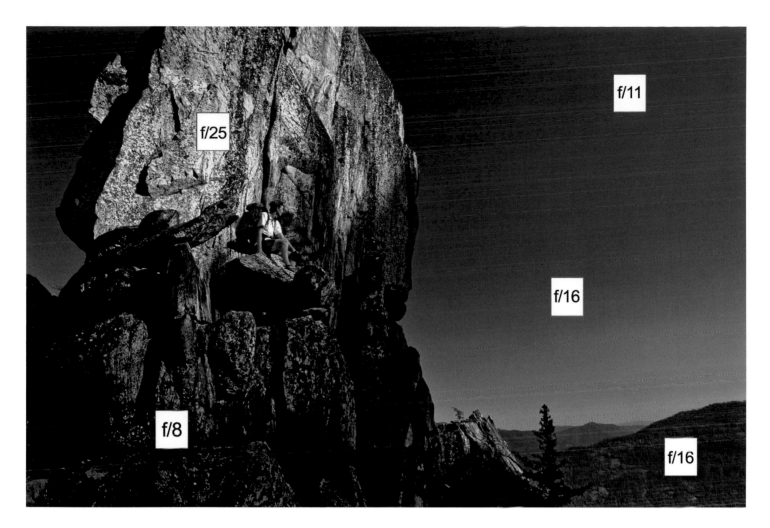

Center-Weighted (CW) or Center-Weighted Averaging: Another main type of metering mode used in cameras going back many years, Center-Weighted meters roughly 13–15% of the center area. If you choose the Center Weighted Averaging option, the entire composition is included in the reading, with the meter concentrating 60–80% of the sensitivity toward the central part of the viewfinder. CW is good for a variety of uses, especially where one tone is relatively large in the frame, such as an area of sky, lake, or grassy hillside.

Pattern metering: Also known as Evaluative, Matrix, Average, Multi-metering, or Multi-pattern, this metering mode reads the light intensity in several points around the frame, averaging them for the final suggested exposure setting and favoring no major portion of your composition. Many feel it is the most accurate of all metering modes. I say it depends on the subject, as well as the balance of light and tone. Metering using Pattern when in Manual exposure mode is tough since you are really in a black box, without a clear idea of how the camera is determining the exposure, how it's weighing highlights versus shadows at various points. Thus, any manual adjustments are hit or miss unless you meter one continuous tone throughout the frame, such as the sky, a lake, or snow. This mode is best for auto exposure modes when you have little choice or time to meter, such as fast action moving in and out of shadows.

EXPOSURE AND YOUR METER

The meter inside your camera is the best tool for calculating exposures, if you understand how it works and what it's telling you. It measures the light reflected off of any subject and is influenced not only by light but also by tone.

Understanding Middle Gray

The concept of middle gray is essential to exposing outdoor scenes. Trying to make everything middle gray—in tone, not color—is the main objective of your camera's meter. Middle gray is the tone halfway between white (highlights) and black (shadows). Ansel Adams referred to this as Zone V; others refer to it as middle toned or 18% gray. Everything in the natural world is not middle gray, however, so I always use the term "meter's recommendation," since your meter is not giving you the "correct" exposure. Your meter is telling you to shoot at a certain setting, but what it is really saying is, "take the photo at this exposure if you want to make this area, or subject, middle gray in tone." If your subject is middle gray in tone, then the exposure recommended by your meter will be fairly accurate, but if it's not, then you have some adjusting to do. How do you distinguish tonal values in nature, what is middle gray, and how much brighter or darker is your subject or scene? This is the part that takes experience, time, miscalculations, and trial and error—the learning curve that takes years to perfect.

Your Metering Needle

Your metering needle, found in your camera's viewfinder or on the top LCD screen, is one of the most important tools in exposure, coordinating shutter speed, aperture, and ISO. Most metering needles (or levels) show a 4- to 6-stop range in a linear area with notches, usually with a 0 in the middle and + and - on each side. Zero is where your auto exposures are set, the setting determined by the meter, not necessarily recommending a correct exposure but one based on middle gray. In Manual, or with EC in Auto exposure modes, once you set your

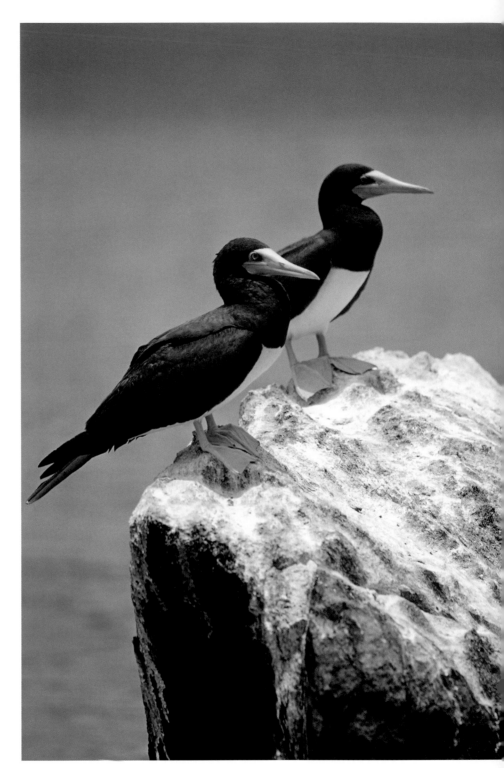

needle to zero, you can either overexpose or underexpose from this recommendation to match your subject's true tone—over if you want to make your subject lighter than middle gray, and under if you want to make it darker than middle gray.

One major reason why exposure takes years to learn is the learning curve of

The tone of the water in Virgin Islands National Park was very close to middle gray, making it easy to meter these brown boobies with my 200mm F2.8 lens. Shot at *f*/4 for 1/1600 sec. using ISO 100.

knowing what is middle gray and what is brighter or darker. Perfecting tones takes years of experience. It also takes knowledge to figure out where and how to meter a scene. Using certain metering modes like Spot, Partial, or CW will show you exactly where you are metering; with this knowledge, you can determine if you guessed that tone correctly once you review the image in the computer. As you make mistakes and learn from them, you improve over time. This is where you stop taking pictures and begin to create art. As you practice more and more, you speed up the whole process, and when a moment happens you can finally react with the proper exposure and setting, producing a solid exposure. "Chance favors the prepared mind," as Ansel Adams so eloquently put it.

Finding Tonal Values in the Real World

Middle gray can come in the form of backlit green grass, weathered wood, the part of a sky between the horizon and its apex, or the orange feathers on a red-shouldered hawk's breast. White with detail might be snow in sunlight, the fur of a mountain goat, or bright fog. Sand may be 1 stop brighter than middle gray. Many of these examples vary since their tones vary. Snow may be white, but not necessarily when it's in shade, or partially lit, as it was in my chapter opener from Yosemite Valley (page 86). Metering the color is not the issue; the correct density or tonal value is. Sometimes color is very hard to assess, or meter. One method to work around this is to meter off of another subject in the same light. That way you can judge a potentially easier tone you know, such as a rock, as a middle gray reference, then point at the color to see how your settings will affect that area, if it will over- or underexpose it from middle gray, and if so, how much. With this method, you can begin to learn a variety of tonal values in nature.

» **tip**

If your camera's meter ever malfunctions, you can use the Sunny 16 Rule: On a blue-sky sunny day, an approximately correct exposure can be obtained by using your ISO setting as your shutter speed and f/16 for your aperture. For example, if your ISO is 200, set your shutter to 1/200 sec. and your aperture to f/16, and you should obtain a decent exposure.

My meter wanted me to turn the fog a darker gray, so I overexposed from its recommendation by roughly 1-1/2 stops to match the real tone. Shot at f/4 for 1/640 sec. using ISO 100.

The Latitude from Highlight to Shadow

Since the big exposure challenge is learning how to judge tonal values, having a reference point always helps. Film has a 5-1/2- to 6-stop range, and an image sensor covers roughly 6 to 7 stops, therefore you can deduce that roughly 2 stops overexposed from zero (middle gray) will give you white with detail, and 2 stops underexposed will produce black, or dark, with detail. Go 1/2 stop further on each side, and the general belief is you will lose most if not all detail. What do our eyes see? Our amazing vision can pick up roughly 14–20 stops of light in one scene, so the assumption that we can maintain all detail in all of our images is an exposure myth. If the contrast ratio from light to dark stretches more than 6–7 stops, you cannot obtain all detail in a single shot. When I think about this, I am reminded of what UCLA basketball coach John Wooden once said: "Don't let what you can't do interfere with what you can do." Exposure could be considered a series of cant's, yet if you understand these parameters you can begin to search for scenes that can handle this range, or better yet, benefit from them—turning a potential disadvantage in photography into an advantage.

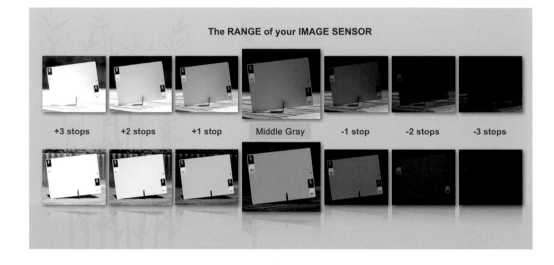

The RANGE of your IMAGE SENSOR

+3 stops +2 stops +1 stop Middle Gray -1 stop -2 stops -3 stops

An example of your image sensor's 6- to 7-stop range using a WhiBal gray card, photographed in shade (top) and in sunlight (bottom). This gives you an idea of the range of light you are able to capture on one single image.

Gray Cards and White Balance

In theory, gray cards are great for determining exposure, but I rarely, if ever, use them for metering outdoor situations. Today, with the advent of white balance, the gray WhiBal card can be used for both metering and balancing the light, but even then I'm not big on using it for exposure. To me, it's an extra device to carry, effective only if you can place it in the same light as your subject, and even then it can change in tone if you tilt it up or down. The palm of your hand can work just as well, since it rarely changes in tone. As long as you test it to see what tone it is, you can use it as a reference when your subject is in the same light. That being said, photography is all about personal preference, so if you feel it works for you as a middle gray reference, go for it.

DETERMINING THE BEST EXPOSURE

How many choices do you have with exposure—only one perfect exposure, right? Wrong. The beauty of exposure is in the choices you have, whether to create an accurate depiction or a mood. Another factor is having to decide what to expose for and when. Take the example of shooting a scene with a slice of shade in it. That shade may not be all that important, so losing all detail if it goes black is fine. If you photograph a scene mostly in shade, however, exposing for it to maintain detail may be mandatory.

Equivalent Exposures

Since shutter speeds, apertures, and ISO all affect one another, once you choose a particular, appropriate, or correct exposure for a given scene, you have the option of choosing many corresponding f-stop/shutter speed/ISO combinations that will allow the exact same amount of light as your initial exposure. Equivalent exposures give you a range of creativity with a variety of correct exposures in one designated scene. This in turn can help you convey messages better. For example, f/1.4 for 1/1000 sec. using ISO 100 is the same as f/32 for 1/2 sec. using ISO 100, yet, depending on your subject matter and the lens you used, both equivalent exposures will produce vastly different final scenes.

Perfect versus Correct Exposures

I do not always choose to create images solely based on technically perfect methods, but rather to create a mood or feeling or to evoke emotion. Some photographers forget that when we look at live scenes, there are areas too bright even for our eyes, so conveying that might be appropriate. The art of outdoor photography is about making photographs in which detail, or the lack thereof, helps us attach emotion to a still image. Sometimes a hint of what is going on, without divulging all of the information, simply works better.

I love this example, because it illustrates the need to find a happy medium in order to expose all of the elements well. Shot at f/22 for 1/15 sec. using ISO 100, with my 24mm F2.8 lens, I chose to underexpose the pines by more than 3 stops, overexpose the waterfall by roughly 2 stops, and use the sunlit cliff face or middle sky area for my middle gray reference.

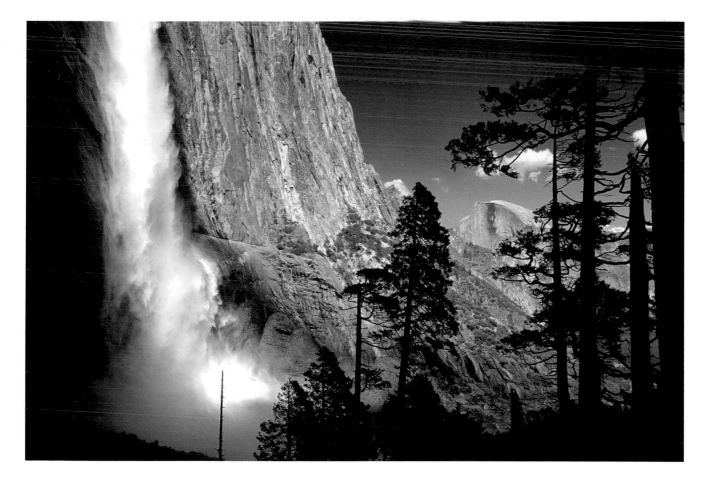

When to Lose Detail

Since our image sensors can't handle more than a certain level of contrast, with many scenes you have to decide which areas you want to keep and which you don't mind losing. When highlights are more important than shadows, expose for them. When the overall scene outweighs a small sliver of bright, over-exposed highlight area, meter for the general composition. When a silhouetted shape is more important than the detail within it, underexpose it.

Partial sunlight and rolling fog combined to create this wild coastal forest scene. My image sensor could not handle the range, but this is why I pointed toward the light: to create a high-contrast scene with a heavenly mood. With my 12–24mm F4.0 lens, I exposed this scene at $f/22$ for 6 seconds using ISO 100.

The canyon walls and the perspective with the hikers is the main focus, but the exposure is the dusk tones since the silhouette creates the drama. Shot with a 300mm F4 lens combined with a 1.4× teleconverter mounted on a tripod at $f/5.6$ for 1/250 sec. using ISO 100.

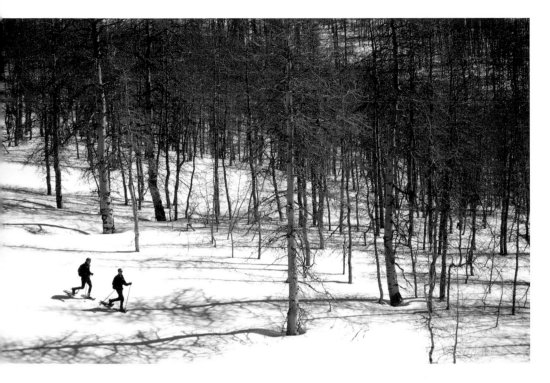

When snowshoeing in Lake Tahoe State Park, I photographed some friends, exposing for the overall scene with little care of losing detail in the bright backlit snow. In fact, if you look at the backlit snow, it will shine so brightly that your eyes can barely retain any detail. This closely matches what I saw. Shot with a 80–200mm F2 lens, set to 125mm, at *f*/7.1 for 1/500 sec. using ISO 100.

Bracketing

Bracketing is a technique that captures several shots of the same scene using different exposures to ensure a good exposure or review alternate exposures in post-capture editing. There is nothing wrong with bracketing; however, it does take up more memory card space, it's tougher to use on moving subject matter, and it can take up more time, but if you cannot determine the best exposure or if light is fading fast, getting the shot becomes the prime concern. With new techniques such as HDR, you may want to use several different exposures to obtain more detail in one scene, something I discuss in chapter 9.

Building a Method

Finding a consistent method of learning exposure can help you follow a step-by-step process toward improving your photography. One system I recommend is shooting four images of the same scene, using your first exposure as your best guess, bracketing 1 stop on each side for the second and third shots, and finally trusting the meter's recommendation for the fourth frame. Whichever way you decide to go, as long as you don't deviate from your approach, you'll learn more about your metering decisions.

Using Auto Exposure Lock

Some become comfortable working in Manual exposure mode, while others learn the concepts but still prefer auto exposure modes. If you choose to work in auto modes, you can still manually meter to some extent by using the Auto Exposure (AE) lock feature. Lock in on a subject or tone, and, if it is middle gray, press your AE lock button to hold the recommended exposure, then recompose and shoot. If what you meter is brighter or darker than middle gray, determine its tone and use your EC to adjust accordingly before firing away. For example, if I were to meter a dark pine tree, I might set my EC to –1.33, meter the tree, hold my AE lock down, and press the shutter, creating an exposure 1-1/3 stops darker than middle gray—perfect for matching the tone of a dark green pine tree.

» **tip**

In the past, when you wanted to capture a scene with extremely high contrast, a ratio from highlight to shadow beyond the realm of film or an image sensor, there was little you could do beyond using a filter or two, wait for better light, or add some sort of fill in the form of light or flash. Today, high dynamic range (HDR) imagery makes it possible to capture these once impossible scenes. I will expand on this technique in chapter 9.

As the last light of day faded fast, we found an S-curve in this inlet and I knew it was the shot I desired. Since I have a tried and true method I've used for years, I was able to meter the difficult scene quickly and accurately. Captured using a 70–200mm F2.8 lens set to 70mm, at *f*/3.5 for 1/1000 sec.

Flash can be a nice addition to exposure, stretching your image sensor's range by filling in otherwise featureless shadow areas. I go into detail with flash in chapter 6.

Auto versus Manual Focus

Another misconception of exposure is that where you focus and where you meter are usually the same. They're not. Depending on the exposure mode and metering mode you're in, as well as the type of camera you own, focusing and metering are usually separate functions. Exposure modes determine how to choose your exposure settings (such as shutter speed, aperture, ISO), and metering modes select the area within your frame to meter tones and light (using spot metering, matrix metering, etc), whereas focusing is done through your lens and is determined by the distance of your subject. Focus is either chosen automatically, if in auto-focus mode, or manually, and is objective depending on the scene you are trying to create.

Nature Assignment #4:

Document a landscape using all available metering modes

One way to learn how your meter works is by comparing what the various metering modes recommend for the same scene. Take a landscape scene, ideally one with contrast, and allow the camera to choose the exposure while you change only the metering mode for each shot. Compare your results and exposures on your computer. In assigning this comparison to students over the years, I have seen up to a 4-stop change between metering modes.

As with each assignment, record the details not included in EXIF metadata—your thought process, your approach to exposing a scene, the area you may have chosen to meter, or how you altered from the recommended exposure, should you wish to study this information later.

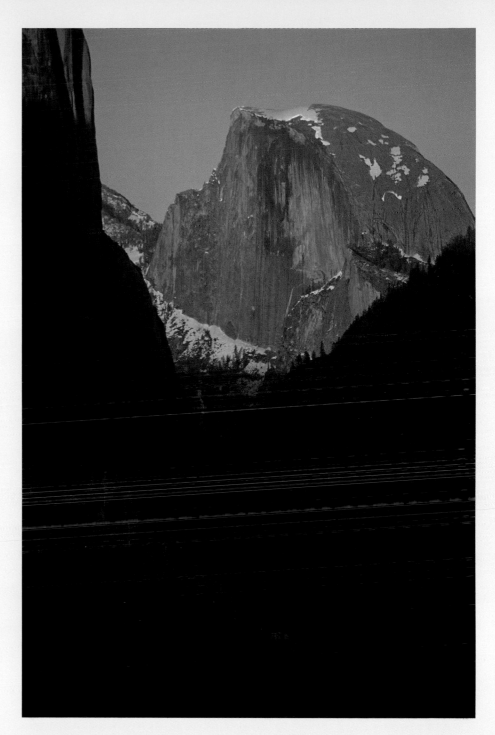

When spot metering a scene like this one, captured in Yosemite Valley, the dark shadowed middle area it points at forces the meter to give a much brighter recommendation than I chose. Center-weighted metering might do better, but still may choose to create a brighter exposure, influenced by the shade. However, pattern metering might perform fairly well since there is a well-balanced mix of tones throughout the scene, and no one particular tone dominates. Using my 300mm F4 lens, I spot metered the sunlit wall of Half Dome for my middle gray reference, since it was my main subject and losing detail in the lower half was secondary.

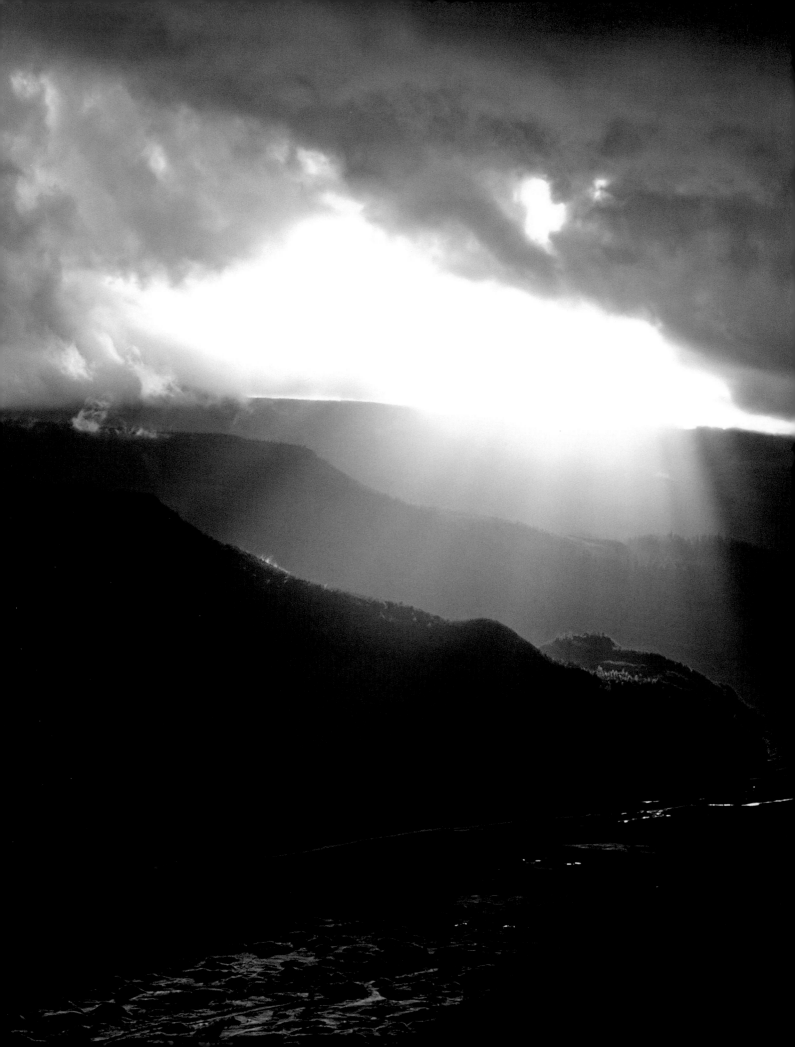

LIGHTING AND WEATHER

One goal I have with my photography is to show the emotional power in nature, to illustrate the isolation and loneliness, the beauty and grandeur, or the chaos and order of the land. I don't want to simply create snapshots of the natural world, but instead share with others how amazing nature can be; therefore, emotion and thought must be tied in. One way to control this is through lighting. Nature photography, similar to other forms of photography, is truly the study of light, and successful nature photography emphasizes light. Quality of light should be a key component in every photographer's arsenal. Light sets a mood, creates focus on your subject, and can contribute to that intangible jaw-dropping "wow" response. Regardless of this fact, the overwhelming majority of people who take pictures do so during some of the worst times of day, or place their subjects in the worst lighting conditions. You might not be able to control weather or light, but you can plan for it, manipulate it, or alter it to fit into your creation.

Pablo Picasso once said, "An artist must know how to convince others of the truth of his lies." This fits well with lighting and outdoor photography. People look at my images and ask, "Was that the real color of the sky?" My usual response is, "Yes, that was the color of the sky—maybe not the entire sky, but that one area where I focused in on was that color." Once you know how to find light, it becomes one of the first things you search for when you are ready to shoot.

USING LIGHT IN NATURE

When you are in a place that has great light, you can often find a cornucopia of images. On his first trip to Yosemite in 1916, Ansel Adams wrote, "There was light everywhere!" I interpret his words to mean, "There are opportunities for photographs everywhere!" Sometimes that light stays around long enough for you to document it in a variety of ways; other times it is gone in a second. If you know how to react once you find the light you desire, whether through the direction you shoot or the exposure you chose, you're halfway there. If you recognize what light works best for which subject matter, you can begin to optimize your time in the outdoors and use the existing light well. Knowing how light reacts in certain situations affords you the opportunity to benefit from what may seem to be a drawback to another photographer. This is what I call the quiet eye—the ability to notice subtleties and oncoming change, and how to make it work to your advantage. It is perfect for situations involving weather and lighting in photography, and something I had no choice but to figure out when given assignments that were tight on time and low in budget.

Choosing a Time of Day

While running one of my workshops, I was once asked why I felt waking before dawn or staying out until dusk would help produce the best photographs. The student felt she captured her best images during brighter times of day. Most likely her captures were with faster exposures, which may have lead to sharper images, depending on her techniques (or lack thereof), fooling her into believing these times of day were better. But different times of day produce different types of lighting, color, and even weather. Light is critical for producing impressive scenes. Since color is a big part of the aesthetics of nature and a powerful form a nonverbal communication, picking the right time of day can alter color in an image and make or break your photo. As anyone who has been caught in an afternoon storm caused by rising temperature levels can attest to, the time of day you choose can add to or detract from your final picture.

As these clouds glided over the south rim of the Grand Canyon, resembling ancient Native American gods set against a deep blue sky, I knew the light was right to get the shot I desired. Using my 24mm wide-angle lens with a polarizer, I exposed the scene at f/11 for 1/30 sec. using ISO 50.

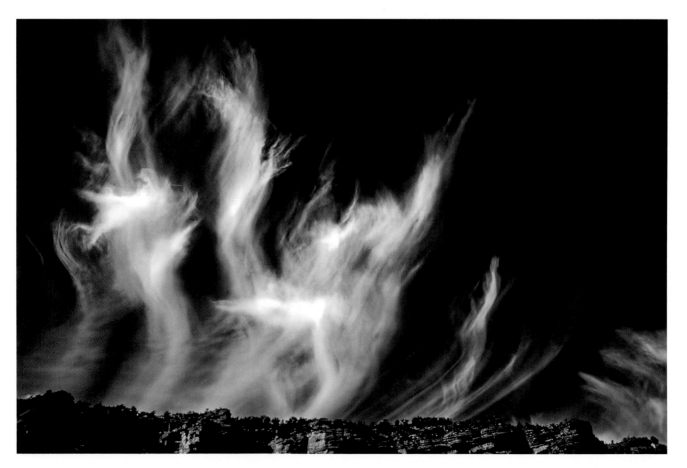

Magic Hour: Dawn and Dusk

I have read a few definitions of "magic hour" or "golden hour," but to me, it is the thirty minutes before and after sunset and the thirty minutes before and after sunrise. Either way, the word "magic" or "golden" is added to this hour because of the wonderful qualities of light. This is why I tend to shoot mostly around these times. Colors appear that typically do not at any other time of the day, tones that emotionally connect with people. They can be subtle hues in soft light or strong, deep shades in direct specular light, most often in yellow, orange, pink, and purple. Sometimes these colors are harder to see with the naked eye but are picked up by our cameras more vividly, even when we think the light is almost gone. Slower exposures are needed in these low-light conditions, which are great for capturing movement in water, clouds, and grasses, but can also cause camera shake or subject movement. Light changes quickly at dawn and dusk, similar to the moments after sunrise.

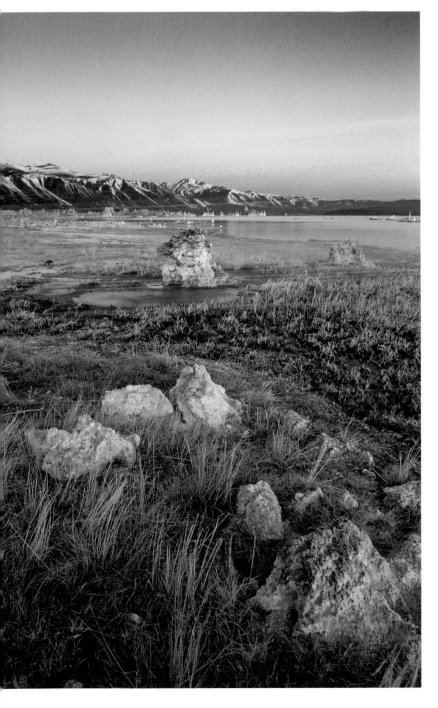

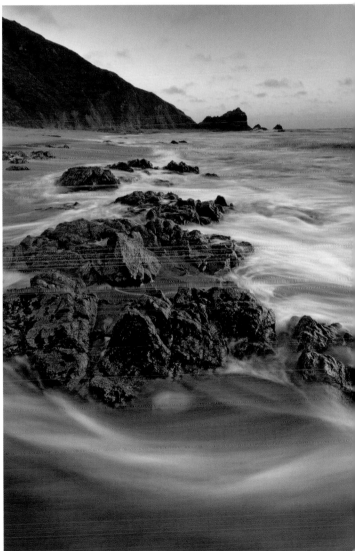

People often head home after the sun goes down, but whether you choose dawn (as I did with the Mono Lake image, at left) or dusk (the image of the California Coast, above), both times of day provide wonderful hues and tones. The Mono Lake landscape was shot with a 24mm F2.8 lens, at f/22 for 2 seconds, ISO 50, and the coast scene with a 12–24mm F2.8 lens, set to 17mm, at f/22 for 1 second using ISO 100.

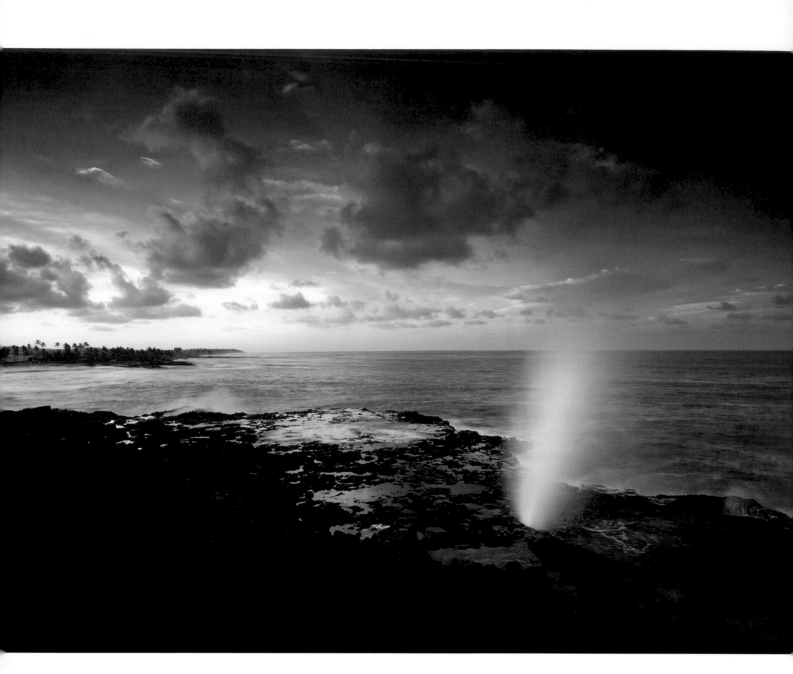

First Light: Sunrise

Sunrises are tough to shoot because light changes quickly, and unless you are in posi-tion to get your shot, the light gets worse as the sun gets higher in the sky. When the first light strikes a landscape, at that moment the light is beautiful and warm, but it increases in intensity, growing harsher as time passes. I've experienced times at sunrise where I noticed subtle hues in the light, set up my tripod, and lost those colors by the time I was ready to shoot. Exposures change dramatically every minute during sunrises and sunsets, so close attention to your meter readings is crucial. Over time you will improve at noticing light changing, but even after 30 years, I have a tough time seeing the shift.

Skies tend to be clear at sunrise because of low night temperatures, but in most cases there is no way to tell sunrise from sunset in photographs (unless you are famil-iar with the area and know the direction an image was captured). As temperatures rise, fog burns off, cloud formations change, and light hits new areas of a landscape. Sometimes this benefits your image; other times it was the shot that got away.

The soft light of dawn slowly changed as the sun rose over Kauai's Spouting Horn along the southern coast. The low light allowed me to capture this 8-second time exposure. Using my medium format camera and a wide-angle lens, I set the aper-ture to $f/32$ using ISO 100.

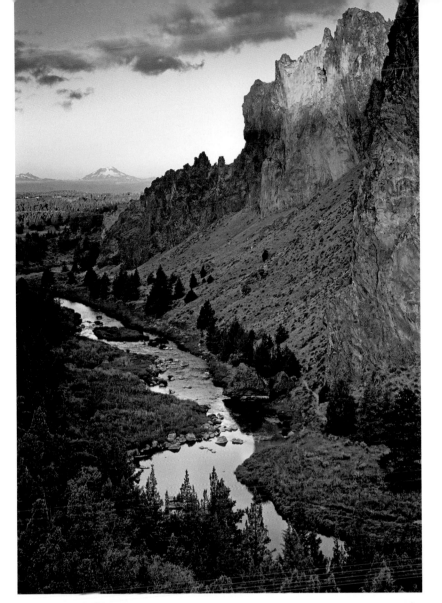

My sole purpose when photographing at Oregon's Smith Rock State Park was to arrive before the first light of day struck the tops of the rock walls. I was unable to find a vantage point to catch the peak reflecting in the Crooked River, but was still pleased with the overall landscape. Taken with a 24mm F2.8 lens, $f/22$ for 1/3 sec. using ISO 100.

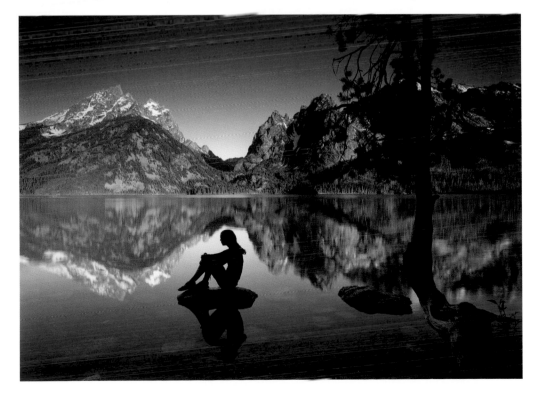

Getting up at 4:30 a.m. to get to my sunrise location was tough, but lack of sleep was furthest from my mind as my vision came together—the Grand Tetons lit up in golden light, reflecting in the waters of Jenny Lake. Photographed with a medium-format camera, a 50mm F5.6 wide-angle lens, and exposed at $f/32$ for 4 seconds using ISO 100 and a 2-stop graduated neutral density filter.

Last Light: Sunset

Sunsets (and sunrises) provide some of the best light. The quality of light at sunset is warm, rich in hues, and more appealing than that of the high midday sun—not necessarily less contrasty, but definitely less harsh. The beauty of sunset is that you can watch the light improve the closer it gets to last rays of the day, giving you the chance to get into position for your shot. Exposures drop as the fall-off of light intensifies colors in a landscape, so be prepared to use your tripod with slower shutter speeds.

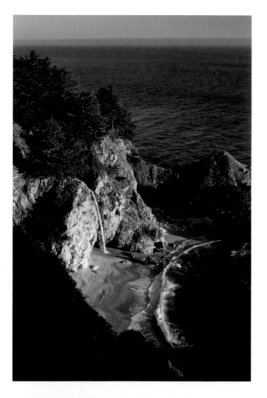 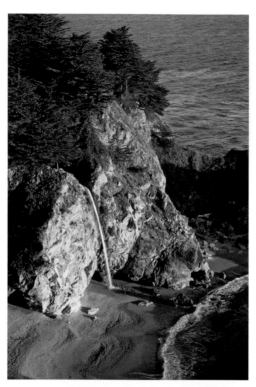

Within a period of thirty minutes, I watched the light on the Big Sur waterfall change, warming every second as the sun dropped closer to the horizon. It was tough to see with my eyes yet clearly evident in this series of images.

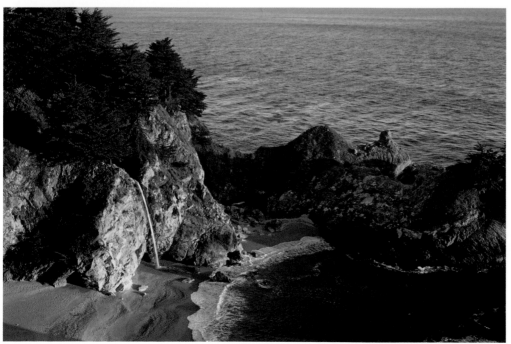

» tip

Alpenglow often happens in high altitudes when the air is clear and the sun is just below the horizon. In this optical phenomenon, a wonderful, ethereal crimson-colored light bathes mountainsides, caused by light reflecting off airborne snow, water, or ice particles low in the atmosphere.

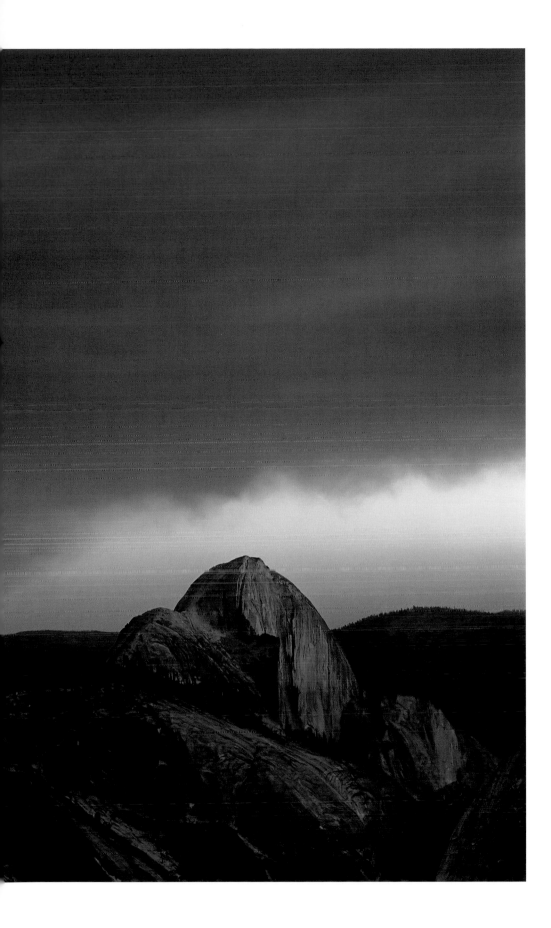

Photographing Half Dome from Olmsted Point, the last light of day turned its granite face a deep orange. Using an 80–100mm F2.8 lens set at 170mm, I framed the scene and set the exposure to f/5.6 for 1/60 sec. using ISO 100.

Morning Light

The light you need for a particular scene may not always come at sunrise, depending on what geographical features lie to the east, the direction you are shooting, or the general surroundings. When you wait for sunrise light to hit a certain area, the warmth of the light may dissipate some, but there is little you can do about it (as seen in the Mono Lake landscape below). Regardless, morning light can still be warm and colorful.

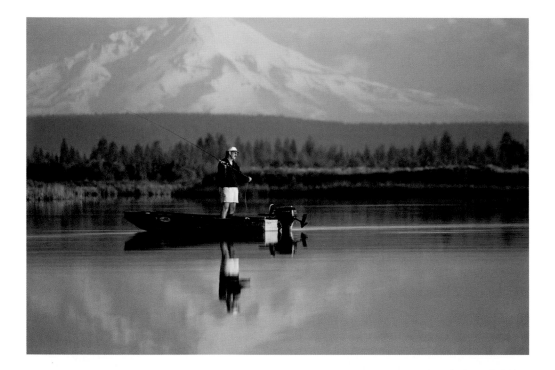

With a fairly flat horizon to the east, I knew I wouldn't have to wait too long before the light struck this fisherman, still wrapped in warm sunrise colors. Photographed with my 180mm F2.8 lens at *f*/4 for 1/250 sec. using ISO 100.

Below: I had to wait for the pink light to turn more golden as it crept down the Sierra Nevada Range to light this tufa tower along the southern shores of Mono Lake. It was not the moment I wanted, but it was the only way to document this cold February morning. Using my 50mm F1.8 lens, I exposed the landscape at *f*/22 for 1/8 sec. using ISO 50.

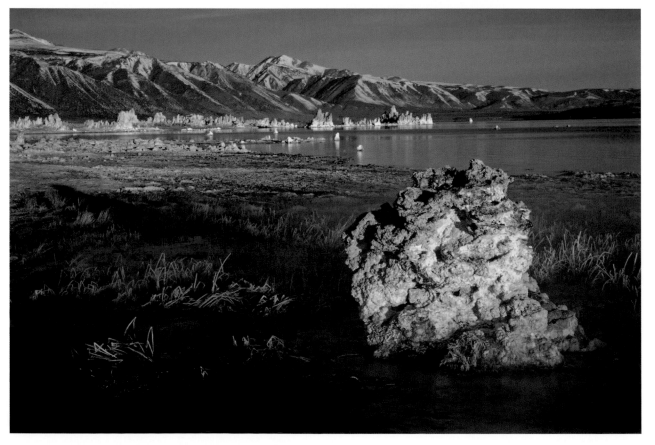

Midday Light

In general, midday light is the worst type of light you can photograph in. The overhead light is colorless, harsh, and uninviting. Finding a scene that is strong, where shadows don't create problems with contrast and loss of detail, and where clouds, blue sky, or other elements help to improve the scene, is essential to distract from the less-than-pleasing quality of light when shooting at this time of day. What do I do during harsh midday light hours? I may scout for shots to capture later in the day, I may take a nap (since getting up before sunrise and shooting after sunset can make for a long day, especially during summer daylight hours), or I may spend it hiking or driving to my next location; these are all good ways to pass the time during hours that are not the best to photograph in.

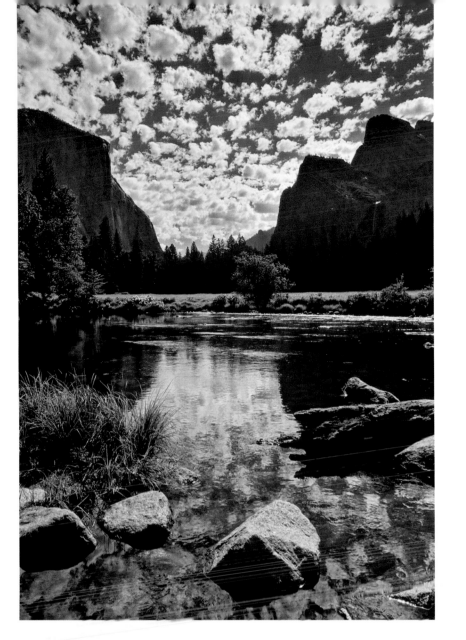

Finding a place to eat lunch in Yosemite Valley, I happened upon this scene at the Merced River, normally a place I visit at sunset. On this day, however, the altocumulus clouds and strong light helped create a unique image of the much-visited riverbank. Using my 24mm F2.8 lens, I metered and exposed the landscape at f/22 for 1/20 sec., ISO 50.

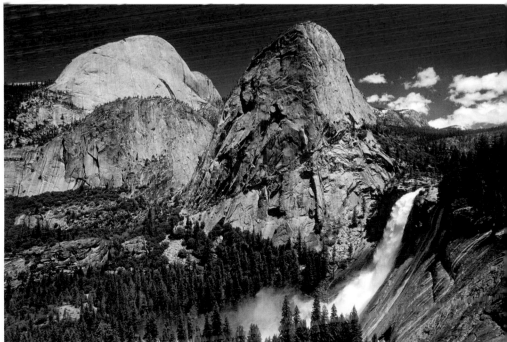

This image of Nevada Falls was captured late in the morning, but the front lighting helped minimize deep shadows and a polarizer cut reflections to bring out stronger hues in the forest and sky. Shot with a 24–105mm F2.8 lens set to 35mm and exposed at f/16 for 1/20 sec. using ISO 100.

Late Afternoon Light

Late afternoon light slowly turns golden as the day approaches sunset. You can watch it move and change while you are getting into position. Watch the shadows move and cover certain elements of the landscape, and use these changes to improve your images.

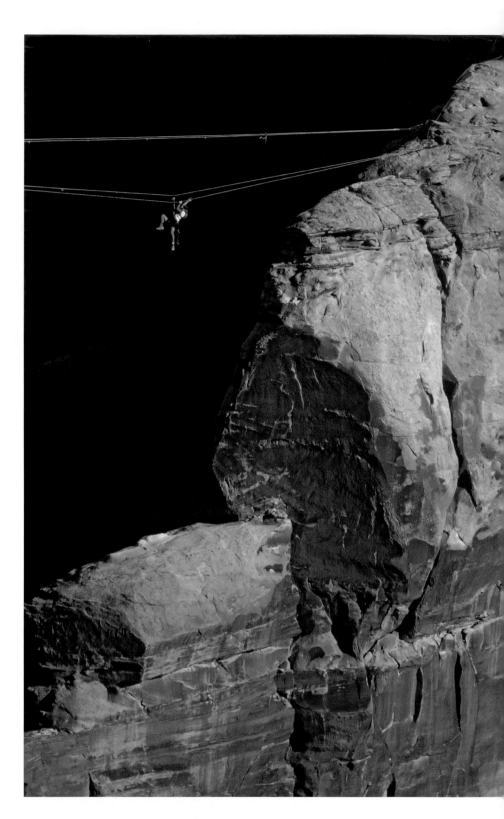

During one afternoon in Canyonlands National Park in Utah, I photographed a rock climber on a Tyrolean traverse. As he started from one end, the canyon behind him, lit by the afternoon sun, blended him into his surroundings. But as the sun fell, shadows climbed up the distant wall, and as he made his way back, I was able to separate him from the canyon, creating a much more dramatic scene. Shot with a 300mm F4 lens and a 1.4x teleconverter (stretching it to 420mm) mounted on my tripod, set to *f*/5.6 for 1/250 sec. at ISO 100.

DIRECTION OF LIGHT

There are various forms of lighting—frontlight, backlight, and sidelight—available to you. All that's required is a turn of your body to choose the direction and type of light to place your subject in. Seems fairly straightforward, but as it is with photography, there is so much more to it, and the affect direction of light has on your subject makes a huge difference between a nice shot and a powerful one. By analyzing these various forms of lighting when setting up a photograph, the biggest advantage I have is the control over the light, which helps me create striking images.

Controlling the Light

Contrast and lighting ratios in a scene are typically determined by the direction of light on your subject. This is important because you can adjust and control contrast by choosing one direction over another. The angle you choose may result in a much better image or less desirable one.

Another method of controlling light is attempting to predict what it might do—where the sun may go as far as direction and location, and how that might change your shot. I typically use these methods when I scout or plan for a moment, such as arriving at a lake in the afternoon and determining where the sun (and moon) may be at sunset or sunrise.

Avoiding Flat Scenics

A common blunder is positioning yourself between the sun and your subject, with the sun at your back, which provides the most light on the scene, but renders the light now cast on the surroundings as flat and boring. This is known as frontlighting. Frontlighting is often harsh, giving your subjects little shape or dimension, but it is somewhat easier to expose because of the diminished contrast. However, I would choose this type of light only if my scene was truly stunning and the light was spectacular and colorful.

Creating Depth and Dimension

The key to creating shape and dimension in a photograph is using highlights and shadows, often achieved with sidelighting. Sidelighting is when your subject is half lit by a light source and half in shade. Another way to think about it is when the light source is 90 degrees off axis from your camera. This type of lighting is no different in nature than it is on a face or any three-dimensional subject. It helps give shape and texture or the perception of distance, nicely translating a three-dimensional subject into a two-dimensional medium.

Knowing how to expose in this contrasty light is not easy. Sometimes you may pick a happy medium between highlights and shadows. On occasion, you may decide to meter for the bright side and let the dark side go almost black. Conversely, you may expose for the shadow side, allowing the highlight areas to be overexposed. It all depends on your subject and what you're trying to accomplish.

Left: Besides wanting to capture a wonderful mix of warm and cool tones, I used the side- and backlight in this Bryce Canyon sunrise scene to help create dimension to these sedimentary rock formations called hoodoos. Shot with a 80–200mm F2.8 lens set to 180mm and exposed at *f*/4 for 1/60 sec. using ISO 100.

Below: Documenting rock climbers in Buttermilks near Bishop, California, I used the available low angle of the sun to backlight my subjects, drawing attention to their shapes as well as the shapes of the large boulders. Positioning myself so the sun barely peered out from behind the left boulder, I exposed the scene by metering the sky just above the climber and used this area for my middle gray reference. Using a 12–24mm F2.8 lens set to 16mm, this scene was shot at *f*/11 for 1/15 sec. using ISO 100.

Shooting into the Sun

Photographing toward the sun is routinely thought of as too contrasty or difficult to deal with as far as exposure, yet it is my favorite type of light, a kind I regularly search for. Backlighting, when the light source is behind your subject and you're shooting toward the light, accentuates form, adds a dramatic element to your images, helps to create beautiful moods, and emphasizes light; that is, the viewer notices the light more. It's tough to expose because of the extreme contrast ratio from highlight to shadow, but the challenge is worth it if you get the desired result.

When I attempt to backlight a scene, I usually meter for everything but my silhouetted subject—the tone of the sky or water, for example. Frequently, I search for some type of "gobo" (derived from "go between"), a natural object used to block the light source from the camera's lens. It can be a tree, a branch, a flower, an animal, a person, clouds, a cliff or rocky outcropping, or even a bird flying in the sky, just as long as it blocks the sun from my lens. In essence I am making the sun my friend, using it to my advantage by using the light while avoiding the glare of the extremely bright star. I lose any flare I may get by pointing my lens toward the sun, as well as control how much or little of the sun I want to appear around the object. One way to find where to place your camera is to look for your object's shadow and place your camera's lens in it; that way you are guaranteed to have the sun blocked.

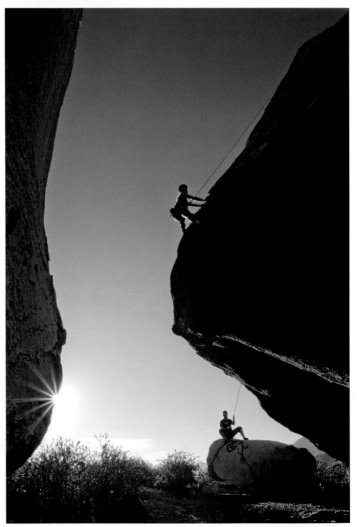

I knew when I found this tree branch lying in the Napa River that it would be my main subject for the sunset. The backlighting silhouetted the branch, and I was able to find the right angle to frame the sun just before it fell below the horizon. Shot with a 24mm F2.8 lens set at *f*/22 for 1/2 sec. using ISO 100.

» **tip**

The Photographer's Ephemeris is a free software program (for Mac, PC, or Linux) designed to help photographers with sun and moon coordinates for any location in the world. Outdoor photography is not necessarily about predictability, but knowing where the sun and moon are positioned can afford opportunities and assist in capturing known events, such as an eclipse or a full moon evening.

WEATHER, ATMOSPHERE, AND CLIMATE

If there is one part of nature you can't control it is the weather. There is just no way to find idyllic conditions everywhere you photograph, and sometimes decent conditions are all you can hope for from Mother Nature. You can, however, put yourself in the best position to create solid images by understanding how to photograph, and what to look for, in a mix of atmospheric conditions.

Researching

Today, there are so many portable ways to get weather reports. I use my iPhone, which has apps for everything from weather in specific areas to moon phases, sunrise and sunset times, wind, tides, and even radar information. Gathering as many particulars as possible about the climates you may be photographing in helps you not only with the type of gear you need to bring, but also with the photographic plan you may implement. Through watching weather and seasonal reports, you can arrange to visit certain locations on specific days or during optimal seasonal times. Or go low-tech and step outside your tent to check the weather live.

Predicting

As mentioned in the previous section on light, following the sun's direction to know where it is going is important when planning to capture a scene. Knowing what the weather might do can get you into position to get shots no one else has thought of. Predicting the weather is hard for anyone, but combine it with enthusiasm, patience, and the willingness to take a chance, and you can find moments you never imagined.

Case in point: While in the Swan River valley in western Montana after a long day of shooting and travel, I found the next day's weather report. Low morning clouds were expected in the valley, so sunrise images along the lakes and rivers were out of the question. But I knew that if I could find a fire trail to take me above the clouds, I might have a chance at some nice light. The next morning the skies looked bleak, but with a local map in hand, I headed up a few roads until I finally broke through the clouds. Above the low-lying clouds I could tell I had a potentially amazing scene in front of me once the sun made its way over an eastern ridge. A few moments later, as the sun cast its light on the landscape, I captured a group of silhouetted pines being engulfed by the fog.

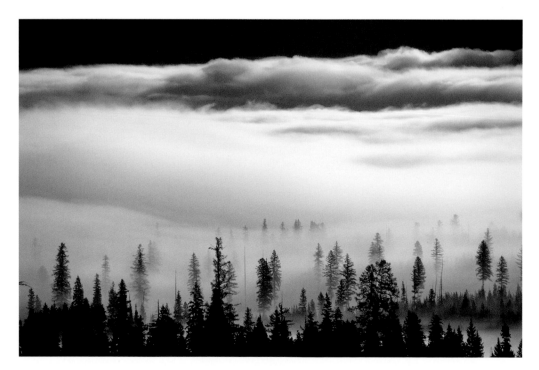

When I left my cabin pre-dawn, a thick layer of clouds implied that any bit of sunrise would be a wash. But knowing I was in a valley, and the weather forecast was predicting a fairly sunny day, I decided to head up a mountain road to see if I could get above the clouds, which paid off nicely at sunrise. Shot with a 300mm F4 lens using f/8 at 1/500 sec., ISO 100.

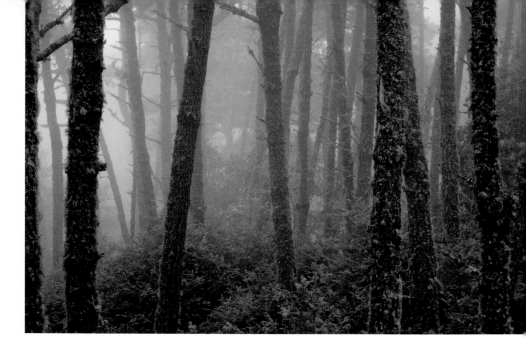

Overcast

Overcast light is soft and diffused, providing even lighting for your scenes. You can photograph landscapes in overcast light as long as you choose the right landscape.

Overcast conditions disperse the light, creating fewer shadows with less contrast. Overcast is great for forest scenes, since direct sunlight is extremely contrasty. Overcast also mutes color and replaces it with a monotone feel, so think in tonal values similar to black-and-white photography. Macro photography also benefits from this type of lighting, as I elaborate in chapter 8. One word of caution: The norm is avoiding white skies with landscapes in overcast light; they are thought of as uninteresting and devoid of information, so I usually crop them out. But as is the case with all art, rules are made to be broken.

There is also a difference between bright overcast and heavy overcast. Bright overcast is more forgiving, offering more subject matter to capture using the light. Heavy overcast can be dark and muddy and very difficult to work in.

As we headed out for a field session on one of my workshops, the thick fog rolling over the hills told me a beach sunset would most likely not work. So instead, I chose a location on a nearby mountain, knowing a forest landscape would benefit with the soft light. I used my 60mm lens and exposed the scene using *f*/22 with a 2.5 second shutter speed, ISO 100.

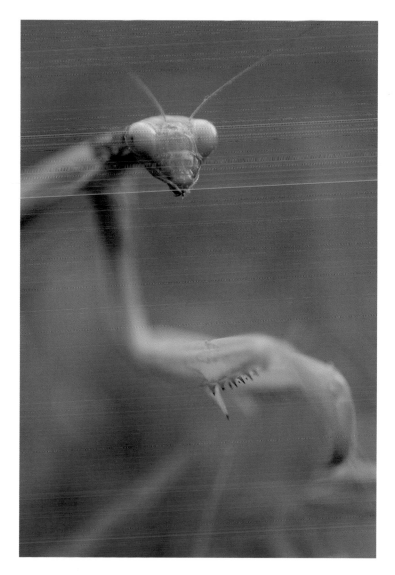

Soft overcast light also works well for macro scenes, creating softer shadows, as on this image of a Praying Mantis. Exposed at *f*/4 for 1/160 sec. using ISO 400 and a 60mm lens.

Storm Light

Some of the best and worst light to shoot in is storm light. You never know when the light may change, if a sunbeam might appear through the clouds, or if the sky will just get darker and colorless, turning to rain and dreary skies before the day peters out to darkness. However, if the clouds do part for a few seconds or minutes, storm light can be the catalyst for turning good scenes into amazing images. You can find exquisite skies that are high in contrast between dark grounds and brighter rays of sunlight, the combination creating powerful moments in nature. Color can burst into the scene, aiding in creating unique, extraordinary landscapes.

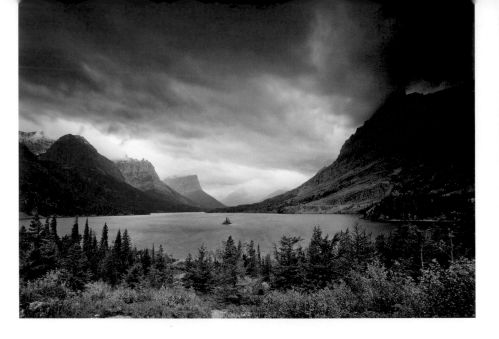

Two weeks of rain and overcast skies in Glacier National Park did not afford me much in the way of extraordinary light, but persistence paid off as I captured a wild sunrise with a subtle double rainbow. Using a 50mm F5.6 wide-angle (medium-format) lens, I photographed the landscape at $f/32$ for 1/4 sec. using ISO 100.

As I crossed the border from England to Scotland, a drab day finished with a bang as the light from a sun that had already set shined onto storm clouds above a ridge, creating a crimson red that only lasted a few minutes. With my 80–200mm F2.8 lens in hand, I zoomed in and exposed the scene at $f/5.6$ for 1/100 sec. using ISO 100.

Admittedly, I am not an expert lightning photographer, but I have captured lightning a few times and can offer some advice on this tricky yet rewarding type of outdoor photography. Bear in mind, safety is always a concern when lightning is close enough to capture, especially because you most likely will use a tripod, and holding a long metal device can make you a target for a strike. First, choosing a place where the view of the sky is optimal helps create a better final image. Also consider your foreground and overall composition. Second, photographing in a place just outside of the storm not only gives you a clearer photo, but also allows you to watch the storm system as it moves. Then, choosing a longer exposure gives you more of a chance to record a lightning strike, but may also require a cable release. Shooting with the smallest aperture, a low ISO, and in low-light situations results in slower shutter speed options—moving past 30 seconds (or whatever might be the longest shutter speed option on your camera) to the B (bulb) setting allows you to hold the shutter open as long as you wish (naturally attempting to coordinate a proper exposure while keeping the camera still). Exposures vary depending on the time of day and strength of the lightning strike. A focal length between 24mm and 150mm, focused on infinity, gives you some leeway since these lenses cover a good portion of a sky. Lightning triggers are available that fire the camera when there is a sudden change in light. Triggers fire much faster than our fingers and cause less shake as well, but also can fire the camera even if the lightning is not in frame.

As a lightning storm rolled through the Florida Keys, I set my medium-format camera to Bulb and captured a timed exposure of 45 seconds at $f/5.6$ using ISO 100. During the exposure I caught a bolt of lightning stretching from the highest clouds down to Florida Bay.

Ambient Light

Ambient light is any nondirectional light, such as shade, dawn, or dusk light. Similar to overcast, the light is soft, evenly distributed, and diffused, presenting few or no shadows. Ambient light is normally blue in tone, and whether you decide to white balance it to neutralize the shift or use the color to create a mood is up to you. One example of ambient light I captured was during a winter day in Yosemite Valley. The sun was already striking the north wall, but most of the valley was still in shade. I framed a group of birch trees in with the soft blue light, giving the scene a cool winter feeling, as was the case that morning.

The cool tones of dawn were perfect for this winter scene in Yosemite Valley. Using my 70–200mm F2.8 lens set to 130mm, I documented the scene at f/9 for 1/40 sec. using ISO 100.

USING THE ELEMENTS TO YOUR ADVANTAGE

In photographing nature for more than 30 years, I have learned a mix of small tricks to create something from nothing. As they say, half of the battle is getting there, and sometimes you have to brave the elements and try to use them to your advantage to create a great scene. Simply put, half of good nature photography is effort and commitment: the effort to hike back to camp in the dark through a rainstorm, the commitment to having your legs freeze in a glacier-fed river in order to get the best angle on a landscape, and the dedication to tolerate mosquitoes because you can't miss the sunset light happening in front of you.

When I hear the question "How can I take better photos in bad light?" the one-word answer that often comes to mind is "Wait," because if you wait long enough, the weather will change.

Rain

Rain itself rarely produces great photos, since one of the main ways you see rain in a still image is by it being backlit from direct sun, and that is rare. However, rainbows are an aftereffect of rain and sunlight. When white light is separated, it displays all the colors of the rainbow. Therefore when rain or water mixes with sunlight, the light can be spread out into a rainbow. Rainbows usually appear 42 degrees off-axis from the sun—that is, if you are staring at the sun, turn your back on it, then look roughly 45 degrees to the left or right to find a rainbow. This can be useful when trying to predict a rainbow and to find a scene for it before you even see one. The tough aspect of shooting a rainbow is finding or framing a good scene before it dissipates or disappears—that's why it's a bit easier to capture rainbows in continuous water areas such as waterfalls. I have even captured lunar rainbows, or "moonbows," at midnight.

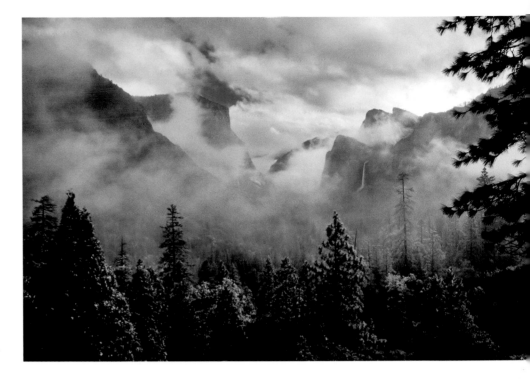

I waited 4 hours in the rain until the clouds parted, the sun shined on the foreground pines, and Yosemite Valley never looked better. Using a 2-stop graduated ND filter on my 24mm F2.8 lens, I set my exposure to f/22 for 1/4 sec. using ISO 100.

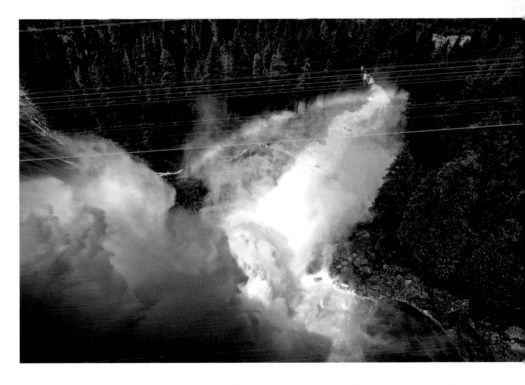

Mist from Nevada Fall combined with the afternoon sun to create this strong rainbow. Shot with a 24mm lens at f/16 for 1/60 sec. using ISO 100.

Sun

Besides using the sun to illuminate my subjects, I like to make use of it in other ways, whether I use various elements to block it, bounce it in as a reflection to make water shine and sparkle, or reflect it into shadows to add light to an otherwise dark area. Playing with the sun in your photos can create duds or masterpieces.

Wind

Wind can wreak havoc on your photography through camera shake, and when the wind kicks up you might think it is time to bag your camera and head home, but getting creative with your photography means taking advantage of these times. Weigh down your tripod with your camera bag or backpack, block the wind with your body, or search for a protected area, and use the wind in combination with long exposures to make a mosaic of color with wildflowers or a surreal scene with swaying trees.

Finding a tide pool in Point Lobos along the Big Sur coast, I lowered my tripod to include the sun's reflection and captured this landscape with a spark. With a 24mm F2.8 lens set to f/22, I fired off the shutter at 1/15 sec. using ISO 50.

Photographing an Optical Illusion

Mirages provide wonderful conditions in which to capture signs of heat, creating false reflections and changing the shape of subject matter. The main piece of equipment needed to capture these conditions is a long lens, 300mm and up, which will give you the magnification necessary to document a mirage.

Nature Assignment #5:

Photograph a scene using the light to your advantage

Controlling or predicting light in the field is key to creating solid nature images. Knowing how the time of day will affect your exposure, how the direction of the sun can influence the shape of an object, and what type of weather you may be shooting in plays a big part in using the elements to your advantage. Attempt to capture an image that illustrates this.

For your assignment, attempt to remember the non-EXIF metadata details such as the direction you chose to shoot, the thought process you used for your decision, and how the light either positively or negatively affected your final creation.

To give you an example, I planned a hike to the top of Sentinel Dome in Yosemite, arriving in the late afternoon in order to capture the sunset light. I knew the first quarter moon would be high in the sky, so I hoped to incorporate it in my final shot. Once I arrived at the famous Jeffrey pine there, I used the golden light of the setting sun to sidelight the tree while including the dome and the moon in my composition. Choosing my 24mm F2.8 lens, I mounted my camera on my tripod, set my aperture to its smallest opening of f/22 to ensure sharpness throughout the scene, and exposed it for 1/8 sec. using ISO 100.

FILTERS AND FILL FLASH

The twentieth-century painter Paul Klee said, "Art does not reproduce what we see; rather, it makes us see." There are many ways to produce great depictions of nature, but sometimes your camera needs some assistance. On occasion, film or image sensors can see what our eyes can't, and other times we can see what they can't; this is usually the crux of most photographers' frustrations. Many times I've been able to document scenery that students standing alongside me could not, simply because I had a piece of equipment they did not or because I knew how to use my equipment in a way they did not. Two pieces of gear that can add a ton of detail to your images are filters and flash.

With the understanding of how photographic filters and flash techniques help you create better photos comes power—in this case, the ability to capture difficult shots consistently. Knowing what to add and when increases your chances for a strong final rendition, gives you more control, and tells you when your scene is fine and when it needs some help. Increasing color, controlling a reflection, and pulling the contrast ratio together for a better exposure are all facets of applying filters. Adding light where light is needed is the main benefit of a flash. Learn how to use both tools of the trade and people will begin to wonder how you made your photographs.

BENEFITING FROM FILTERS

There are three objectives in applying any filter: to use it in an effective way that helps the exposure, to compensate for the loss of light, and to find a scene that benefits from the filter.

People ask me which filters are best to buy. There are a number of solid filter companies to choose from: B+W, Heliopan, Hoya, Promaster, Singh-Ray, and Tiffen, but one feature I always recommend is glass over resin or plastic. Some filters don't come in glass yet still do a great job, but if you have a choice (and the budget), choose high-quality glass first.

Today's nature photographer can use two types of filters: in-camera filters (the tried-and-true method of attaching filters to your camera while you shoot) and Photoshop or plug-in filters you apply in post-processing. I still believe it is better to use filters with your camera to attempt to get as much as you want in your original image file than to add something later on the computer. If you don't capture certain highlights or details in your original scene, it may take quite a bit of time to pull them back using Photoshop or other software methods—not to mention the cost to buy the software—and on many occasions the final file will not look the best or as realistic.

Problems resulting from adding a filter to your camera can come in the form of more flare, slightly less sharp detail, vignetting (seeing the edges of the filter when using a wide-angle lens), or overuse (when the filter use is obvious and unrealistic, which can be fine if that is the effect you are going for, but unacceptable if you are trying to depict nature in an accurate manner).

Whenever you add a filter to your lens, it will have an effect on your settings. You will need to lengthen the exposure, depending on the filter's color and density, to compensate for any light loss. This can range anywhere from 1/3 stop to 9 stops. With all current camera systems, the meter will adjust the exposure. In Av, Tv, or Program mode, your exposure will change automatically. In Manual mode, the meter will recommend a different exposure than what you need, but you have to remember to adjust your settings. It's good to be aware of this exposure change since, for example, adding a polarizer filter can slow your exposure by up to 2 stops, which may not help if you're shooting action or wildlife and trying to stop the subject in motion with a fast shutter speed.

There are hundreds, if not thousands, of filters you can purchase and use in the field. Personally, I stick to just a few to assist me when I am in need: graduated neutral density, polarizing, warming, and neutral density filters.

I could not maintain detail in the sunset highlights on Yosemite's El Capitan, yet by adding a 3-stop graduated neutral density filter I was able to pull the contrast together for a solid exposure. Shot at *f*/22 for 1/2 sec., ISO 100, using a 24mm lens.

Graduated Neutral Density Filters with Landscapes

Skies are often brighter in exposure than the landscape, especially during optimal shoot times. Although you can see the scenery with your eyes, your film or image sensor tends to exaggerate the difference in contrast, forcing you to lose detail in the subtle color of the sky or in the formations on the ground. Applying graduated neutral density (grad ND) filters to landscapes is one of the best ways to improve your overall image through the exposure assistance the filter applies. They are clear on the bottom and darker on top, and they come in degrees of 1, 2, or 3 stops. The best ones are square in shape, giving you the option to slide them up or down, depending on your horizon line. How do they correspond with exposure? A grad ND filter takes a scene with a high contrast ratio and reduces it by darkening the brighter parts (in the dark half of the filter), while leaving the shadow areas alone (in the clear half of the filter), pulling the contrast together to create a better exposure.

I prefer grad NDs over split NDs since they provide a softer, seamless edge, resulting in a less noticeable change in most of my shots. These filters work best with wide-angle lenses (20–35mm), because these lenses can see a wider field of view and cover the entire filter (and gradation) from top to bottom. Ultra-wide lenses may cause vignetting, whereas lenses above 50mm are less effective since they see only a portion of the filter. Split ND filters have a harder edge, which is why they are better for lenses ranging from 35mm to 60mm; the sharp line of delineation blurs some because of the length and coverage of the lens.

Grad ND filters are more noticeable when used with overcast skies, so they are best used with colorful skies, and the choice for which strength to use (1, 2, or 3 stops) depends on the contrast ratio in the scene. One-stop versions are subtle, 2 stops are traditional, and 3 stops are for extreme situations. How to expose using these filters? The best way I've found is to judge the sky's exposure, overexpose from that correct setting depending on the strength of the grad ND filter used, then determine if this new setting will give you enough detail in the darker ground area. If the contrast is such that it will not, then consider slightly overexposing your sky or using a stronger grad ND, such as a 3-stop version.

» **tip**

To achieve star effects with a specular light source, such as the sun or its reflection on water, use a small aperture—no additional star filter is needed.

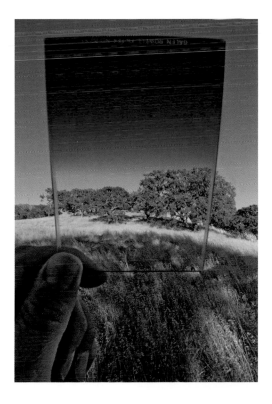

An example of a 2-stop graduated neutral density filter and its effect on the surrounding landscape.

Reflections

The best grad ND filter to use for landscape reflections is usually the 2-stop model, because the exposure difference between the sky and the area of the sky mirrored in the water is roughly around 2 stops. I have used 3-stop versions in the past (one on page 138), for the Yosemite Falls at sunrise), but because I don't want the reflections to appear brighter than the actual landscape since it doesn't look realistic, I use my 2-stop grad ND filter more. This makes the reflection the same as or slightly darker than the sky, which is what I see with my eye.

Three examples of 2-stop grad ND filters used on reflections in Glacier National Park (bottom left), Yosemite (top left), and the Grand Tetons (opposite). I also prefer a true ND filter over a colored ND filter, since the colored type often looks fake or strange, especially with bodies of water (since water reflects the colors of the sky) and you don't get this result with a half-colored filter. The Yosemite scene (top left) was shot with a 24mm F2.8 lens at f/22 for 1/8 sec. using ISO 100. The reflection from Two Medicine Lake in Glacier National Park (bottom left) was also photographed with a 24mm F2.8 lens, this time at f/22 for 1/12 sec. using ISO 100. The Grand Teton scene (opposite) was exposed using a wide-angle 50mm medium-format lens set to f/32 for 1/4 sec. using ISO 100.

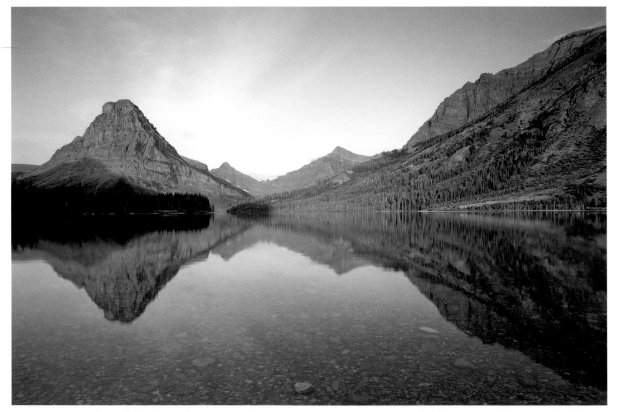

Polarizing Filters

Polarizing filters also fill a special need in outdoor photography, one that cannot be replicated in Photoshop, at least not yet. There are a few types, such as circular (the main ones used today), Gold-N-Blue (which add more color intensity), and LB ("lighter, brighter," which polarize a scene without cutting as much light).

There are a number of situations in which polarizing filters (also known as polarizers) can be used effectively to reduce or eliminate haze in skies and reflections on water. In fact, polarizers work on any reflective surface, such as ice, glacier polish, or even leaves, removing sunlight to create a richer green tone. They are most effective at certain angles, usually 30–45 degrees off-axis for cutting reflections and 90 degrees off-axis of the sun for atmospheric conditions. Their effect produces intensified blue skies (helping billowy clouds and the moon stand out), deepens green tones in forests and plants, and boosts most primary colors. For landscapes or skies, polarizers are most effective when used in sunny conditions, and strongest when pointing north or south; they lose their strength the closer your point your camera toward east or west.

The image on the above right is how my eye saw the scene, but my image sensor's latitude overexaggerated the contrast between the landscape and its reflection, resulting in the shot on the left. A 3-stop grad ND filter darkened the sunny area of Yosemite Falls, cutting the contrast and allowing me to expose the Merced River longer, thus producing a far better final exposure.

» tip

Try not to use more than one filter on a lens. Stacking filters can cause potential loss of optical quality, as well as vignetting in wide-angle lenses.

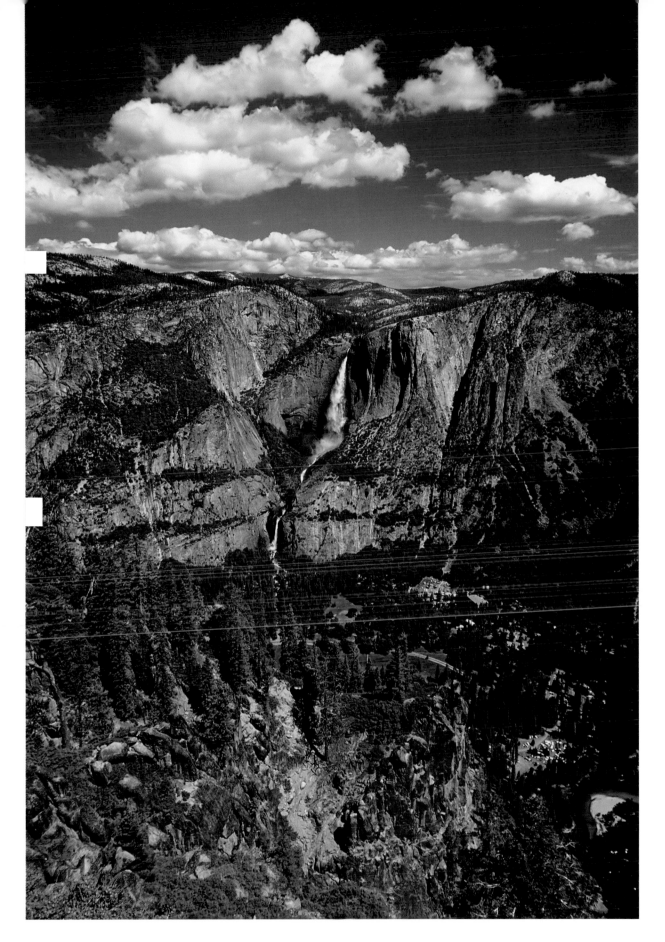

A polarizing filter helped accentuate the cumulus clouds above Yosemite Falls while cutting reflections on trees and plants, deepening their green tones. Shot with a 24mm F2.8 lens at f/16 for 1/30 sec. set to ISO 100.

A before-and-after comparison of a scene in Sunol Regional Wilderness using a polarizer. The top image uses no filter, while the bottom scene benefits from the filter. Shot using a 24mm lens, the top image was exposed at $f/10$ for 1/60 sec., the bottom at $f/10$ for 1/30 sec., both using ISO 100.

Polarizers also add contrast, deepening the sky's tone while maintaining a rich landscape. In some circumstances, the filter causes exposure problems because of the added contrast, such as a strong gradation in wide-angle scenes or an unrealistic look to a sky, something that could be used for dramatic effect. Polarizers can increase the presence of a rainbow by intensifying the refractions of light in the water droplets that create the rainbow's hues, or reduce its presence by diminishing them.

The best way to start with the filter is to rotate it while on your lens or even in front of your eye to see if you notice a change. A polarizer changes the strength, from 0 degree minimum to 90 degrees maximum polarization, as you rotate the filter. Polarizers are not as effective during harsh midday hours, depending on angles, the sun, the weather conditions, and the lens used.

The drawback of polarizing filters is the loss of light. Depending on the strength of the polarizer, the loss is usually 1 to 2 stops, hence a slower shutter speed, wider aperture, higher ISO, or a combination of all three is required. Once you dial in your polarizer, re-meter the scene to adjust for the change in exposure.

Another side-by-side polarizer comparison. The nonfiltered photo on the left was captured at f/22 for 1/40 sec., the polarized image on the right at f/22 for 1/10 sec., both using ISO 100. The scene on the right more closely approximates what my eye saw.

Warming Filters

Cool color shifts, mostly from shade and overcast conditions, are neutralized by warming filters. The blue shift mutes skin tones, lessens warm colors, and gives an overall cold or gloomy feeling. Warming filters do exactly what they say, warming up a scene in varying degrees, depending on the filter used. With the emergence of white balance and photo editing software to correct for this, warming filters are slowly fading from use. If you shoot with film, there are varying strengths of the filter in the 81 series, 81A, 81B, and 81C being the strongest. Their effect on exposure is minimal, from 1/3 to 2/3 of a stop, depending on the filter's strength, and again your meter adjusts for it.

Neutral Density

Neutral density (ND) filters are used to cut light, allowing the photographer to use a slower shutter speed for certain effects. The neutral density covers the entire filter, similar to a polarizer, and ND filters come in strengths from 1 to 9 stops. Most of the time with outdoor photography, ND filters are used on water to give it a soft, ghostly effect, but they can also be used on other moving subject matter, like clouds or blowing trees. In a landscape where your setting is at the maximum depth of field at f/32, using the lower ISO setting of 100, your 1/2 sec. shutter speed is still too fast for the desired effect. Add a 3-stop ND filter, and now your exposure can be 4 seconds long; add a 9-stop ND filter and your shutter speed can be stretched to 4 minutes.

Photoshop Filters

There are Photoshop filters that emulate the effects of warming, cooling, and ND filters, as well as others. There are also myriad plug-ins, created by companies like Alien Skin software, Nik software, or Topaz Labs, to change, alter, or enhance your scene—something I address in chapter 10.

» tip

Many people ask about UV filters. There is some debate about their usefulness, but I never use them. I see no effect or value in UV filters, since they only act as protection for your front lens element. If you own a nice lens, placing an inexpensive UV filter over it could negate some of the quality of the lens. I use my lens cap to protect my lens and don't own a UV filter, and in more than 30 years my lenses have never been scratched, nor have my images been affected because of the lack of a UV filter. If you crack or break your UV filter, the shards of glass will most likely scratch the front lens element anyway.

Along the shores of Baja, I used a 3-stop neutral density filter to create a long exposure of the incoming waves at sunrise. Using my 12–24mm F2.8 lens set to 16mm, I exposed this shot at *f*/22 for 2 seconds using ISO 100.

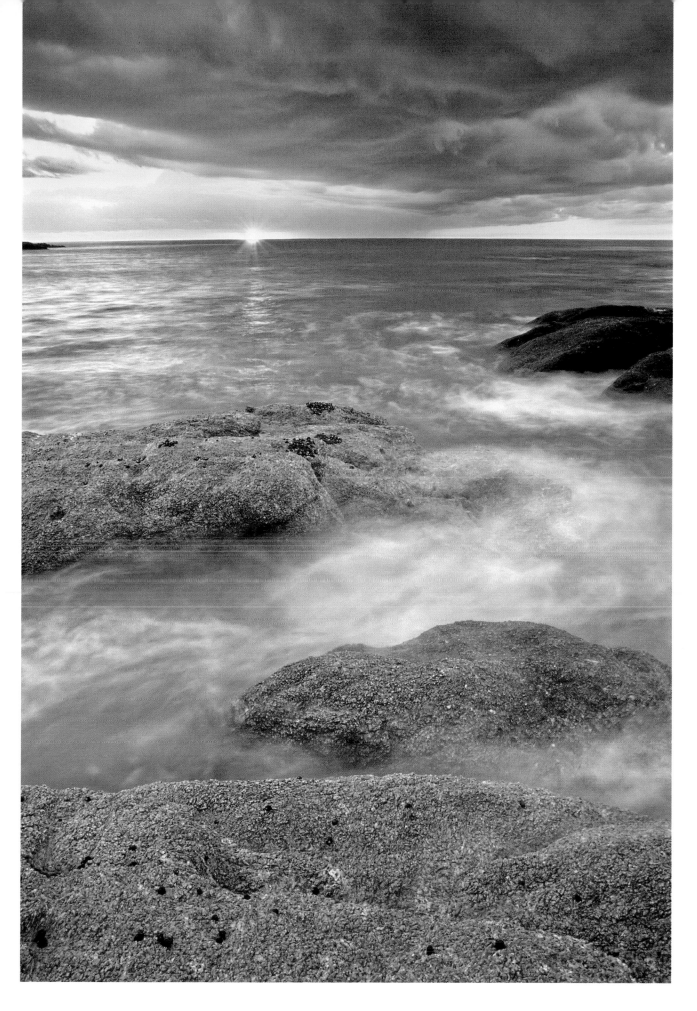

FILLING IN THE SHADOWS

Adding flash (strobes, speedlights) or any alternate light source (reflectors or another fill source) to your repertoire can modify the light in a scene, cutting the contrast ratio by illuminating certain areas otherwise underexposed or without detail. Flash adds color to shaded areas, especially warm tones diminished by the ambient blue light. However, incorporating fill flash can be difficult, probably the toughest challenge in regard to exposure. You must meter the overall scene while implementing flash, not knowing the area the additional light may cover or how powerful it may be. Then, picking the right scene to add light to is another learning process. Asking yourself what your flash will add light and detail to is a good first step. When you think this way, you begin to look at highlights and shadows to see if there is a high enough contrast ratio—wide-ranging tones your image sensor cannot handle in one shot. Experimentation along with experience can help you in these instances.

How to Add Fill Flash to Your Scenics

One goal with fill flash is to help your image sensor cover a contrast range it normally cannot handle, usually deep shadow areas relatively close to your camera. Backlighting or sidelighting are applicable conditions for adding fill flash since they contain higher contrast, creating shady areas where fill flash can be applied.

The light from a flash unit travels only so far, depending on its power, typically 15–50 feet. Some flash units are stronger than others; they are measured using guide numbers. Aperture and ISO also play a part; the light of the flash does not extend as far with smaller apertures or lower ISOs because of the decrease in light and sensitivity of your sensor. The general overall lighting of the scene is another factor;

The additional light gained by adding flash to this blanket of leaves lying in a still pond brought color and detail back to the leaves while balancing with the reflecting blue sky. I also tilted my speedlight up, directing the unit toward the leaves farther away, in order to spread out the light from my on-camera flash in a uniform fashion. I exposed the scene with a 28mm lens set to f/16 for 1/4 sec. using ISO 50, the TTL fill-flash dialed down -1.3 stops.

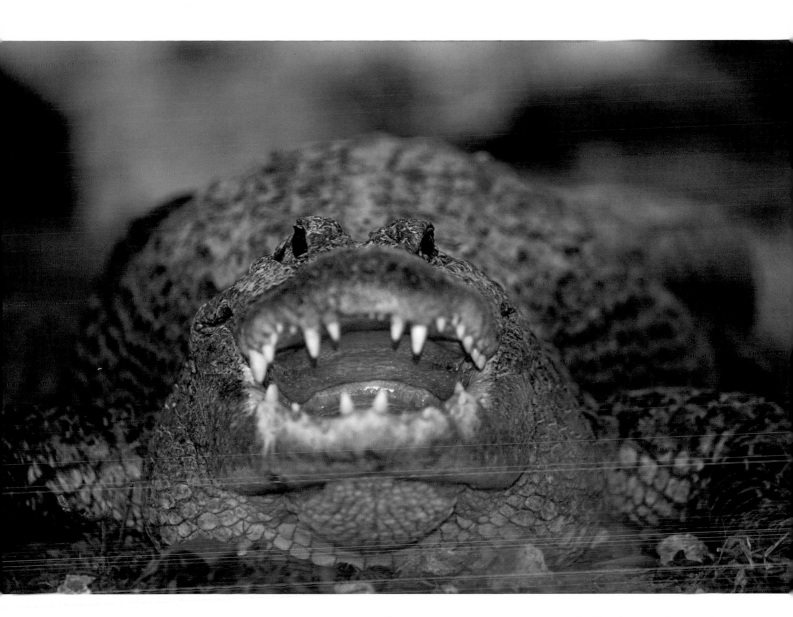

lower-light situations enable the flash to be detected more easily than in brighter circumstances.

A second objective is to add flash (or fill) in a subtle, natural way, giving your final image a realistic feel. One method of achieving this is to lower the power of your flash, because most flash units at full power are too bright, overwhelming a scene, and often too obvious, especially in low light or shade. Speedlights that mount to the hot shoe on your DSLR provide more options in regard to power, allowing you to drop the power through stops (+1 stop, –2/3 stops), percentages (100%, 50%), or fractions (1/2 power, 1/4 power, and so on). My default starting point is –1 stop, but I have added flash at –3 stops using the through-the-lens (TTL) metering mode on the unit. In most sunny conditions, flash won't overexpose highlights unless you have a very powerful pro flash or you're extremely close to your subject. In most cases we see little change in the sunny areas, yet more detail in the shadows.

You can add a warm amber gel, a light orange plastic piece that connects to the front of the flash, or a cellophane-type material applied with tape, as I use, over the flash. The white artificial light of the flash unit is thus lessened and more representative of normal, slightly yellowish light, bringing warmth back to your subjects. A third way to achieve this effect when metering is to expose for the highlights, the brighter parts of the scene. This ensures detail in those areas since you will be adding more detail to the shadow areas through your fill flash.

As I lay down to photograph this alligator, it opened its mouth and hissed at me, and I knew if I popped in some fill flash, it would brighten the dark interior, emphasizing the color as well as what this predator is all about. My flash was set to –1 stop from full power so as to not overpower the low-light situation. With my 80–200mm F2.8 lens set to f/2.8, I shot this image for 1/125 sec. using ISO 100.

Most DSLR cameras sync only to 1/250 or 1/200 sec. (some only up to 1/125 sec.) when your flash is on, so shutter speeds above this will not record the light of the unit—a critical exposure aspect to be aware of. A flash may fire extremely fast (1/10000 sec., for example), but the shutter needs the time to open, fire the flash, and close; therefore your exposure is limited to shutter speeds equal to or below your maximum sync. Because of this, using flash outdoors can prevent you from using wide-open apertures, something a bounce card or reflector won't do. You may be required to use smaller apertures or ND filters in brighter situations to allow less light in and cut the shutter speed. Check your camera manual to confirm your highest shutter speed sync.

You must also accept that if you use your white balance flash preset (often around 5400 K color temperature), the balance of available light with your flash unit may not correspond, which is another reason I use a preset that matches the scene. I then add a gel over my flash unit, balancing it manually with the light I am photographing in—the warmer the light, the warmer the orange gel I add to my flash.

» **tip**

To avoid overlighting closer subject matter with flash (for example, branches or leaves closer than the subject you are trying to illuminate) consider changing your composition, moving left or right of any foreground subject in order to eliminate the distraction.

Firing my on-camera flash in this cave in Borneo enabled me to bring out detail my film could not retain owing to the extreme contrast ratio between the cave entrance and the formations inside. I used a 28mm lens set to f/16 and exposed the scene for 1/2 sec. using ISO 50.

Finally, when you use your on-camera flash (as opposed to a unit not connected to the top of your camera or front of your lens), directing the unit to the left or right, or up or down, called "feathering your flash," can also create a more realistic feel. This helps to balance the fall-off of artificial light between a closer subject and one farther away. If you do not feather your flash, it ends up lighting the foreground subjects more than the background, appearing brighter and unrealistic. In these cases, you can tilt your strobe toward the background more, up or down or to the left or right. This will even out the exposure with your flash, depending on how much you tilt combined with the distance of your subjects.

While photographing this hawk, I turned on my flash to fill in the shade on its face. By feathering my flash up, the additional light exposing its face and wing was more evenly distributed (since its wing was much closer to my camera). Shot with an 80–200mm F2.8 lens set to 200mm, at f/4 for 1/250 sec. using ISO 100.

Reflectors and Fills

There are a variety of other ways to add additional light to your scenes: fill or bounce cards, reflectors, or even mirrors, flashlights, or clothing. Using these items does mean carrying extra gear, as well as holding more equipment during your exposure, but at least you can see the additional light being added. You can make your own fill cards or buy ones that fold into a compact circle.

Using these cards requires you to bounce in light from a specular source such as the sun, since a softer type of light, such as ambient or overcast, provides very little direction and subsequently little fill. Again, these reflectors or fills are most effective on side- or backlit subjects, and need only a little bit of light to make your shot look natural.

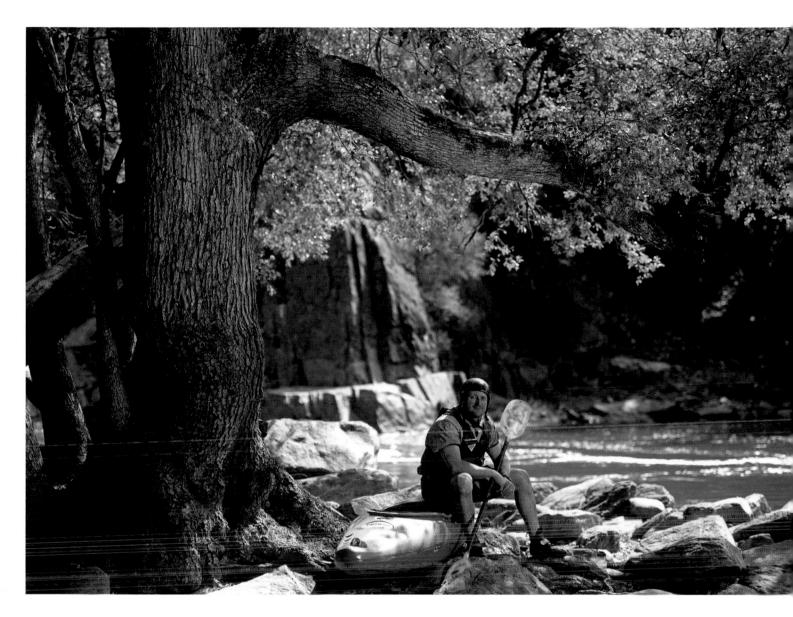

Here are two instances where I added off-camera flash to bring out detail and create shape and dimension through sidelighting. The image on the left was captured in Great Basin National Park using my speedlight attached to my camera with a cord, held on the left to bounce in just enough light to add detail to the bristlecone pine. The kayaker on the right was created using a strobe off to the right of my camera, a larger soft box mounted on a flash, and a light stand. The Bristlecone pine tree (opposite) was captured with a 24mm F2.8 lens, at f/16 for 1 second using ISO 100. The kayaker (above) with a 125mm medium-format lens at f/5.6 for 1/125 sec. using ISO 100.

Nature's Fill

From time to time, you can find fill sources in nature, either by chance or through visualization of what may occur when, say, the sun reaches a particular position and bounces in light off of a hillside or rock formation. You never know where fill may come from, improving your final exposure and creating a rare and unique portrayal of nature.

One chilly winter morning while photographing the sunrise in Bryce Canyon National Park, the sun reached a certain position in the sky. Its rays bounced off of a snow-covered hillside, filling in the large hoodoo formation—nature's fill card, I call it. Thor's Hammer in Bryce Canyon (at left) was photographed with an 80–200mm F2.8 lens set to 100mm, at f/8 for 1/60 sec. using ISO 100. The larger horizontal landscape below was shot with my 24mm F2.8 lens, at f/22 for 1/4 sec. using ISO 50.

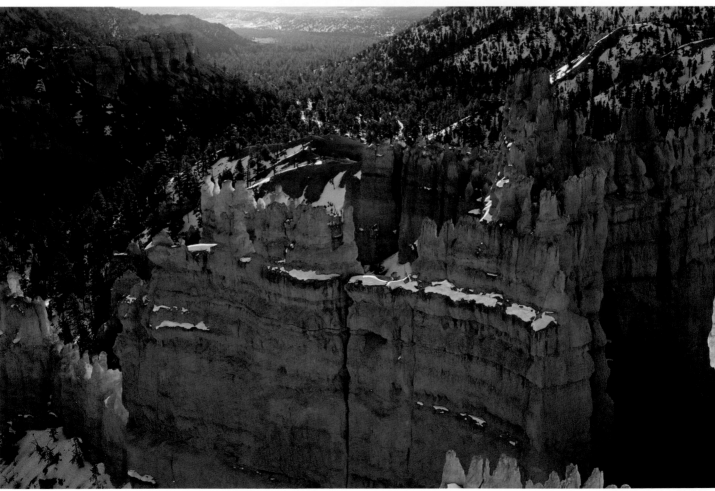

Nature Assignment #6:

Document a landscape using a grad ND filter

A 2-stop graduated neutral density filter for one of your wide-angle lenses should be a staple in your photo bag. This filter can cut the contrast ratio of many landscape scenes, helping your image sensor retain detail otherwise lost in a nonfilter capture. As you search for your scene, consider ones where your exposure is relatively brighter in the upper half than the lower half of your composition.

Don't forget to record as many specifications and details about your assignment image, including the strength of your grad ND filter, and how you may have metered the scene—information not found in the EXIF metadata.

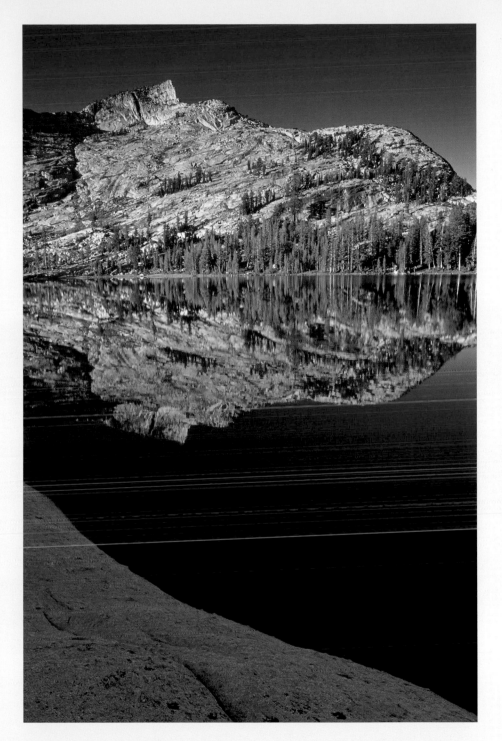

My example of this assignment came when I was shooting California's High Sierra Mountains for a travel magazine. Waking up at dawn, I positioned myself along the shores of Lower Cathedral Lake, added a 2-stop grad ND filter to my 24mm lens, positioned it to match the opposite shoreline, and waited for sunrise. The light cut by the filter helped the reflection match the mountainside, while the longer exposure gave me detail in the shade. Exposed at f/22 for 1/4 sec. using ISO 100.

CAPTURING

WILDLIFE

Jane Goodall, in speaking about her study of chimpanzees, said, "I feel honored to record the history of beings that can't record their own history." I couldn't agree more. I find myself more excited when I photograph wildlife than most subjects I capture; my senses are heightened and my energy level is at its highest. There is a thrill and a challenge to photographing such beautiful, sentient beings unlike anything else.

Wildlife photography is a combination of knowledge, effort, and luck. You become part athlete, part zoologist, part Zen master, and part photographer. Documenting animals can require a great deal of effort in the field and means leaving trails to hike cross-country and getting into position while carrying heavy photographic equipment over rough terrain—the athlete in you becomes aware of the strength and stamina needed. Whether you find wildlife by chance or through research, knowing how they act and behave in certain situations gives you another leg up on creating a better photograph, translating what that animal is all about into a still image while making sure you are safe in the process. Patience is just as much a tool as your camera gear when photographing animals. With patience comes foresight and dogged perseverance, attributes that help you deal with the adversity that comes from documenting unpredictable subjects. Finally, the photographer in you begins to think about the settings you need, the light you crave, the framing you desire, and the technical skills and techniques required to catch a fleeting moment. All your knowledge and experience is required when capturing wildlife—animals that are on the move, traveling through changing light, and altering distances from your camera. Every aspect of wildlife photography creates exposure, focus, and compositional challenges.

HUNTING WITH A CAMERA

Hunting or stalking wildlife with a camera is no different than with a gun, except for the final result, of course. In fact, a number of hunters have switched to cameras after the thrill of killing a majestic animal subsided. Some photographers who exclusively photograph animals may take extreme measures to procure the most difficult images, but you do not have to mimic their actions. My wildlife images are diverse, having come to me in a variety of ways, many of which were happenstance while out in the wilderness. Be that as it may, applying some hunting techniques to your photographic trips can bring you a little closer to animals, increasing the chances of a better shot.

Working in pea soup fog in Point Reyes at first seemed to offer very little in the way of good photographs, but as I listened to the sounds of tule elk, I knew that if I could find one, I might have something. When I finally spotted one, I waited for it to crest the ridge to separate it from the land as a silhouette against the fog. Shot with a 300mm F4 lens, ISO 100 at f/4 for 1/60 sec. with a tripod.

» tip

If possible, turn the sound off on your camera—the less noise you make around animals and birds, the less chance they will flee. Then, comparable to shooting a gun, take an extra second to take a few deep breaths, blow out, and then press your shutter or remote. These two techniques will keep the animal closer and add extra sharpness to your images through less camera shake and more attention to precise focus.

Risk versus Reward

Wildlife photographers get into trouble by not recognizing danger signs or by not acting on the bad feeling they experience while around wild animals. When it comes to risk versus reward, I am always willing to lose an image if it means not getting attacked. An animal may look cute and cuddly, but corner it by accident and you might realize too late that you have made a mistake. In most cases, animals prefer to flee rather than confront, but you should still be prepared to expect the unexpected. Trusting your gut is key since your body can tell you when something doesn't feel right, more so than your vision or mind. I am very calculated with my movement when in these situations. You can come away with great wildlife images without having any knowledge about your subject, but the more you learn about an animal's behavioral habits, the higher the quality of shots you can get while reducing your risk.

As with any wildlife situation, always be aware of the distance between you and the animal. Watch for any signs of agitation that might result in the animal charging at or attacking you. One of the worst situations you can create for yourself is to get between a mother and her offspring. If you find a young animal to photograph, be aware that one or both of its parents could be close by, and an attack may be imminent if they feel you are preying on their young.

There are other ways to record animals in a safe manner, such as at a game farm, where, for a small fee, you get some time to take closer, portrait-style images of animals. I don't see anything wrong with this, as it is great practice for shooting in the field, as long as you label these images as captive wildlife.

A fresh black bear paw print in the aptly named Bear Valley gave us good warning the large creature wasn't far away. While making loud sounds and using my 60mm macro lens, I exposed the scene at f/16 for 1/15 sec. using ISO 100.

Bringing Wildlife Closer

"Craft skills" is a term used in the military to describe techniques required to operate stealthily during the day or night regardless of weather or terrain, to see without being seen. You don't have to become a military sniper to bring animals closer, nor should you ignore the fundamentals of safety, but using some of these techniques can get you closer to the wildlife you hope to document.

Some of these methods are used by wildlife photographers, biologists, and specialists, but by no means should this information replace your own research, knowledge, or experience. Most are based on my past adventures combined with details I have learned through my own fieldwork.

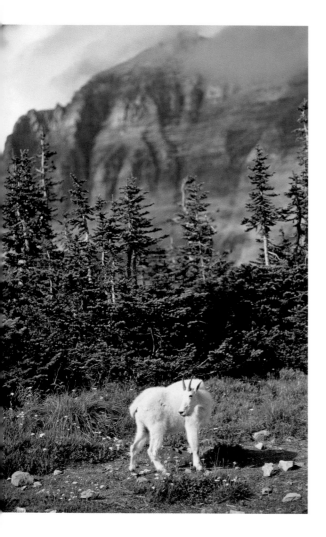

These Mountain goats fed on a high alpine meadow when I first spotted them. I wasn't in position to capture the shots I wanted, so I waited for them to slowly move closer, often pretending to be disinterested while making little movement. Over a period of an hour, they approached my area and felt comfortable enough to move within fifteen feet of me. Swapping back and forth between my 80–200mm F2.8 lens and my 300mm F4 lens, I snapped off a number of scenes including these three images. From left to right, the first was captured at f/2.8 for 1/125 sec. using ISO 200, the second at f/4 for 1/250 sec. using ISO 200, and the third at f/2.8 for 1/250 sec. using ISO 200.

Body Language

Communication with animals is often through body language, and you can make them feel either secure or fearful. There is usually one solid way to get rid of an animal in the wild: stare it down. However, little eye contact should be the rule when photographing animals. The less they know you are looking at them the better, since a predator-prey feeling can arise any time you focus intently on an animal. Most likely they will move farther away, or they may act out to defend themselves. Of course, when trying to photograph wildlife, you need to use your eyes, but there are a few ways to avoid eye contact.

Another part of nonverbal communication with animals is your position in respect to theirs. Being higher than a bird or mammal usually makes them feel vulnerable. Try not to lean forward, since you may appear as if you are about to run toward an animal. Crouching down can also become dangerous, since you may look like prey to certain animals or like a predator to others if you appear to be stalking them. In many cases I can't avoid crouching down, but I am always aware of what signals I may be sending. Turning your back on an animal may sound weird, but I prefer this method in some cases where I feel safe. I use my LCD, my eyepiece, or my sunglasses as a mirror, which allows me to watch them in the reflection. Obviously there is no way to be sure how this may affect them, but I believe it makes a creature feel as if I have less interest, giving them enough comfort or trust to stay in an area to be photographed or move even closer.

These tactics can change depending on the situation and the animal. If crouching scares an animal, stand up slowly. If your size is intimidating, consider a lower profile. If sound scares an animal, be quiet. If sound is not a big deal, talk normally. How you behave around an animal depends on the situation, your intuition, and your general knowledge of the species.

When you have a general sense of how an animal may react, you can predict its movements better. While photographing in the mountains near San Diego, I spotted this horned lizard, whose color matched the dirt almost identically. As I observed it, I noticed it was moving toward a small hole, most likely its den. Knowing that the intensity and angle of light would separate it from the dark background, I lay down on my stomach and, over a period of a few minutes, slowly inched my way closer with my 60mm macro until I got the shot I wanted. I kept my aperture wide open at f/4 and exposed the scene for 1/640 sec. using ISO 50.

Camouflage

Many wildlife photographers don themselves in full camouflage. Occasionally I wear camouflage in the field—shorts, a jacket, a hat, or a combination of all of these. In general, I wear colors that blend into the outdoors: greens, browns, blues, and other muted dark colors. Animals see and are attracted to different colors, but the less you stand out, the less you are noticed.

Another way to blend into the environment is to hide. Depending on the direction of wind and your surroundings, you may be spotted or you may go unnoticed. Getting low to the ground not only makes you less conspicuous, but it also helps you see the animal better on their level, and assists with creative compositions. If you are downwind and the animal is not aware of you, this can be a good option. If you are upwind and your scent has been picked up, there is usually no reason to hide. In fact, it may be better to show yourself and pretend as if you have no interest in the animal.

As I discuss in chapter 1, blinds are yet another sound way to get closer to wildlife, the perfect kind of camouflage. They provide a hidden place, making animals and birds unaware of your presence, making them feel comfortable. They're a great way to get shots you could never get if it were not for the disguise. Photographic blinds offer openings to shoot through and lightweight, compact designs, and they come in a mesh camouflage parka or tent styles. Blinds can be cumbersome and get hot and uncomfortable, and the time spent in them can be long and tedious. The payoff is your image results. Your camping tent can also serve as a simple blind.

Camouflaged in the deep grasslands, I was able to watch this mule deer walk carefully through a field of wild mustard. Taken with a 300mm lens at $f/4$ for 1/500 sec. using ISO 50.

LEARNING BEHAVIOR

Whether you study animal behavior in the field or research it through books and other media, that knowledge can be an asset. It can add to your protection and allow you to predict an activity or movement you may be able to document. Behavior can be the territory an animal prefers, the way its hunts, or even the subtle head movements it may make as it looks around.

Birds thrive along the Lee Island coast, and roads are extremely close to the beach areas where they feed and nest. Using my vehicle as a blind, I lay down on the ground and photographed from under my car to nab this Caspian Tern. Using my 300mm F4 lens, I exposed the scene at *f*/4 for 1/1000 sec. using ISO 100.

» tip

Speaking to locals, rangers, or guides about wildlife can also give you a better idea of where to go, what to look for, and what times of day certain animals may be around.

Hawks are often on the hunt, looking for small prey to swoop down upon. As this Swainson's Hawk turned its head in the afternoon light, I quickly pressed my cable release to fire the shutter and capture its gaze. Photographed with a 300mm F4 lens, exposed at f/4 for 1/1250 sec. using ISO 100.

Recognizing Camouflage Techniques

Animals are often adept at integrating camouflage into their terrain as a survival tactic, making them tougher to find, track, and photograph. Looking for movement within any landscape can help you locate wildlife. An animal can blend well until it crests a ridge and becomes silhouetted against the sky. Patience and luck again play a part here. I've spotted wildlife far away by sitting and carefully scanning a landscape, or simply by chance. You can use a spotting scope that mounts to your tripod to zoom into distant areas, but this is yet another piece of equipment to carry.

Self-Education and Respect

Researching any subject you photograph is a good approach to take to ensure your safety and also the safety and future of the animal. Disturbing an animal's nest or habitat for the sake of a photograph is highly unethical behavior; some species abandon their nests if they have been disturbed, and it can have a negative impact on an animal's behavioral patterns or reproductive numbers. If you feel you are altering the behavior of the animal, remove yourself from that situation. Fines or even arrests may come from breaking park rules or endangering animals or their offspring.

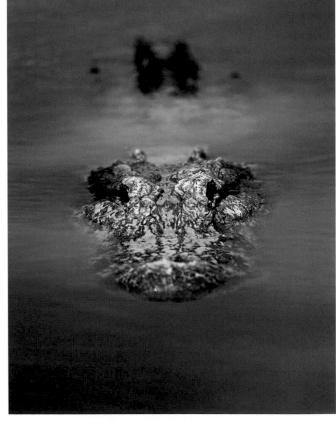

While hiking in the jungles of Borneo, I almost stepped on these mating rufous-sided sticky frogs, their tone blended so well into the thick, muddy orange trail. Using my 60mm F2.8 macro and a tripod, I framed this scene and exposed it at f/16 for 1/30 sec. using ISO 100.

This alligator was not necessarily the one to worry about; it was the ones moving out of the water, in my peripheral vision, that I couldn't see that were the danger. Luckily, I had two alligator specialists with me ready to take action if one lunged at me, giving me some security to photograph this one. Utilizing my 80–200mm F2.8 zoom lens, set to 180mm to create the best composition of my moving subject, I exposed the scene at f/4 for 1/800 sec. using ISO 100.

I also like to identify all my wildlife images with the common names of the animal, as well as the scientific (or Latin) names. This can add to your knowledge of a species and is always a good habit if you plan to photograph wildlife professionally or sell your images as fine-art prints.

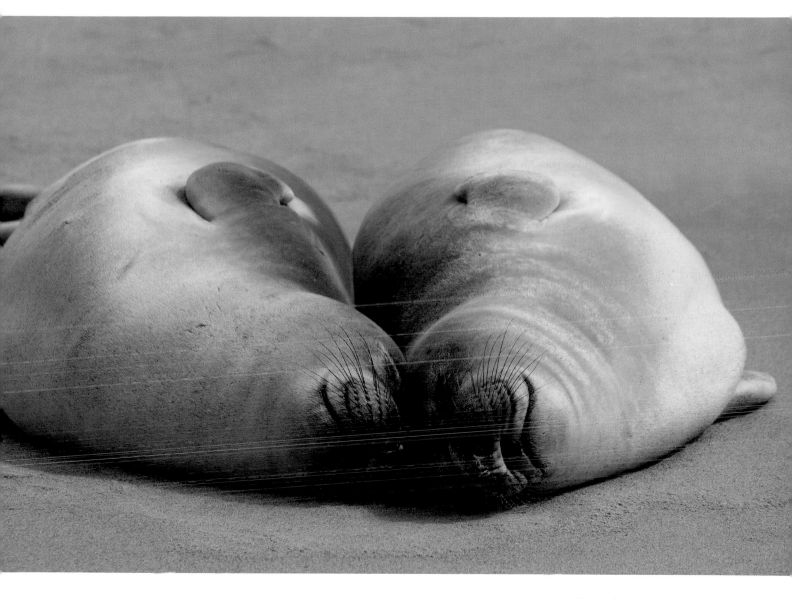

These elephant seal pups slept on Drakes Bay along the California coast, unaware of my presence, giving me the chance to move in, capture this sweet moment, and move away without disturbing their behavior. With a long 400mm F4 telephoto lens set to *f*/7.1, I exposed the scene in manual mode for 1/500 sec. using ISO 100.

EXPOSING ANIMALS

Another misconception about nature photographers is that we work at a slow pace, that nature photography is an effortless job that only requires you to hold a camera and snap a few pictures. This is far from the truth. Nature moves fast, and nature photographers have to keep up, whether working with ever-changing light, dealing with rough weather, planning out a day, hiking to a location to catch optimal light, or attempting to keep up with powerful and agile animals in difficult conditions. Under these situations, especially with wildlife, you have to work fast, a skill to aspire to yet not necessarily the best method to use when you start. As I tell my daughters, you make mistakes when you work too fast.

One of the toughest parts of exposure is having to meter a subject moving in and out of altering intensities of light and past backgrounds with different tonal values. The trick is to learn the features and functions of your gear that are good options in certain settings and to use a mix of techniques to get the shot. Then and only then can you learn how to work fast, and even then you will make mistakes—we all do. Here are a few ways to expose wildlife in different circumstances.

When to Shoot in Manual

Metering wildlife is no different than metering any other scene that requires you to determine the best exposure to maintain as much detail in the highlights and shadow areas. However, when an animal's tone is critical to the scene— say, maintaining white fur detail on a mountain goat—then spot metering the animal itself is preferred. Now it is about nailing one tone instead of a range of tones. Judging an animal's tone, to either overexpose or underexpose from the meter's middle gray recommendation, is the way to go. How do you figure out an exposure on an animal? It takes time and experience to learn tonal values and understand what your meter is telling you.

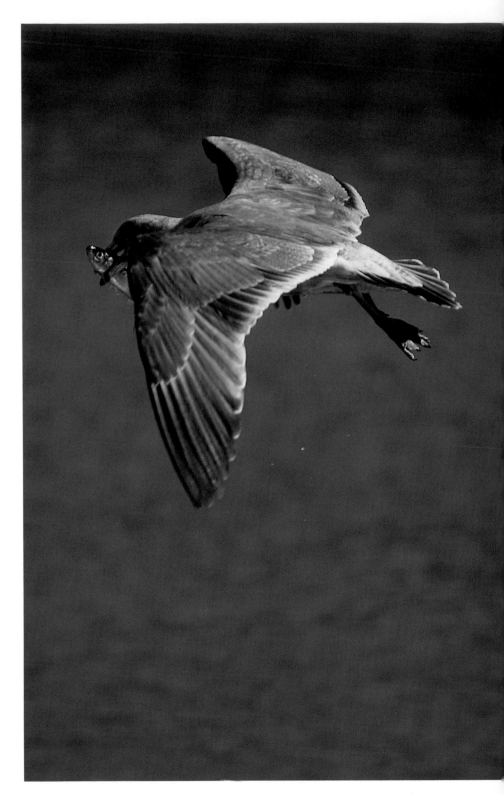

Photographing along California's central coast, using my 300mm lens, I pre-metered the light and set my exposure so I could follow and focus on feeding birds without worrying about backgrounds altering my settings. Documented at f/2.8 for 1/1600 sec. using ISO 100.

When tracking moving wildlife, such as birds that move past a mix of bright and dark backgrounds, shooting in Manual mode protects your exposure from changing drastically. Meter the scene or the animal and lock in your desired setting to cut out some of your variables and give you the chance to concentrate on nailing focus while creating a decent composition. Once the light changes, or when you have a break in the action, re-metering is always good to do, especially in Manual.

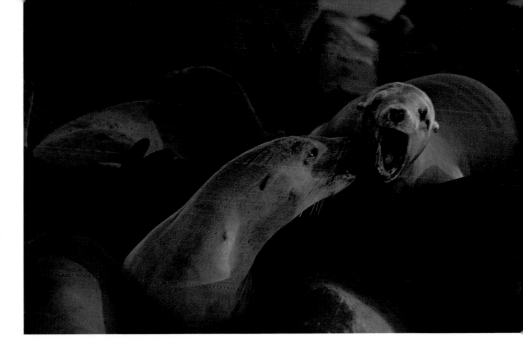

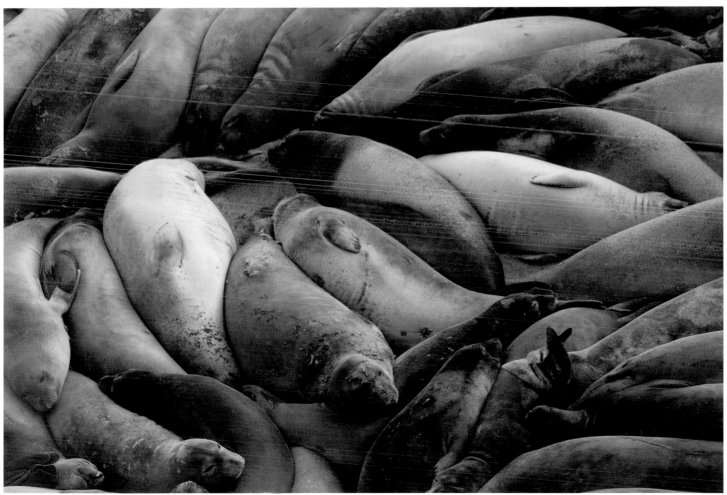

Top: The amber glow from an amazing sunset cast wonderful light onto these sea lions as they jockeyed for position along the California coast near Monterey. Metering to maintain these warm tones, I used a 400mm lens and exposed the scene at $f/5.6$ for 1/160 sec. using ISO 200.

Bottom: Elephant seals may be gray in color, but photographing a rookery at dusk at Point Reyes National Seashore shows how tones and colors change within a species. If you meter the light seal on the left, your meter will recommend a much different exposure than if you meter the dark one below it. Exposed at $f/4$ for 1/320 sec., ISO 800, using a 300mm lens.

When to Choose Shutter Priority

Every so often, I will jump out of Manual mode and switch to Shutter Priority (Tv) mode when photographing animals. If they're running through an area where the light is changing, or moving in and out of sunlight or shade, since I can't meter that fast in Manual, I like using a mode that allows me to set my shutter speed while my meter decides on the appropriate aperture for my exposure; Tv does this. I set my metering mode to Pattern (Evaluative/Matrix) and accept the fact that I can't meter every shot dead on, but at least I can get a number of images in one fell swoop.

Take into account that if you are working in low light when in Tv mode and your ISO is set low, and you decide to use a very fast shutter speed, your camera meter may blink, telling you that you need more light. Your aperture may be set to its maximum wide-open setting, but that still may not provide enough light to expose your image sensor. In these cases, using a slightly slower shutter speed or a higher ISO or waiting for more light may be necessary.

When in Shutter Priority with an animal on the move, you have to decide which message to convey: speed and motion with a slower shutter speed, or power and strength with a fast shutter speed. Freezing wildlife in motion can be extremely tough, since the fast shutter speeds needed to stop their movement require larger apertures, and larger apertures mean less depth of field and thus little leeway on focus. Being farther away or pulling back with the lens you're using (that is, using a shorter lens) can help you with focus, but the downfall is the image will most likely become less interesting. The closer you are to filling the frame with a fast-moving animal, the better, but focus will always be a challenge. This is why great wildlife images are so hard to capture. The only way to raise your odds is to practice and to try to predict where the animal will move to next.

Another technique to try in Tv (or in Manual) mode is called panning. A pan blur is when your camera follows a moving subject, such as a running animal, while using a slower shutter speed to capture motion. A fun part of panning is not knowing what you're going to get, but you can get some wonderful movement and convey speed well with this method. The best technique is to track an animal moving at a consistent speed and an unvarying distance, firing off a series of shots as it runs by. What shutter speed should you use? That depends on the animal's speed, the lens chosen, and the distance of the animal, but dragging the shutter speed around 1/30 sec. gives you a good starting point. The goal with pans is to capture movement while having a main part of the animal, usually its head, sharp and in focus. If you track the animal and

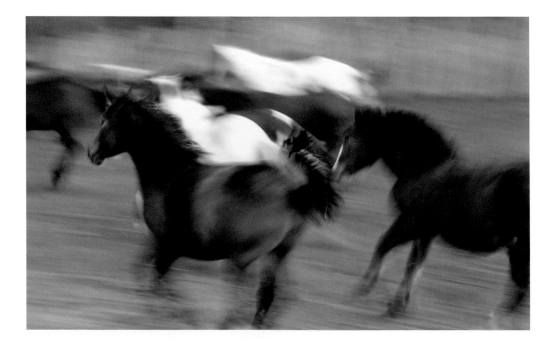

These horses running in New Mexico were perfect subjects for Shutter Priority. Using the technique of panning the subjects, I used my 80–200mm F2.8 lens and captured this scene at *f*/16 for 1/15 sec. using ISO 100.

keep it in the exact place in your frame through your exposure, you can get this. An indistinguishable blur across the frame usually isn't what you want, but then again you might create an abstract of color and motion that connects with you and others. One advantage of pans is that when you decrease the shutter speed, it usually requires you to use a smaller aperture, which in turn gives you more depth of field and some leeway with focus.

When to Use a Higher ISO

In most cases I try to use a low ISO for minimal noise and rich color, but as mentioned in the fast shutter speed example in low light, sometimes a higher ISO is needed when photographing wildlife. Another example comes from a hike I once made out of the Grand Canyon. I came across a bighorn sheep in shade, and, not having the time to pull out my tripod, I quickly switched my ISO setting in order to handhold my 200mm lens. It should be noted that as newer camera systems hit the market, digital noise at higher ISOs continues to improve; however, lower ISOs will always offer less noise.

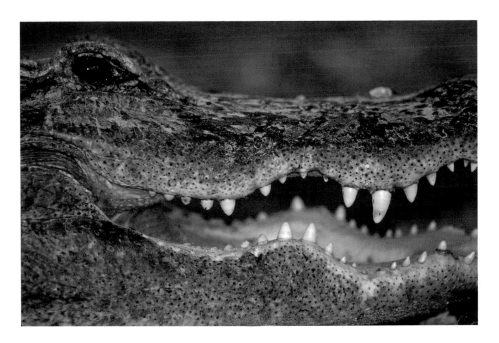

This alligator was impressive, but the shade muted its color and detail, diminishing the power of the moment. By adding fill flash to the scene, I was able to give it back some of its impact. With my 80–200mm $f/2.8$ lens set to 150mm, and my TTL fill-flash dialed down 1.0 stop, I shot the shaded scene at $f/2.8$ for 1/200 sec., ISO 100.

While teaching a workshop, my group and I stumbled across a newly born fawn hiding in the tall grass on a bluff overlooking the Pacific Ocean. Knowing we only had seconds to spare before its mother might appear, I chose my superwide 12–24mm lens, turned on my flash, and popped in enough light to lessen the shade while exposing for the overall grassy scene. Taken at $f/4$ for 1/100 sec. using ISO 100, with the flash set in TTL at –1 stop.

Using Flash

Flash can assist night shots of nocturnal animals and birds, but it is often harsh and unimpressive, not to mention difficult. One method I prefer is using fill flash, illuminating the shadow areas on an animal close enough, balancing the power of my flash with the surrounding available light to make it look natural. The additional light from your flash also brings out color lost in the low light of shade. You can also diffuse your flash with a number of aftermarket products, and, as mentioned in the last chapter, add some warmth to your flash and dial its power down a bit to balance it with the available light. There are also flash extenders you can add that will boost your flash output by 2–3 stops, increasing the range with animals a little farther away. My favorite flash mode is TTL (through-the-lens) flash metering. The flash exposure is handled automatically by your meter, which makes it easier to produce fill flash shots (as long as you lower the power of your speedlight). For animals at a distance, full power or even a +1 setting on your flash may be necessary.

Lens Choice

A common thought with wildlife photography is that long lenses are critical. This isn't necessarily true. I've used every one of my lenses with animals in the field, from a superwide to a 400mm with a teleconverter.

» tip

Teleconverters are a nice way to extend your lens focal length without the need to purchase another lens or carry a much heavier one. However, because of the additional light dispersion caused by a teleconverter, your exposures will be slower, depending on the strength of the teleconverter—the 1.4x version loses 1 stop of light, and a 2.0x loses 2 stops (for example, a 300mm F2.8 turns into a 600mm F5.6 when using a 2.0x). Also note that autofocus may not work when using a teleconverter, and camera shake may be a concern because of slower shutter speeds.

Capturing facial expressions not only can create more interesting wildlife photographs, but also can give a feel for what the animal is about. When this lowland gorilla yawned, the muscles in its face, chest, and arms contracted to show the power of this gentle giant; the large jaw and sharp teeth didn't hurt either. Using a 300mm F2.8 lens and a 1.4 teleconverter, I exposed him at f/4 for 1/125 sec. using ISO 200.

Framing Wildlife Scenes

For wildlife portraiture or safari trips, long lenses are the norm; they get photographers close without the need to close the distance. This keeps an animal more comfortable in its environment and makes for tighter compositions while the photographer remains at a safe distance. Telephoto lenses, similar to binoculars, can emphasize any little camera or subject movement during the exposure, so fast shutter speeds can help to negate this issue. Focus is critical, usually tied into the subject's eyes, although this is a guideline and not a hard and fast rule.

Another guideline I follow when framing animals is that when I can't get in tight—owing to the distance of the animal, my lens, or my vantage point—my mind-set switches to find the most interesting composition, placing the animal in its surroundings. At first, photographers can get disappointed when they can't get close enough, but some of the most amazing wildlife images are ones that include scenery and show animals in their environment.

Last but not least, don't forget about vertical compositions with wildlife. They are tougher to accomplish and therefore more unusual and possibly more pleasing than horizontal versions.

Shooting from a boat at sunset with my 300mm lens forced me to set my aperture wide open to use a fast shutter speed of 1/640 sec. with my ISO at 200. As I drifted past the feeding egret, I framed the scene to include its reflection to create a pleasing composition.

» tip

Ball heads for tripods have become the trend in outdoor photography, mostly because of their speed and flexibility to get into position fast. I own an Acratech and a Gitzo ball head and love both. A sturdy ball head is just as important as a sturdy tripod. The key is to make sure your ball head is strong enough to lock into position and can hold larger, heavier lenses without slipping.

As I headed up a trail to the top of Yellowstone National Park's Mount Washburn, my hopes were to find a herd of bighorn sheep and capture a few portraits with my telephoto lens, but as the elusive and skittish animals kept their distance, I was forced to change my goals. All in all, I was very pleased with some of the compositions I was able to create—ones I might have passed on if I had been able to get within portrait range. Both were captured with my 300mm F4 lens using ISO 100. The top image was shot in high winds at $f/4$ for 1/1000 sec., and the bottom image was documented at $f/4$ for 1/250 sec.

Nature on the Move

Framing wildlife on the move is hard to master since capturing a moment becomes about timing and focus while attempting to create an interesting, well-balanced composition. Everything is moving fast, and at the moment of capture your viewfinder is closed, allowing the shutter to be open for the exposure. Sometimes it's a guessing game, yet as you improve that guess can turn into an educated guess. Regardless, part of the fun is never knowing completely what you will get until you see the final shot.

Following any of the compositional guidelines mentioned in chapter 3 can aid in creating a nice flow and balance to your scene. When you first spot an animal, take the documentary-style shots first and let the scene play out. You may get that "wow" moment if the animal moves into a nice position, but if not, at least you have a few images to take home. Consider features such as Continuous Shooting mode on your camera-motor drive. This gives you the ability to fire off numerous frames fast in case a fleeting moment occurs. A fox walking through a field might be a nice image, but if you freeze it in mid-air as it all of a sudden jumps high to pounce on its prey, then you have something special.

Capturing sea otters from a boat makes focus, framing, and exposure all the more difficult. I chose a vertical composition for this fuzzy cutie, metered the water to find the right tone, and exposed at *f*/4 for 1/500 sec., ISO 100, using a 300mm F4 lens.

Shooting with a 400mm F2.8 lens, I tried waiting for these shorebirds to fly across the moon—missing many as they shot through quickly—and also closing in on one (which would turn in the opposite direction at the last moment). Over a period of time I was able to get four frames where a gull crossed the full moon—part luck, part persistence, and part skilled technique perfected over time. Exposed at *f*/4 for 1/1000 sec. using ISO 100.

Remember to follow the handheld shutter rule and use a tripod, a cable release or remote, mirror lock, vibration reduction or image stabilization (if you have it), or a combination of these, since camera shake can ruin a nice wildlife image. When it comes to panning, the handheld shutter rule gets thrown out. You can use a tripod if you wish, or simply handhold and move with your subject, following it in any direction.

When you find a moment where wildlife is silhouetted, side angles, as opposed to front angles, create better shapes of the animal. The same could be said for people. As for eye contact, sometimes having an animal's eyes look toward the camera can be powerful, but it's not always necessary, especially if you prefer to document the creature in its natural habitat, without the inference of a person being present.

Shooting from a moving boat made using a tripod less effective, so I made sure my shutter speed was above the length of my lens, to avoid camera shake. Photographed using a 500mm lens at f/5.6 for 1/3200 sec. using ISO 200.

Autofocus versus Manual Focus

Autofocus (AF) continues to improve with newer systems, yet there is still an error factor when it comes to AF. I prefer to use manual focus most of the time, to focus on the spot in the frame I choose, whether on a still or moving subject. Whether to use auto or manual focus is a personal choice. Some photographers get great at locking in their autofocus, recomposing, and shooting a sharp image. Others prefer my way: manually focusing, predicting the place where an animal will cross, and firing off the shutter when the animal hits that mark. Either way you choose, recognize that nailing focus takes practice, whether shooting on land or from a boat or other moving object. You will also miss focus on some images regardless of whether you are in auto or manual focus.

Focus can be easier to achieve when a bird or animal is traveling past you side to side as opposed to coming directly toward you or traveling away from you. As the animal moves perpendicular to your position, the focal point hardly changes, and nailing focus becomes slightly easier—not easy, but easier.

I was ready when this captive Swainson's hawk decided to take flight. Quickly focusing on its eyes, I fired off a few shots before it left my frame; some were tack sharp and others were slightly out of focus. But as someone once said, it doesn't matter how many bad shots you got as long as you captured the image you wanted. Operating my 300mm F4 lens in manual focus, I froze my fast moving subject at 1/1000 sec. using *f*/4 with ISO 100.

Nature Assignment #7:

Capture an animal in its habitat demonstrating behavior

Whether you practice in the wild, at a zoo, or in your backyard, find an animal to photograph and, through your choice of lens, exposure setting, direction of light, and decision of the moment, attempt to show some sort of characteristic of that creature. Be patient and persistent, and you might create an image you are proud of.

While working on this assignment, attempt to record the specifications and details of your selected image not included in your EXIF metadata. You can find most of your exposure settings through the metadata, but not filter type or the direction you were shooting, should you wish to share this information later.

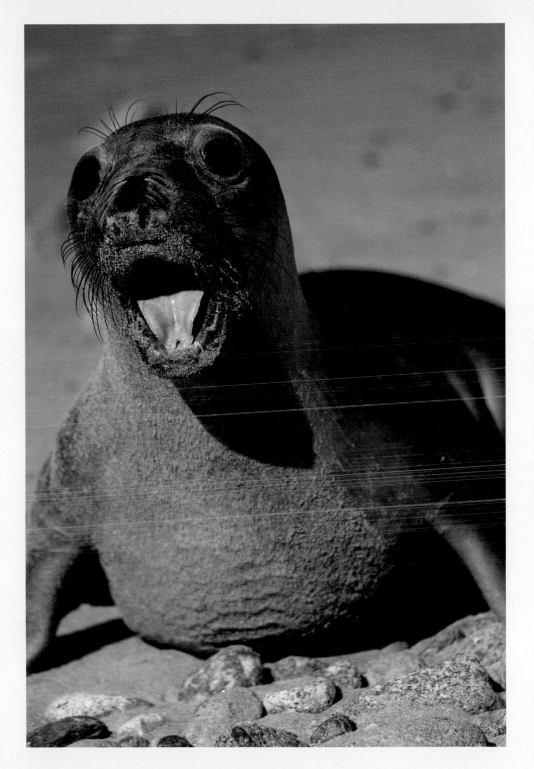

For this assignment, I photographed a young elephant seal pup along the California coast in Point Reyes National Seashore as it lay still in the sand for minutes on end. Not giving up, I continued to set my exposure and focus, and when it finally turned and barked in my direction, I was ready. I set my aperture to its largest setting of *f*/2.8, for minimal depth of field, and shot for 1/250 sec.

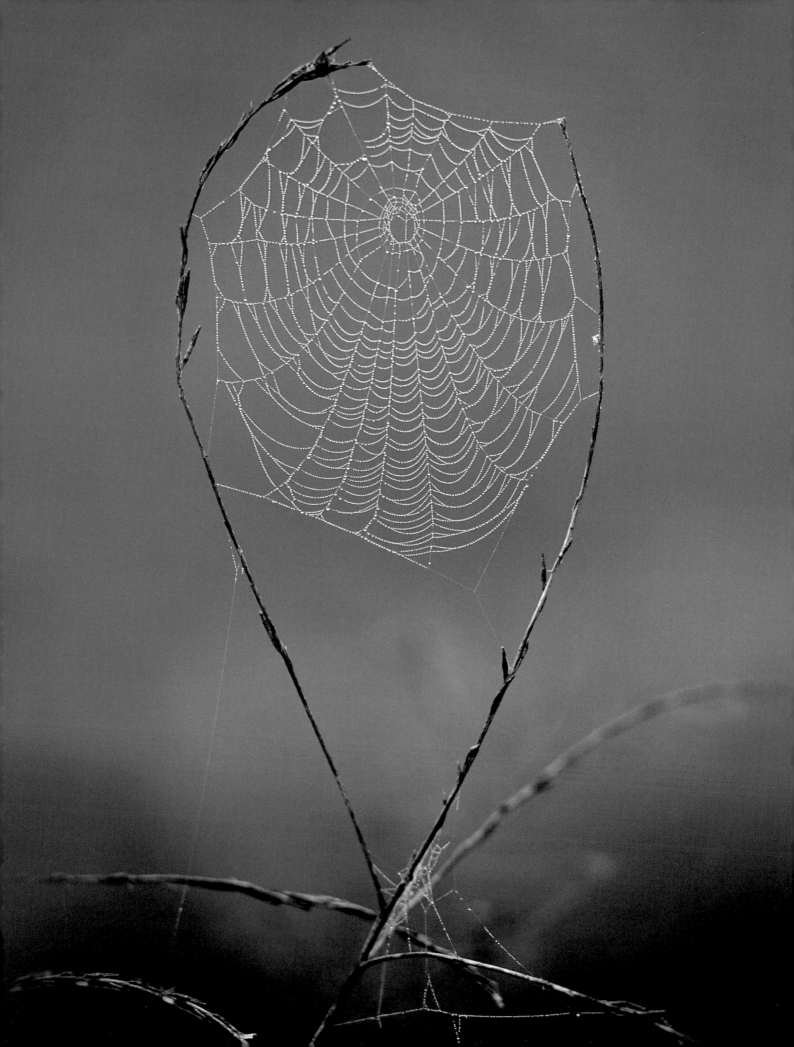

CHAPTER EIGHT

MACRO AND INTIMATE SCENES

"I really believe there are things nobody would see if I didn't photograph them." Diane Arbus, an American photographer known for her controversial images of people, said this, and although her work may be far from nature, these words pertain to it. To cover the gamut of outdoor photography means including close-ups of flora and fauna. This is the beauty of macro photography, capturing amazing intricate details and the colors and forms of the natural world that most overlook on a regular basis: flowers that grow into unique shapes, insects with alien-looking bodies, reptiles that appear prehistoric, or a group of rocks spread out in a mosaic design. To do it well is to produce a piece of art, to find a rare little gem, something unique, fragile, or delicate. To photograph a landscape is to show nature in harmony; to create a macro image is to enter a whole other world.

MACRO IMAGERY

Another quote that expresses how I feel about macro photography comes from the painter Georgia O'Keeffe, who said of her style of work, "I decided that if I could paint that flower in a huge scale, you could not ignore its beauty." Macro photography is about emphasizing small parts of nature you normally don't see. You can show the detail of a particular subject, highlight an interesting shape or form, or produce impressionistic abstracts. This can include the pattern a river makes as it flows over a small rock, or a spider web spun into a shape like a Native American dream catcher, as I found one morning near Monterey, California. This image was not my initial goal when I arose from a warm bed before sunrise on an April morning. My initial thoughts were to photograph the first rays of sunlight as it crested a distant ridge, but as I ventured into the hillsides along a trail, there was nothing but fog. At first I figured my morning was a wash, but I soon changed my mind-set and decided to search for scenes that benefited from soft light—macro scenes. By switching gears I was able to come across a wonderful find, a pleasant surprise. A number of spider webs surrounded a small pond, so I decided to look for one that stood out. When I found this one (page 176), I was blown away. As it spun its web, the spider pulled the two reeds together to create a perfect oval. It was close to various branches and had numerous trees in the background, so I knew I wanted to eliminate as much of the surroundings to draw focus to this masterpiece. The spider created the art form and I documented it in a way that gave it the attention it deserved.

Lens Choice

Because photographing a subject close up is beyond the focal range of most normal lenses, you need a lens that can focus within inches instead of feet. This is how macro is defined in photography. Any lens that has the ability to focus closer than a normal lens of the same length, usually by stretching the glass elements inside farther apart, or by the general configuration of the lens, is considered to be macro. Some cameras have the ability to switch into a macro setting, although true macro lenses provide more options.

A wide-angle lens that can focus within inches is a nice option when trying to fit into small areas since the lens can cover a wide field of view, like the image I created at the end of this chapter (page 193). When it comes to standard and telephoto lenses, there are three main macro lens lengths: 60mm, 105mm, and 200mm. The 60mm lens allows you to get closer to your subject, including a bit more of the surroundings than the longer lenses. I've owned a 60mm macro for years and love it. But if you can't get close to your subject for one reason or another, it may not be the best choice for you. The 200mm version allows you to focus on your subject from a longer distance, but it also cuts the amount of background you can see through the limited angle of coverage and through the low depth of field it provides. If you want your subject completely in focus or desire more depth of field, this might not be the lens to use. A 105mm lens falls somewhere in between—not too short, not too long, not as much depth of field as the 60mm lens, but more than the 200mm model. It is said that most macro lenses focus better close up but are not as sharp at normal distances. This may be true, but I've never personally noticed this when using my macro lenses in all types of situations.

You can also get macro-type images using a telephoto lens, which is great for when you can't get close to an area but still want to come away with a close-up shot, such as when you want to photograph a small area of a fast-flowing river without entering it, or when you're shooting cactus plant and hoping to avoid any injury.

» **tip**
Internal focusing macro lenses can reduce the risk of the lens bumping your subject during focusing since the front element doesn't move in and out.

Using my F2.8 macro lens, I watched my maximum aperture change as I came in closer on this orchid, making the necessary shutter speed adjustment to obtain proper exposure. Photographed at f/4.2 for 1/100 sec. using ISO 400.

Using a 105mm macro lens set to f/4.5, I focused on this Sierra wildflower's petals, blurring the distracting background into a mix of soft hues. Exposed for 1/250 sec. using ISO 100.

Adjustments

Slow shutter speeds can affect your macro scenes because, as in long lens shooting, every bit of movement from your camera or by your subject is enhanced. Match the speed of your shutter to the movement of your subject. Even slight wind can cause your small subject to move enough to consider a larger aperture or a higher ISO to give you the shutter speed to stop the motion. Because camera shake can cause a slight blur across your entire image, consider using a tripod, a cable release or remote, a mirror lock, or an IS/VR lens. The handheld shutter rule (see chapter 4) applies just as much to macro lenses as to any other lens.

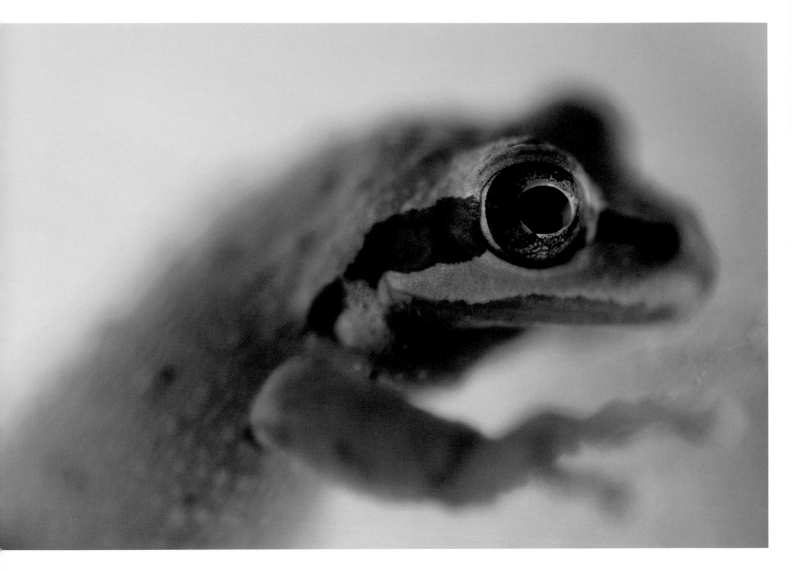

Photographing this frog at an extremely close distance while it moved in and out of focus ever so subtly had me thinking about using a fast shutter speed, so when I focused on its eye I could fire off my shutter with little camera or subject movement. Captured at *f*/5 for 1/200 sec. using ISO 100.

When it comes to bright, vibrant colors and exposure, a challenge that often occurs with wildflower close-ups, meters tend to jump all over the place. Deep reds and bright yellows are difficult to read, and in these cases, finding an easier reference point to meter that is in the same light can give you a better idea of the proper exposure.

As you inch closer to your subject, you may also notice the minimum or maximum aperture of your lens decreasing. The internal glass elements of your lens stretch to maintain focus, and as this occurs there is some fall-off of light, which requires the need for a longer exposure. When your lens is set at the minimum or maximum *f*-stop, you see it change to a smaller aperture, but if it is set somewhere in the middle, the only adjustment needed is a longer shutter speed or higher ISO; the aperture will not change as far as *f*-stop number, but your meter will still need to adjust. Take my 60mm F2.8 macro lens. If I focus it as close as I can, I notice the maximum aperture adjusting from *f*/2.8 to *f*/3.5 to *f*/5. At *f*/32, my normal minimum aperture, I may see it change all the way to *f*/57 as the camera adjusts to the loss of light. As the elements inside the lens extend, they disperse the light entering the camera and cause less light to hit your sensor or film.

Shooting straight down onto a shrub to photograph morning dew on a spider web was possible only by using a 60mm lens, since a longer lens, such as a 105mm or 200mm macro, would have required me to be higher than I could have been. Exposed at *f*/57 for 1.3 seconds using ISO 100.

Depth of Field in Macro

The changes in aperture in macro are also similar to the comparison of wide-angle lenses versus telephoto lenses. The longer your lens, the less depth of field you have, whereas in macro, the closer you are, the less depth of field you have. In many cases, if you are within inches of your subject, even at f/22 your depth of field may be no more than 1 foot. Move back a few inches and your depth of field may have increased to 10 feet—move in closer and it may be inches. Regardless, choosing the right amount of depth of field is extremely important for getting certain elements in sharp focus and deciding just how much in the way of detail, or hint of detail, you desire in the other areas. The trick with macro and depth of field is finding the best angle to show your subject in the most interesting way, getting what you want in focus, and editing out the less important elements of the final scene. This usually means applying a larger aperture for a less distracting background, or a smaller aperture to show detail throughout the composition. Either way, finding the correct angle is crucial. You may need to make sure your lens is parallel to the plane of your subject or find an angle where only one small section comes into focus.

Minimal depth of field for macro images not only gives depth and dimension through selective focus, but also helps to give the appearance of softness, delicacy, and fragility. It offers a clean, less distracting background and draws focus to your subject. Having said that, focus is critical with minimal depth of field, and finding the right spot to have sharp is not always easy, especially on a three-dimensional subject. If you find that place with your subject, your mind tends to complete an image as long as there is one critical area in focus.

Adding depth of field can give a hint of your small subject's surroundings and change the overall feel of the image. The increase in subject matter with focus can also flatten the scene by blending the elements together through sharpness. This means you are dealing with a mix of subject matter, such as a blanket of fall leaves on a forest floor, which requires you to pay close attention to each element in the shot.

With my aperture open at f/5 on my 60mm F2.8 macro lens, I was able to turn a somewhat busy background into a smooth, bright, soft area, bringing more attention to the patterns in the feather. Using ISO 100, I exposed the scene for 1/400 sec.

Finding this wonderful mosaic of color on this lichen-covered rock, I decided to use a very small aperture to ensure sharpness throughout the scene, highlighting the pattern and not the shape of the rock. Exposed at $f/45$ for 2 seconds using ISO 100.

Understanding 1:1

Macro lenses come in different measurements, depending on how close you can get to your subject, usually measured in magnification. Most standard lenses magnify subjects at roughly 1:8 to 1:10. Size in comparison to what, you may ask? In the days of 35mm film, when film was 24mm x 36mm in size, this measurement was a macro term used to describe the actual object photographed as compared in size to its image on the piece of film. If a bug was documented at 1:10, this meant that if you took your 35mm slide (or negative) and placed it next to the insect, the bug's image would be approximately one tenth of the bug's actual size. Most macro lenses start around 1:4, allowing you to photograph details of a flower, a small insect, or reptile. The closer you are able to get, the more magnification you acquire and the closer to life size the final image becomes. At 1:1, you are at the actual size of your subject. That is, if an insect is exactly 36mm in length and is shot at 1:1, it would cover the horizontal length of the film, or the diameter from edge to edge in a digital image file.

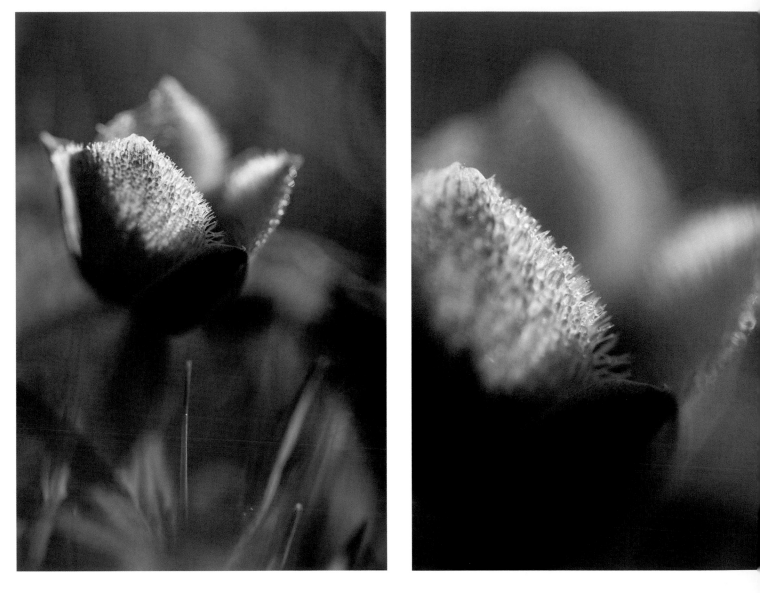

Pussy ears at sunrise, magnified at roughly 1:4 life size on the left, and 1:1 life size on the right. Both photographed at *f*/5 for 1/500 sec. using ISO 100 with a 105mm macro lens.

Extension Tubes, Bellows, and Extenders

If you have interest in photographing the minuscule, which requires a great deal of patience, you need to look into purchasing some specialized equipment to fit your needs. To go below the 1:1 life-size ratio, you need extension tubes, a bellows system, or some type of extender for your lens. Extension tubes attach between your camera and your lens and can be used with many macro and standard lenses. These devices come in a variety of lengths and sizes, depending on the amount of magnification you wish. The longer the tube, the more magnification you acquire. Some even give you the ability to focus on an insect that attached itself to the front of your lens.

Diopters, thick filters that screw onto your lens to give you closer focusing capability, are another option. They are lightweight and can produce quality shots if you purchase a high-quality version. They work better on fixed focal length lenses.

A bellows system, constructed using two sets of rails and bellows between your camera and lens, is usually designed for a high scale of magnification. To use the system, you first have to extend the bellows for the desired magnification, then adjust the entire assembly until your subject is in focus.

You can handhold most of these systems, but you are better off using a tripod. As with most, if not all, extension devices that give you great magnification, the light transmitted through your lens is less and the increase in movement more obvious than with standard lenses, and thus may require slower shutter speeds, higher ISOs, fill flash, or the use of a tripod, shutter remote, or mirror lock.

By using an extension tube, I was able to fill the frame with this crane fly, which was attached to the front of my lens, as well as show the complex detail of this dew-covered spider web. The crane fly was shot at *f*/5 for 1/125 sec. using ISO 200, and the spider web at *f*/5 for 1/30 sec. using ISO 200.

Paying Attention to Detail

As mentioned in the section on depth of field (see page 90), considering your entire frame should be a common theme with your outdoor photography, and it is just as essential to your macro photography. The smallest of details can add to or subtract from your final image. Smooth, even lighting can help remove any potential splotchy highlights or shadows, helping create a cleaner, less-distracting background and drawing your eye to the main subject in focus. A blade of grass in the background in shade may not affect your scene much, but if it catches sunlight and shines brightly, causing a hot spot, then it becomes a distraction.

Another consideration with macro is searching for small elements that can help your composition. Search for that one interesting fall leaf that may hold the most interesting color or shape out of hundreds, or for the one resting on a rock that is physically separated from the others. Finding the right subject is important, but combining your knowledge of composition, depth of field, exposure, and lighting is just as significant.

Photographing in Point Lobos, along the California coast, I carefully considered my composition of these patterns and colors of rocks to frame the macro scene I wanted. Shot using ISO 100 at f/32 with a 3-second exposure.

Seeing the Light

People who review my photographs sometimes think I have found extraordinary light, especially with macro images, but often they are simply the result of searching for the right light. For example, one of the best ways to separate your macro subject from the background is through light, finding a light background for a darker subject to create a silhouette, or finding a dark background for a bright or colorful subject. Another way is by waiting for the right light, for the moment when the light hits a certain area in your scene, as I did with the image of the water droplet resting in a lupine plant below.

I also consider the direction of light, such as backlighting, which allows my subjects to pop off the frame, to glow if translucent, and to separate from the background. There's an easy way to accomplish this besides simply backlighting your subjects— point in the general direction of the sun and search for the line of demarcation between the sunlight and the shade. When you find this, search for an interesting subject, such as a flower or an insect attached to a reed, that is just enough in sunlight but bordering this line of shade. By photographing this subject, you should be able to have your subject stand out by using the close shaded background, as I did with the lupine plant at sunrise, below.

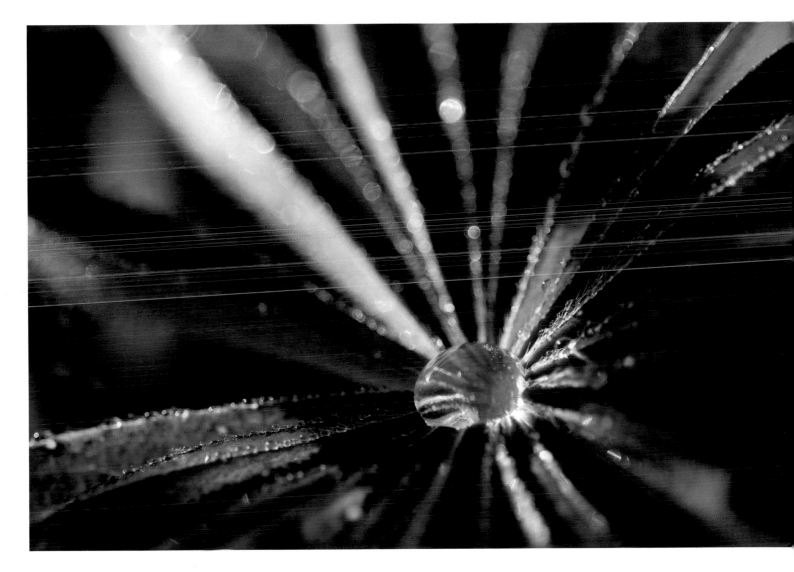

While teaching a wildflower workshop along the California coast, I framed this detail of a lupine plant and waited for the warming sunlight to hit the dewdrops resting in the center. Shot with a 60mm macro lens at f/4 for 1/400 sec. using ISO 100.

Viewing these frontlit patterns in the sand didn't do them justice. But as I rotated behind them, back-lighting the sand against the setting sun, the shimmering light created a dramatic exposure. Shot at f/3.2 for 1/10 sec. using ISO 100 and a 90mm lens.

» tip

Making a grab bag, a trick bor-rowed from studio photographers, for your macro work is one way to create unique images. You can purchase the fold-up versions of a fill or bounce card (avail-able in gold, silver, or white), or use virtually anything, including black velvet, for a rich, nonreflec-tive backdrop. Other items could include a PVC tube or lightweight clamp to hold a flower steady, a spray bottle to add water to a macro scene, or aluminum foil or a small mirror to bounce in reflected specular light.

Controlling the Light with Fill

One advantage of working with smaller subjects is the ability to control the contrast of light with a mix of fill options. You can use your flash unit to pop in some additional light, filling shadow areas, but you can also use fill or bounce cards, mirrors, a white T-shirt, a reflective pocketknife, tinfoil, or your hand. The key in backlit situations is to use the main light source, usually the sun, and angle the light to bounce off of your fill source and onto your subject. Ring flashes—flash tubes arranged in a circle around the front of the lens—help in lighting subjects at close distances by eliminating shadows, which may often be yours. Ring lights using white LEDs can also provide a continuous light source for macro photography.

By getting in nice and tight with this wildflower, I was able to block the harsh morning light and create softer ambient light with a white fill card, fitting the soft, delicate qualities I was hoping to convey. Shot at f/5 for 1/80 sec. using ISO 250.

Unique Perspectives

"Nature will bear the closest inspection. She invites us to lay our eye level with her smallest leaf, and take an insect view of its plain," said Henry David Thoreau.

The lengths to which you are willing to go to capture the best shot will vary from photographer to photographer. Whether mounting your camera on a tripod to steady it for a sharper shot, patiently waiting for a small flower to stop moving in the wind, fighting the cold permeating your body as you lie in the snow, or dealing with pain in your back or neck—these are the little things that push your macro images to another level. Much of what turns out to be a great macro shot is hard work: the willingness to bend into awkward positions, finding yourself with aches and pains you wouldn't normally have, making strange sounds you don't normally make as you stand up after a macro session. Being down low can give the feeling of flowers reaching toward the sun and can exaggerate a subject's size or accentuate its shape by silhouetting it against the sky. Digital can be an advantage when finding a unique angle; you can lay your camera on the ground pointing straight up, use the self-timer to back out of the scene, and check your LCD screen to review your composition. Finding the most unique perspective can get your clothes wet or dirty, or your arms and knees scraped up, but it may be the best way to create distinct and interesting views of the world around you. However you choose to photograph is acceptable and up to you, whether you prefer to carry kneepads, wear old clothes, bring a tarp to avoid getting wet, or just rough it.

I was as low as I could go to get into position for this detail of a California poppy blooming in Northern California, but it was the angle I needed to create the colorful and minimal composition. With my 60mm F2.8 macro lens set to f/5, I exposed the delicate scene for 1/320 sec. using ISO 200.

Creating Abstracts

When you shoot macro images, part of the fun is creating abstract scenes. Not everything has to be in focus, and in fact the entire scene can be completely out of focus. With macro you can experiment to concentrate on color and light, movement and form, instead of focusing on a specific part of your subject. Impressionism was once described as taking reality and changing it ever so slightly with emotional intent. This statement also fits macro photography, since the close-up world can appear abstract and photography as art isn't defined through the true or real depiction of a subject.

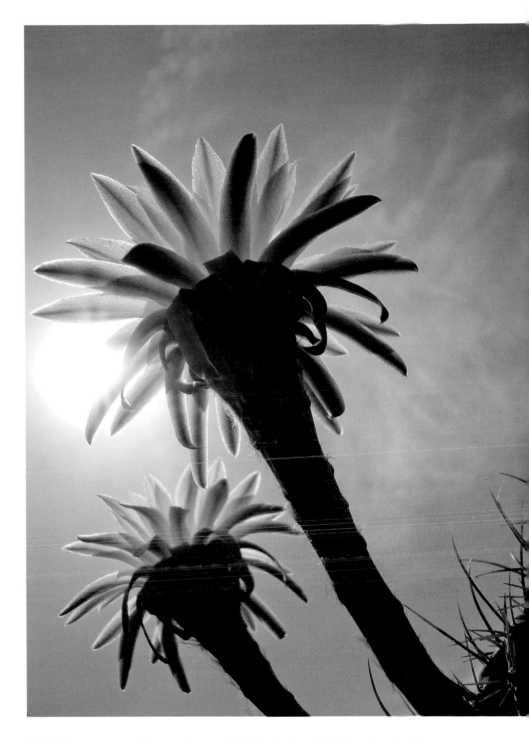

By holding my camera close to the ground in the shadow of this barrel cactus flower, I was able to silhouette it against the afternoon sun, bringing out its color and form while creating an interesting shot during a harsher time of day. Using a 35mm F2.8 lens and ISO 64, I shot my backlit translucent subject at f/8 for 1/1250 sec.

INTIMATE SCENES

I define photos that fall between macros and landscapes as intimate scenes, a small section of the surrounding environment, part of a landscape but not necessarily composed within inches or a foot or two. They may not be macro by definition, but they focus on a small section of a location, and they can be great when less-than-perfect weather eliminates a landscape composition, or when skies are a bit boring. I kick myself sometimes when I find an inner scene like this in a landscape I already photographed, wondering why I didn't notice the small area where magic was happening when I was standing there documenting the expansive version. For these scenes, you can use a macro or a standard lens. Generally, the images are about singling out an area, focusing on just a few elements, and making light and compositional balance of the essence. I crop out skies and focus on small areas on the land around me. I often prefer to record these vignettes of a larger landscape using small apertures to get edge-to-edge focus and to create patterns and show detail, all of which add to the composition. However, this isn't always necessary, and it depends on the scene and your creative intentions.

All four of these images may not fall into the technical definition of macro, but they all focus on small elements in the wild (clockwise from top left): incoming surf along a coast (shot with a 70–200mm lens), icicles on a waterfall (using an 85mm lens), a tree blending into a granite boulder (captured with a 50mm lens), or the remnants of a fish along a shell-covered beach (making use of my 35–70mm zoom).

Nature Assignment #8:
Photograph a macro scene with a clean background

Controlling your backgrounds in macro photography, whether through depth of field or the angle you choose, may be critical to your final image. Find a close-up scene where you can use minimal depth of field or an interesting perspective to give you a less distracting background and draw focus to your main subject.

While working on this assignment, attempt to record the specifications and details of your selected image not included in your EXIF metadata. You will find most of your exposure settings through the metadata, including time of day and lens length, but not the type of filter or the direction you were shooting, should you wish to obtain this information at a later time.

For this assignment, I found a pair of poppies growing out of a rock outcropping in the hills of Berkeley, California. Using my 12–24mm lens, I pre-metered the sky, positioned my camera in the shade of the flowers to backlight my subject while blocking out the sun, and exposed the scene at f/8 for 1/640 sec. using ISO 64.

CREATIVE TECHNIQUES

Now that you know how to pack and prepare, and have learned the features of your DSLR and how to frame, expose, and capture a diverse range of subject matter, you're now ready for some of the techniques outside the norm. Aristotle wrote, "In all things of nature there is something of the marvelous." Regardless of which method you use with your nature photography, experimentation has to be part of the process of trying to create the marvelous. On occasion, you need to be calculated in your approach, but other times you can take chances. Digital has changed photography for the positive and for the negative. The joys of discovering the images you captured a week earlier are gone with the instant access the LCD screen provides, but the opportunity to reshoot the ones you may have missed offsets this. Some photographers prefer to record nature as it is, while others want to construct images that may or may not portray nature in the most accurate way. Whichever preference you have, discovering new and imaginative techniques to meet your goals can push the boundaries of your outdoor photography.

CREATING THE EXPOSURE YOU WANT

For most of the images in this book, I was able to perform all of the tasks I needed in camera: find a subject, choose the light, frame the composition, and decide on exposure. But every so often, generating extreme exposures means either using a few charts and graphs, or, in today's digital outdoor photographic world, implementing a few software programs. When you work in extreme low-light or in high-contrast situations, sometimes the only way to meter or expose a scene to maintain the necessary details requires measurements or methods your DSLR camera cannot provide, at least not yet.

NIGHTTIME PHOTOGRAPHY

In camera meters measure light from dawn to dusk, but once that light diminishes to a certain point (usually around twilight), your meter stops working. It's not sensitive enough to measure the low amounts of light available. This is where exposure value charts, experience, and your imagination take over.

Photographing Yosemite Falls lit by the full moon at midnight, I exposed the scene by delving into my past experiences with nighttime photography, which began with studying exposure value charts. Using my medium-format camera and a 125mm lens, I shot the scene at $f/5.6$ for 5–6 minutes using ISO 100.

Using Exposure Value Charts

Exposure value (EV) is a term used to measure light, not to be confused with exposure compensation (EC). Zero is the base starting point for EV, measured as ISO 100, f/1 for 1 second. EV was developed to address certain lighting types or conditions. For nature photography EV mostly applies with nighttime scenes where time exposures are required. In Table 9-1, I address most nighttime conditions, scenarios where your meter may not read the light accurately, such as the first quarter moon, or where your meter may not be able to read the light at all, such as a 4-hour time exposure of the stars. Please note that the exposure settings I recommended can be changed to other equivalent exposures, whether through f-stop, shutter speed, or ISO. For example, when shooting tar trails with moonlight, the exposure is set at f/4 for 2–8 minutes using ISO 100. You can use these settings, or an equivalent, such as f/2.8 for 1–4 minutes using ISO 100, or f/5.6 for 2–8 minutes using ISO 200.

Table 9-1

Exposure Values for Nighttime Photography

Lighting type/condition	Exposure value (EV)	Exposure setting (at ISO 100)
ZERO (0) EV	0	f/1 for 1 second
THE MOON		
Full moon	15	f/16 for 1/125 sec.
Gibbous (between a full moon and half moon)	14	f/11 for 1/125 sec.
Quarter moon (first quarter or third quarter, also known as a half moon)	13	f/8 for 1/125 sec.
Crescent moon	12	f/5.6 for 1/125 sec.
MOONLIGHT (photographing scenes using the moonlight)		
Full moon moonlight	-3 to -2	f/5.6 for 2–4 minutes
Gibbous moonlight	-4	f/5.6 for 8 minutes
Quarter moon moonlight (also known as a half moon)	-6	f/4 for 16 minutes
AURORA BOREALIS AND AUSTRAILS (the Northern Lights)		
Bright	-4 to -3	f/5.6 for 4–8 minutes
Medium	-6 to -5	f/4 for 8–16 minutes
NIGHT SCENES		
Lightning	2 to 0	f/16 for 1–4 minutes
STARS		
Star trails (no moonlight)	-6 to -5	f/4 for 8–16 minutes
Star trails (with moonlight)	-5 to -3	f/4 for 2–8 minutes

One evening near my home, coastal clouds began to roll over the hillsides, illuminated by nearby city lights. I quickly grabbed my camera, headed out, and exposed this scene at $f/4$ for 30 seconds, using ISO 400, with my 12–24mm lens set to 14mm. The shorter exposure gave me the pinpoints for the stars while the higher ISO exposed the overall scene.

Stars

The direction you point your camera in the sky determines the pattern of the stars in your composition when capturing star trails. You can carry a small cheat sheet of the graphic I've included showing you the curvature of the stars, evidence of the rotation of the earth. This drawing will not be completely accurate since the direction depends on where you're located on the globe, here at about 38 degrees north (the latitude that crosses most of Europe, Asia, and North America).

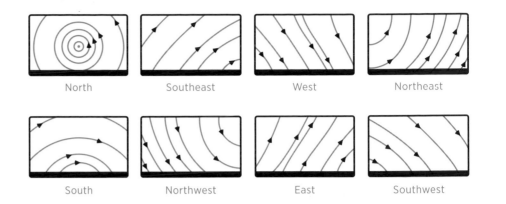

North Southeast West Northeast

South Northwest East Southwest

Camping at 12,000 feet below Mount Whitney, as the moon rose to expose the range, I mounted my camera on my tripod, and, using my 24mm F2.8 lens, set the exposure on Bulb, holding the shutter open at f/4 for 10 minutes, using ISO 50.

Two examples of star trail patterns being determined by the direction I photographed. The image above was a 4–5 hour exposure facing west, and the shot on the right was a 45-minute exposure looking directly north (in fact, you can see Polaris, the North Star, as well as the Big Dipper). Both were shot at ISO 100, the photo above with a 50mm F1.8 lens at f/5.6, and the one at right with a 24mm F2.8 lens at f/4.

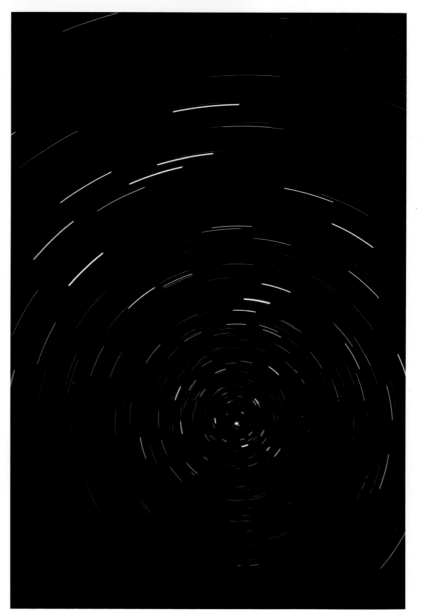

Painting with Light

Another fun technique is using a speedlight, headlamp, or flashlight at night, combining a long exposure with artificial light to brighten areas of a landscape otherwise void of detail in the nighttime darkness. You can add colored gels to your lights for a surreal effect, or simply fire off multiple pops with your flash to illuminate certain sections in your scene.

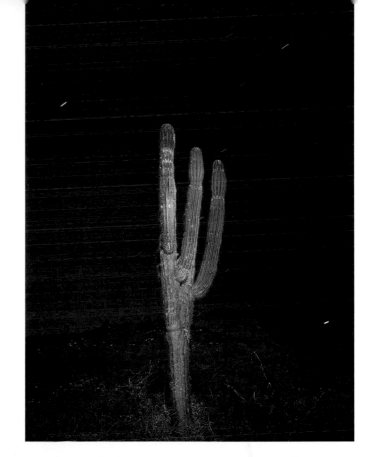

Two examples I've provided came from Southern Baja in Mexico. The image of the cactus was taken in pitch-black darkness, around 11 p.m., by keeping my shutter open (in Bulb) for roughly 5 minutes while I "painted" the cactus with my flashlight, up and down, over and over. The palm tree scene was also exposed for 5–6 minutes, with the camera pointed directly at the full moon hidden behind clouds. I lit the palm trees with artificial lights while the clouds moved, creating a wild result. The constellation Orion and its nebula can be seen just right of the middle. Both scenes were photographed with a medium format camera at ISO 100, the cactus image with a 125mm lens (roughly equivalent to a 50mm lens for 35mm cameras) at $f/4$, and the palm trees with a 50mm lens (roughly equivalent to a 23mm lens for 35mm cameras) at $f/5.6$.

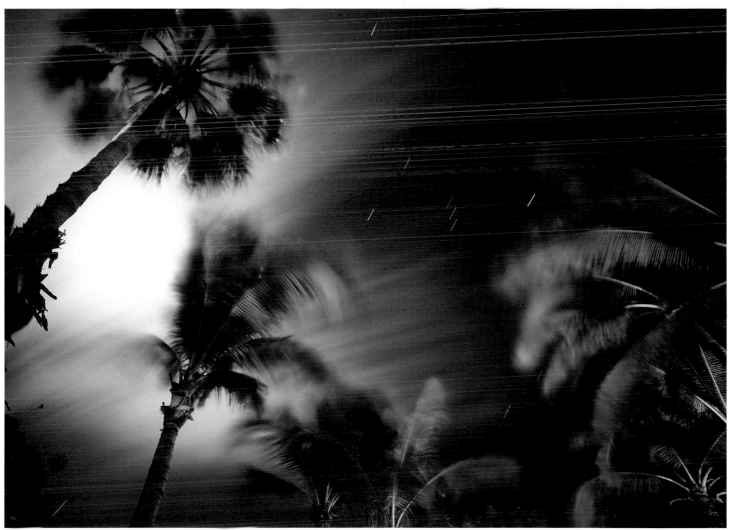

The Moon

One big reason I like to include the moon as an element in my outdoor images is because it adds a little something special as an iconic symbol in our celestial sky. Maintaining detail in the moon is another exposure challenge that eludes most photographers; most over-expose it, turning it into a white ball, especially in automatic exposure modes. As seen in the EV chart in Table 9-1, the full moon at night is nearly as bright as any sunny daytime situation. Therefore, as the levels of available light change around sunrise or sunset, dawn or dusk, balancing the intensity of the bright moon with the darker landscape is extremely difficult because of the high contrast. Unless you time it just right, you're bound to lose detail in one or the other. The key is to photograph a landscape roughly 5–15 minutes after sunset when the full moon is rising (or before sunrise when the moon is setting). The moon's luminosity helps it stand out from the darkening sky (or brightening sky at sunrise), and there is a point at which the contrast between the ground and the moon is within the 5- to 7-stop range your image sensor can handle. At this point, there is a chance of getting detail in both subjects, as I did in chapter 7 with the bird and the full moon (page 172), or in other examples in chapters 3, 4, and 5. If you wait a few minutes longer, the contrast ratio stretches outside of your image sensor's limits. As the moon wanes, its brightness weakens, roughly around 2-1/2 stops in the first or third quarter phases, down to 10 or more stops when it is a crescent shape.

Knowing when you need detail and when you can get away without it is another key to understanding the process. I always prefer to avoid a white ball moon in my skies, but when I can block it with something in my scene, include its reflection in water, or use a wide angle to make it smaller in the frame, overexposure is not as detracting.

The last step when adding the moon to your images is to be aware of its phase and the times of day when it will rise and set. There are many calendars, websites, software programs, and cell phone apps available to provide you with this information. Have this knowledge in hand and you can be prepared to capture a dynamic scene before it occurs.

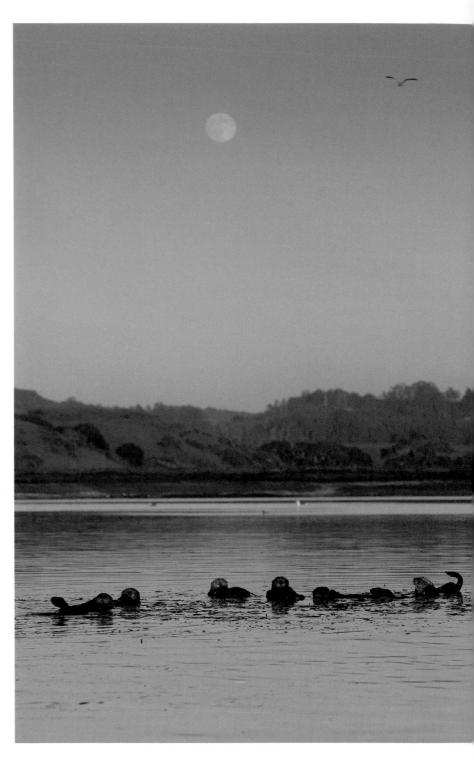

The moon, one day away from being full, rose during sunset as I photographed a raft of otters along the central California coast. I quickly had my driver position the boat in such a way that I could include it in my composition. Using my 70–200mm F2.8 lens set at 105mm, I exposed the scene at f/4 for 1/640 sec. using ISO 200.

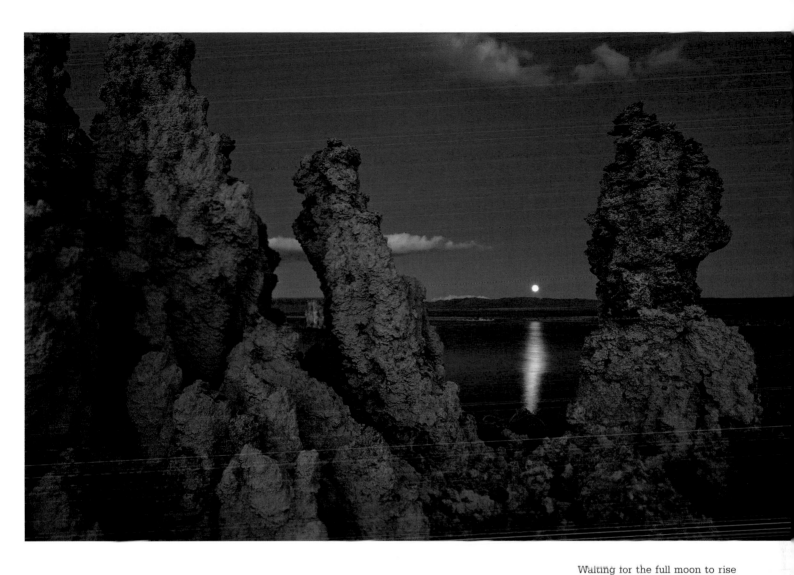

Waiting for the full moon to rise along the shores of Mono Lake, the dusk light diminished to a point where maintaining detail in both was impossible. As I caught the first sliver of the moon, I positioned my camera between the tufa towers and photographed the moment. Exposed at f/11 for 15 seconds, ISO 100.

Our Eyes versus Our Image Sensors

In chapter 4, where I discuss exposure, I explain the difference between our eyes and our image sensors. Our eyes may be able to register more in the way of contrast, but film and our image sensors can see an abundance of light and color, detail our eyes can't, especially in extreme low-light situations, as long as the shutter is left open. Our eyes tend to shut down when it comes to color at night, but this is not the case with our cameras, such as with the moonbow in the Yosemite Falls image earlier in this chapter (page 196). I never saw it, but my camera did. Our cameras can pick up colors in stars and in landscapes at night, scenes that look relatively monotone to us.

MULTIPLE EXPOSURES

Photographing multiple images in one single frame in camera can create wild abstracts, interesting patterns, and surreal scenes. However, advances in post-processing software allow much more control over multiple images than in camera methods these days. This is one of the few aspects of nature photography I would recommend performing after the capture.

But if you choose to play around with multiple exposures in the field, there are a few exposure techniques you should follow. First, finding the functions to control multiple exposures in your camera may require reading the camera manual and may take some time to get used to. Then, following Table 9-2, depending on how many exposures you plan to take in a single image, you must use the proper exposure compensation to create a good multiple exposure. For example, if you meter a cloud scene at f/8 for 1/500 sec. using ISO 100, creating four multiple exposures on a single image would mean underexposing each frame by 2 stops; that is a setting of f/16 for 1/500 sec. using ISO 100, or any combination of equivalent settings.

Table 9-2

Creating Multiple Exposures

Number of photos on one image file	Stops per image to underexpose each capture (exposure compensation)
1	0
2	–1
3	–1-1/2
4	–2
5	–2-1/4
6	–2-1/2

If you plan to add the moon by double-exposing a scene, photograph the moon surrounded by a dark sky to keep other areas of the landscape scene unexposed, and place it in a dark area of the sky in the other capture. In this case, no exposure compensation is needed.

» **tip**

Adding a giant moon to a somewhat normal landscape—for example, a landscape captured using a 50mm lens with a moon that appears to have been shot with a 500mm lens—never looks realistic or believable.

HIGH DYNAMIC RANGE IMAGERY

High dynamic range (HDR) imagery is the process of combining a range of exposures in one scene using post-capture software to collect every bit of detail, from the darkest areas of shade to the brightest elements within a given scene. When HDR imagery came onto the scene around 2006–2007, it was a bit clunky and time-consuming to use. Jump to a few years later, and a mix of programs and plug-ins on the market have made it easier, faster, and truly dynamic. HDR has changed the way we capture many scenes in nature, although most techniques can't simply be thrown away in favor of this new technology. When HDR is used correctly, you can capture scenes that have been impossible to capture any other way in the past 180 years of photography. If HDR is executed poorly, you may end up with odd, unrealistic-looking landscapes that most people assume were digitally altered or enhanced in some way.

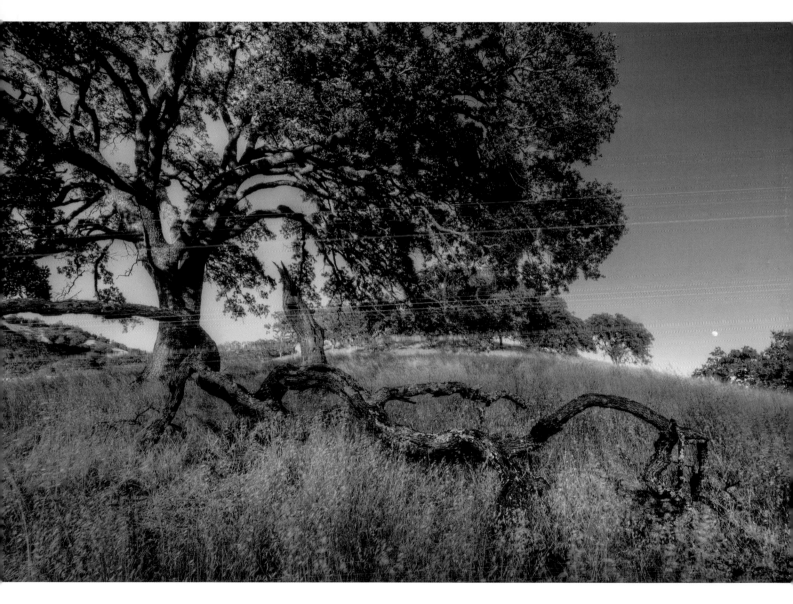

Hiking down a local mountain after a day of shooting, I turned to see the moon rising and realized it could make for a nice HDR scene. Bracketing five exposures to include the range from shadow and highlight detail, I combined the image files with Photoshop's HDR Pro for the final creation.

Although HDR seems to be new to most people, the concept actually dates back to the 1850s. Of course it is much more accessible these days with the advent of digital image files and high-powered HDR software. The process of creating an HDR composite has improved dramatically since Photoshop CS5 and its HDR Pro features hit the market, and the results are better. Software programs such as Photomatix Pro also make creating HDR images simpler, producing top-notch realistic renditions through methods like tone mapping, which reduces the dynamic range, or contrast ratio, of the entire scene, while retaining localized contrast between neighboring pixels. This maintains a true-to-life feel; the final file covers the whole dynamic range while retaining realistic color and contrast. I use both software programs, depending on the scene I photographed. Other manufacturers, like Nik Software, have also jumped into the HDR game with a version called HDR Efex Pro.

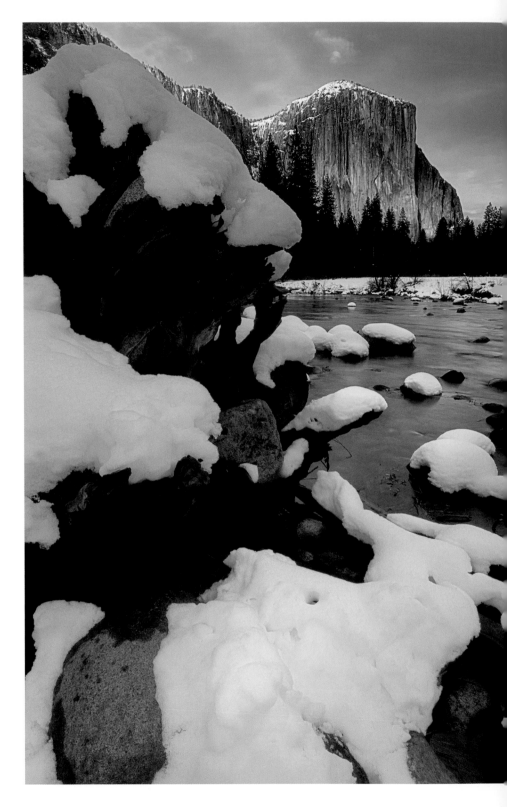

By shooting three separate exposures of this sunset in Yosemite, I was able to maintain full detail in all areas of this high-contrast scene.

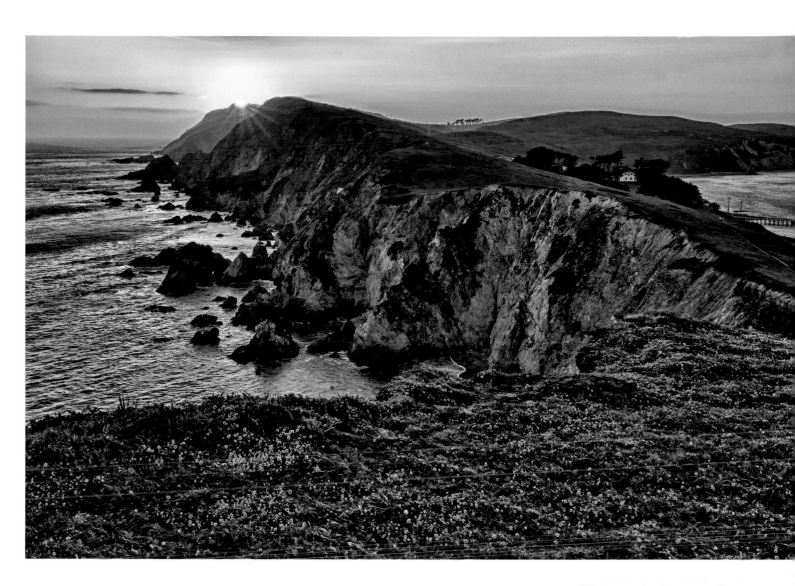

This flowery landscape would have been impossible to capture before HDR imagery. Combining seven exposures gave me the chance to cover more than 12 stops of light in one image file.

The Step-by-Step Process

The process of creating an HDR image is much simpler, but unless you know what to look for from capture to creation, you may be lost in the dark. Many HDR images I see are overdone or should have never been made in the first place. Consider these guidelines to follow when creating your own HDR image:

- Pick the right scene: To produce the best HDR images, the key is searching for scenes with high contrast ratios. A low-contrast scene that can be captured in a single file is usually not worth an HDR creation.

- Know how to meter HDR scenes: You can create an HDR image consisting of three to nine different exposures, so covering the range of exposure from the brightest highlight to the darkest shade is vital if you want to maintain detail. Spot meter these areas to know where your cut-off points are on each end of the spectrum.

- Know how to expose an HDR scene: You can shoot exposures in any increments of stops you wish, but I prefer starting at 1 stop apart. Changing apertures may produce strange results as your depth of field changes from exposure to exposure, so altering your shutter speed is best. The same goes for ISO since the differences in digital noise may also degrade the final image file.

- Consider a still subject: By photographing an unmoving subject, the changes in shutter speed become less noticeable. This is a guideline for HDR imagery, but if you have an interest in ghostly images with wildlife, water, clouds, or people, you may get some interesting results.

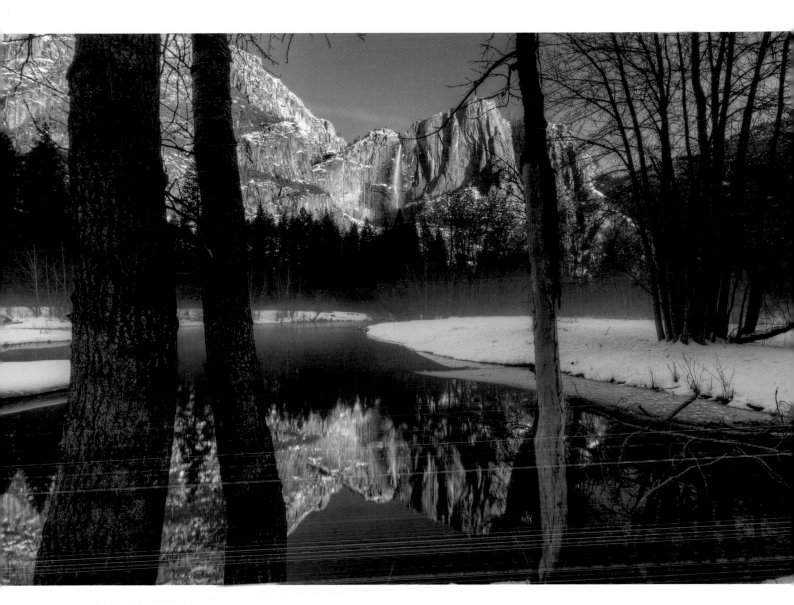

- Get to know your software: Studying your software manual and practicing with your files always helps In getting to know the general process your program follows. Play with each slider in the software and watch what it changes in your HDR image. The more you know what the software can do, the better results you can produce.
- Produce a final HDR image with contrast: HDR is often overdone. Understanding exposure, lighting, and contrast is critical when producing an HDR image file. Although the final rendition may retain detail in all areas, consider reintroducing some contrast to give the feel of realism in your scene. Since the landscape was contrasty to begin with, you will need black shadow areas and bright white highlights. Images with too much processed tone mapping have over-compressed ranges, creating a surreal, low dynamic range rendering of a high dynamic range scene. In more basic terms, too often people exaggerate their HDR images by adding detail to everything, with the results appearing fake and weird, like the over-Photoshopped images we see everywhere these days.

The five bracketed images on the opposite page were the start of the final HDR photograph shown above. The first was exposed at f/22 for 1 second to capture detail in the shaded darker lower-half of the scene. Shooting in 1-stop increments, I increased the exposure to f/22 for 1/15 sec. to expose the bright, sunny highlights on the north wall of Yosemite Valley. All the images were shot at ISO 100.

I love high dynamic range imagery and believe it will, with future improvements, revolutionize digital exposure in many ways. Some manufacturers are already working on DSLR features that combine multiple HDR exposures in one single in-camera image file.

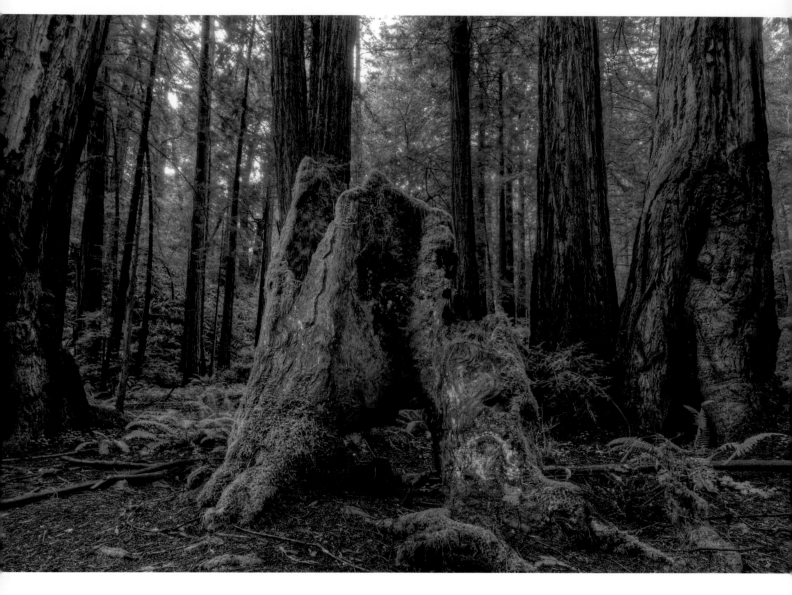

I took six exposures of a scene in Muir Woods and combined them in Photomatrix Pro to create this HDR image, a scene far beyond the range of my image sensor.

AERIAL PHOTOGRAPHY

Photographing nature from the air gives you a perspective unlike anything else, the closest being looking over the edge of a sheer cliff. Whether done out of an airplane, helicopter, hot air balloon, or any flying device, the images can generate many *oohs* and *aahs* from the viewer. The challenges are also great, so here are a few tips to make it a little easier.

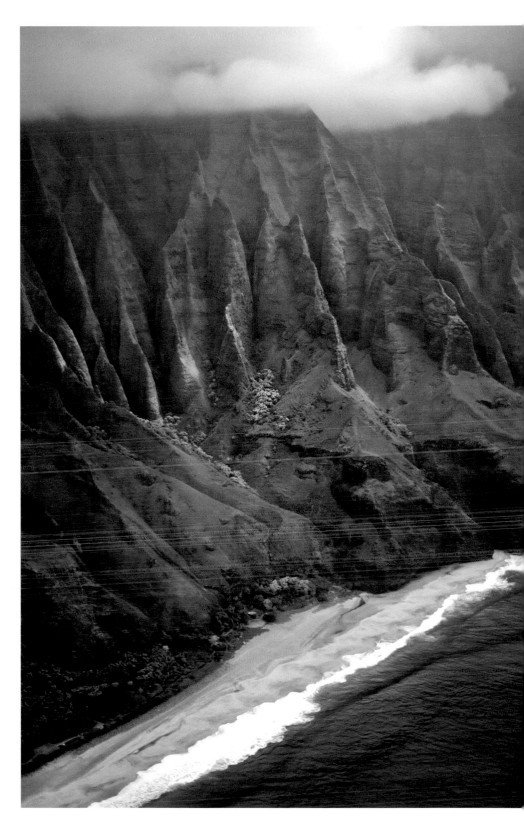

Shooting through a helicopter window, I framed this vertical scene of the Na Pali coast in Kauai and quickly snapped off a few frames before it was gone. Shot with a 70–200mm F2.8 lens set to 70mm, *f*/5 for 1/320 sec. using ISO 100.

Camera Shake

Camera shake is a big problem with aerial photography since you're photographing from a moving object at a distance while trying to maintain the tiniest of detail in a landscape. In the past, when I had to steady my camera from the air, I used a gyro stabilizer to ensure sharp images, since a tripod was useless. A large, heavy, expensive contraption, a gyro stabilizer counteracts your movements, as well as the vibrations of the aircraft, to guarantee a sharp image. They're still used today with still pictures, video, and film, but with the invention of image stabilization and vibration reduction, much of what is needed may be inside your lens already. If you do own an IS/VR lens, be sure to turn that function on for your aerial scenes.

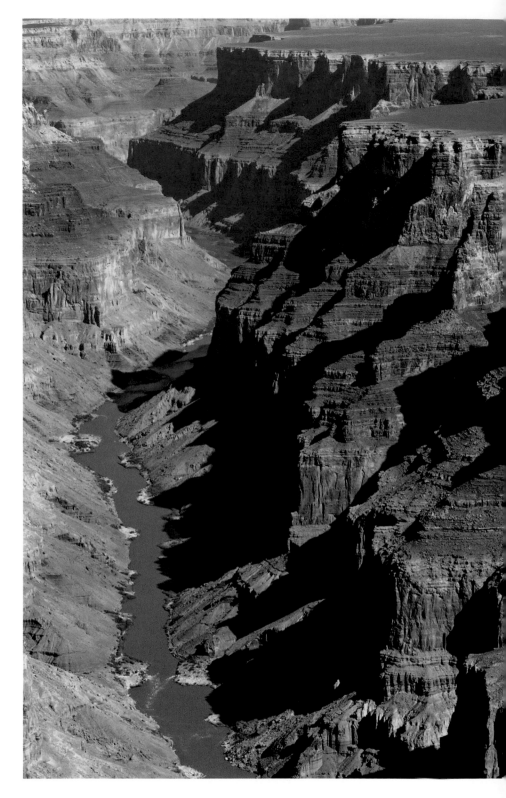

Flying over the Grand Canyon is an amazing experience, and documenting it is quite the challenge. Shooting with a few different camera and lens combinations, I was able to capture this scene of the Colorado River, although after my flight it took every bit of an hour to feel certain that I would not lose my lunch. Photographed with a 80–200mm F2.8 lens, and exposed at f/8 for 1/400 sec. using ISO 100.

Composition and Exposure

Two of the most difficult aspects of creating aerial photographs are controlling composition and controlling exposure. Photographing from a moving airplane or helicopter forces you to shoot fast since the scene in front of you can change dramatically within seconds, making composition with aerial photography very tough. It's almost like capturing sports images, since everything is moving fast. There's no easy advice to give in this case. I say simply compose and shoot, shoot fast, and shoot many photos. Unless you're proficient at photographing in manual using spot metering, the best way to expose aerials is to set your metering mode into Matrix (Nikon) or Evaluative (Canon) and shoot in an automatic exposure mode like Shutter Priority (Tv). Shutter Priority gives you the option to choose the shutter speed you want, and fast shutter speeds are needed to avoid camera shake.

These coastal clouds added to the scene, yet they also fooled my meter, set to Matrix using Shutter Priority, into producing a slightly underexposed image, turning the light gray of the clouds into a middle gray tone. Luckily, with software programs like Photoshop, I was able to correct the exposure without loss of detail. Captured with a 28–105mm F2.8 lens, at f/5.6 for 1/400 sec. using ISO 100.

Shooting through Airplane Windows

The ideal aerial situation is when you can photograph without any type of window in front of your lens. Windows degrade the final image by softening details in the land and potentially adding reflections to the photo. One simple tip to use when you have no choice but to shoot through an airplane window is to hold your camera lens as close to it as possible. By using this tactic, there is less chance of getting the reflection of the interior of the aircraft in your photo and the window is blurred as much as possible, so there is less effect on the quality of your final shot.

Flying above a storm over Northern California at sunset, I could not help but grab my camera from the overhead bin to make some attempt at photographing the heavenly view. Placing my camera directly on the window in the clearest spot and waiting for a moment when the airplane was flying smoothly, I composed this scene and fired off a few frames before we descended. Using my 50mm F1.8 lens, I exposed the sunset at f/2.8 for 1/1000 sec. using ISO 50.

PANORAMIC LANDSCAPES

Panoramic images are photomontages of a series of shots stitched together with post-capture software. This helps to create wide views of a sweeping landscape, giving a viewer an expansive perspective that is usually captured only with our peripheral vision.

How to Create a Panoramic Landscape

To make a panorama using your DSLR, you need two pieces of equipment: a tripod with a bubble level and software to stitch the image together.

A tripod is not required if you prefer to create funky panoramic shots with a bit of style and flavor, but if you want a seamless panoramic image, use a tripod. I've found that without a bubble level on your tripod or camera, it is extremely tough to level your equipment in order to produce a solid, straight panorama. Depending on the lens you use and the scene in front of you, what is level according to the instrument may not appear level to you, so trusting the bubble level is better than trusting your own eye. Bull's eye bubble (or spirit) levels are fine, but I prefer multiple tubular bubble levels to confirm horizontal and vertical leveling. To maximize the perspective of the lens, you should rotate the ball head in a full circle, making sure the bubble level remains completely level throughout.

Then, when you're ready, you can shoot as many images as you wish to stitch together later. I prefer to photograph anywhere from three images with a wide-angle lens, to make a traditional panorama, to nine shots that cover the full 360-degree view. As you capture the images, make sure you overlap each frame in order to retain a smooth transition in the stitching process and guarantee a seamless final version.

Use any lens you wish, although wide-angle lenses create the feeling of standing there. Keep your shadow out of the scene, as well as your camera's and tripod's shadows. One way to do this is to set up in the shadow of a tree, mountain, or rock. Try to implement the same exposure throughout your series of images. This isn't easy, since scenes from different directions can need more or less light, causing contrast ranges to be high. Landscapes in soft, even light are easiest to photograph, but as with any photographic technique, part of the fun is experimenting and going outside the box, which results in occasional failure but sometimes great success.

Two types of bubble levels on tripod ball heads, great for panoramic landscapes when you shoot a number of images to combine in post-capture, needing all to be as level as possible.

A number of companies offer panoramic stitching software, including ArcSoft's Panorama Maker, Photoshop and Photoshop Elements, and Calico. I use Calico since it creates seamless panoramas quickly and easily, yet I have noticed that Panorama Maker is most accurate and seamless with fewer ghost effects.

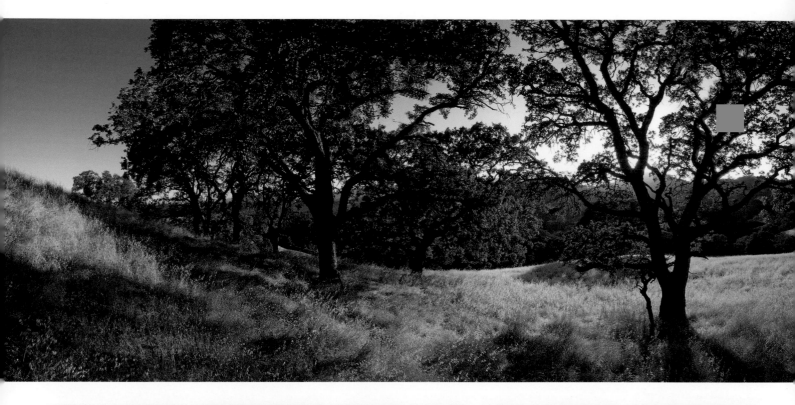

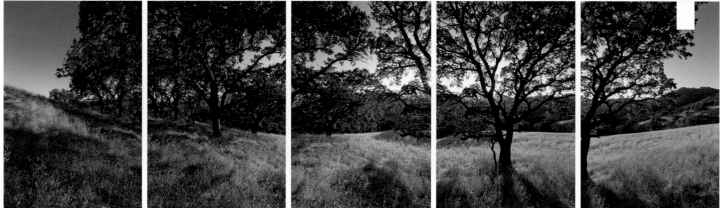

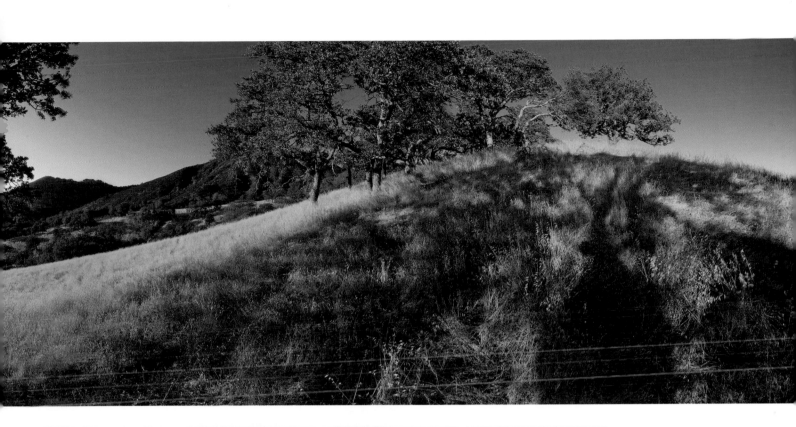

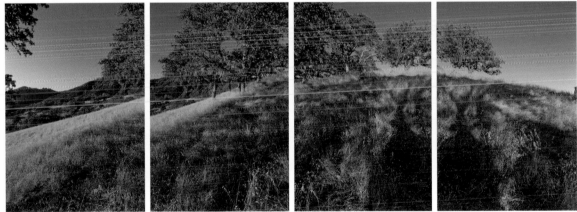

Using my 12–24mm lens, I combined nine images in Calico to give a full-circle view of an oak woodland scene in Mount Diablo State Park. Later, using ArcSoft's Panorama Maker, I created a Quicktime movie and loaded it to my website, giving the viewer a chance to spin the image in all directions. Each frame was shot at *f*/22 for 1/6 sec. using ISO 100.

Nature Assignment #9:
Capture and process an HDR image

Find a scene that warrants the need for a high-dynamic range image, a landscape with such high contrast that it would produce a less desirable photo even with the best exposure you could obtain. Take a series of bracketed exposures and combine them using HDR software.

While shooting your HDR image, study your exposures after you create your final version, compare the differences between each single shot and your HDR creation, and decide if your scene was worthy of this new technique.

For this sunset landscape on McClures Beach in California's Point Reyes National Seashore, I bracketed five separate exposures using my 12-24mm lens set at 16mm. The first exposure was for 1 second and the last for 1/15 sec. (in 1 stop increments), all using ISO 100 and *f*/22 aperture settings to insure the same depth of field for each frame. This allowed me to combine the images in Nik software's plug-in HDR Efex Pro, through Photoshop, giving me detail in the darkest areas of the sand while maintaining rich orange tones around the bright setting sun.

CHAPTER TEN

POST-CAPTURE WITH DIGITAL NATURE FILES

Edward Steichen once said, "When that shutter clicks, anything else that can be done afterward is not worth consideration." Unfortunately, Steichen wasn't able to photograph during the digital age, when so much can be done after the snap of your shutter, but he does have a point. You can take a great shot and fine tune it in Photoshop, but you can rarely turn a mediocre image into something amazing.

On occasion, someone will say to me, "Wow, you really do good work in Photoshop." The funny thing is that most of what becomes my final image is not done with post-capture editing techniques. It took many years to get to the point where my images matched my experiences. The time spent planning shots and knowing what to do when I arrive at a scene is what usually defines my photographs, not the prepping or altering the image after the fact. Nevertheless, there's no reason not to profit from the digital process. Think of the camera's exposure as the recipe, or items you carefully select and mix together, and Photoshop as the oven you cook it all in. You need both to prepare a high-quality final creation. Post-processing is quite different from what we do in the field, yet not all that different from what photographers in earlier times had to do in the darkroom, except that now it is performed with a keyboard, mouse, and monitor instead of in a blacked-out room with an enlarger and a red light.

Many feel computer-based post-processing has made the process of photography easier, but I disagree. Photographers today must have not only an eye to find an image and the skill to use an assortment of photo gear, but also knowledge of and expertise in a collection of software programs, not to mention the budget to afford it all. It's not easy to navigate through the plethora of information in programs like Photoshop, nor can I cover them in one chapter, let alone one book. For this final chapter, I'll present a starter kit on how to process and store your outdoor image files in our ever-changing digital world.

CALIBRATING YOUR MONITOR

A high percentage of my images never make it to print form; most are viewed on my monitor. I process all of my digital images using my monitor as well, checking color, contrast, tonal range, and detail, so knowing if my monitor is calibrated in the most accurate way is important to the quality of my work. Having a poorly calibrated monitor can cause many problems. A dark, contrasty screen or a bright, flat monitor can fool you into adding or subtracting contrast from your scenes, altering an exposure that may not need to be changed, resulting in detail loss and less-than-optimal final image files. Having your screen shifted toward warm or cool tones can also throw the original color out of kilter.

Many options are available for color calibrations, but I prefer to use X-Rite's tools and software including ColorMunki Photo and ColorChecker Passport. ColorMunki Photo is geared toward monitor calibration and printer profiling, while ColorChecker Passport offers a new way to color match your scenes accurately by photographing a color chart in the field to create a custom profile at capture. This does require carrying one more piece of equipment, but the chart is as small as a cell phone and easy to use, and it enables you to get the exact colors you saw when you shot the image.

If you choose not to color match your outdoor scenes, at the very least you should calibrate your computer monitor. This ensures the most accurate color rendition, brightness, and contrast. Color management is like a digital darkroom thermometer; if you don't use one, you have no idea if your colors are accurate from the start. With calibration hardware and software like ColorMunki, the advantage of creating your own profile is that it's geared toward your monitor, your printer, and your paper, giving you the most accurately matched results.

When dealing with an image that has a wide contrast range and large color gamut, nailing every subtle color and tone becomes vital to the success of the photograph. This Grand Canyon sunset was documented with a 24mm F2.8 wide-angle lens, set to *f*/22 for 3 seconds using a 3-stop graduated neutral density filter, at ISO 100.

YOUR DIGITAL WORKFLOW

In chapter 1, I discussed the importance of preparation. As we close out the process of nature photography, the final step is having a fast and efficient process to review, open, save, and file your images so they can be accessed quickly and easily at a later time. I get asked all the time how I go about my digital workflow. The process has changed over the years as new software programs hit the market, but the organizational elements are still the same. There are a number of ways to do this, but the best way I have found is to be methodic in my approach, repetitive in the procedures, and archival in the process. From uploading and reviewing my images a certain way, to creating batch processes through Photoshop actions to repeat simple editing tasks in an efficient manner, to cataloging and storing my photos in specific locations, this is my system for keeping my image files consistent and my post-capture time to a minimum. Make sure your steps are easy, time efficient, and flexible.

Importing

Rarely if ever do I leave memory cards full without immediately downloading and backing up the images on my computers and external hard drives. I have yet to lose a digital image, and I don't plan to. Once I return from a trip, whether that evening or after a week of shooting, I immediately offload my images, and I don't erase the cards until my next shoot, just in case something happens to the files in my office. You can import images straight from your camera using the USB cord provided with your DSLR, but UDMA card readers allow you to bring images into your computer much faster. If you import a few images, it's no big deal, but import thousands over months and years and the time you save really adds up.

Reviewing

It's not easy to figure out which programs you may need, but Adobe's Lightroom and Apple's Aperture are slowly combining post-capture editing software and image databasing into one collective software package. There are many other programs on the market, but these two have become the standards in the industry for bringing out the most in your digital files with the capability of processing one, a few, or hundreds of raw images at a time, leading the way in digital workflow software. I use both to quickly scan and adjust raw files, then I use Adobe Camera Raw (ACR) to fine-tune the raw file and Photoshop to prep and save the final file. Photoshop can review photos using Bridge, a powerful media manager that uses ACR and makes it easy to organize, browse, locate, and view files. As with any piece of photo equipment, if you don't study the best ways to use the programs correctly and efficiently, you can actually do more damage to your images while wasting a great deal of time.

EXIF Metadata/GPS

Exchangeable image file format, also known as EXIF metadata, gives you access to a bunch of shoot information embedded in every image file captured in camera. You can learn a lot about your images from your exposure information, especially if you study your images after the capture. The type of information recorded in each file varies by camera manufacturer and model, and can include:

- Camera information: Make and model, copyright or camera owner, and any additional information you may have added, depending on your camera's metadata options.
- Color Space and White Balance settings.
- Date and time the photo was captured, often noted down to the second.
- Exposure: Shutter speed, aperture, ISO setting, exposure mode, metering mode, and exposure compensation.
- Flash: If your unit fired or not, and whether red-eye was on or off.
- Lens: From prime/fixed focal length to zoom lenses, showing the specific millimeter settings used as well as the auto/manual focusing mode.

» **tip**

After you import your files, copying them to an external hard drive, archiving them onto gold DVDs, and storing these backups at another location gives you the peace of mind of knowing that your images will be saved and protected.

- Orientation: Recognizing if the scene was captured horizontally (landscape) or vertically (portrait), opening the file accordingly depending on the software program.
- Resolution and amount of compression: Resolution in pixels per inch, whether in raw, TIFF, or JPEG format.

EXIF metadata can be accessed through your camera menu or through imaging software, such as Adobe Elements or Photoshop, which may allow you to see more specific information. It should be noted that EXIF metadata doesn't record information such as filters used, the direction you were facing, or any off-camera strobes (flash) you may have decided to use.

A GPS unit attached to your DSLR is another option for geotagging your files; this records the latitude, longitude, altitude, and time information for each image. Many software programs incorporate this information and can pinpoint the locations of your images on a world map.

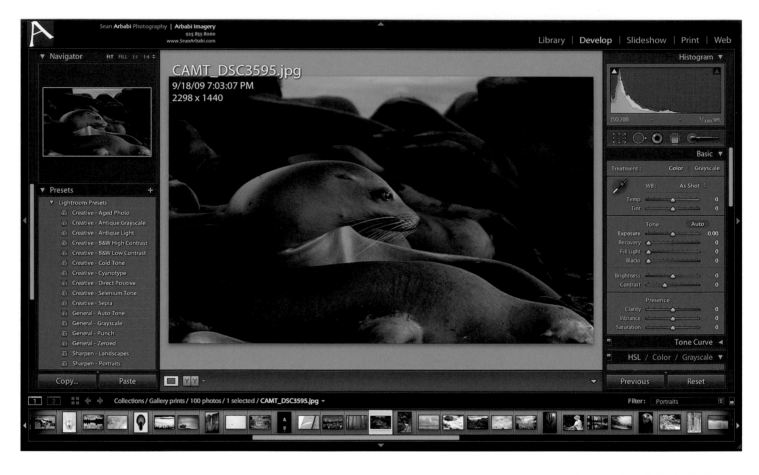

A screenshot of Adobe Lightroom (above) and Apple's Aperture (opposite) digital workflow software applications.

Adobe Camera Raw (ACR)

Opening raw files is one of the most important steps in post-processing. Once you have spent the time planning your outing, finding the best scene, dealing with weather, and metering and exposing your scene correctly, if you don't process your raw file well, you could end up losing some of the quality of your efforts.

ACR is another step in post-processing where quick functions can save you time. Recent upgrades in Photoshop include automatic image straightening, a white balance tool, a rule of thirds cropping tool, a color picker, a grad ND filter, and the ability to save 16-bit images as JPEGs.

Certain sliders, such as Recovery, can actually change the color and tones in certain areas of your image if it's used too strongly. This might be good or bad, depending on the area it changes. I rarely move my recovery slider past 50 (on a scale of 0 to 100) in any of the adjustments, and I do so only if it recovers the areas I desire, as opposed to certain subject matter I wish to leave alone, such as white snow. Another tendency is to drag the Vibrance or Saturation sliders up, oversaturating an outdoor image that may have been colorful to begin with. When processing raw, my main goal is to pull out more detail and set proper color, while creating an accurate representation of the original scene. When it comes to nature photography, in Photoshop the general rule has always been to make only minor adjustments if you want to keep your scenes looking real.

Before you open the file in Photoshop, check the workflow options at the bottom of the window. I open my raw files in Adobe RGB 16 bit, at the resolution and size of the original image. ProPhoto RGB is another color space option when opening raw image files. It contains the largest color space coverage and is used in the printing process.

Color Correcting

For a majority of lighting and color situations I'm able to correct any potential color shifts when I initially open the file in ACR by using the White Balance tool in combination with the Temperature and Tint sliders, referencing either a WhiBal gray card I've placed in the scene or a neutral gray area within the scene itself. Having some experience in judging color can help, but as with any raw file, returning to camera defaults is always an option. In Lightroom and Aperture, I can adjust white balance by batch processing a number of images, which can save a ton of time. However, recognize that all of the files adjusted together in a batch should be in the same color temperature range. That way you're accurately adjusting a group of similar images all at once. Having this control in Aperture, Lightroom, and Photoshop, combined with the fact that it's not processed in a raw file until opened, makes white balance one digital feature that is easy to correct post-capture.

A screenshot of Photoshop's Adobe Camera Raw showing the histogram and sliders used to adjust raw files.

Making Exposure Adjustments

Since no one, including myself, has the ability to produce perfect exposures in every outdoor situation, adjusting the exposure in post-processing to get the look and effect you desire is a great feature of the digital process. When using any digital workflow program to adjust raw files before opening them, one window to watch as you make exposure adjustments is the histogram. Although I don't believe it is the greatest tool to use in the field, it is one to consider using in post-capture editing. By watching the histogram as you move the Exposure slider brighter or darker, or adjust your Recovery slider, you can monitor your highlight and shadow detail, making sure one, the other, or both are maintained.

Another great tool is the Graduated filter, basically a fully controllable grad ND filter. It is great for any image in which you want to darken the sky, but wonderful for shots taken with lenses longer than 50mm (since normal grad ND can't work on these lenses). I have complete control of the filter, with exposure adjustments from 1/20 stop to 4 stops, giving me the ability to produce finely tuned effects I couldn't in the field. These are the tasks I like to use Photoshop for, those I could not do in the field because of the limitations of my equipment, instead of creating something that was not there in the first place.

The last exposure tool I will talk about is the Adjustment brush. This acts like a dodging or burning tool, yet it gives you the option, after using it, to adjust the exposure in that area by moving the Exposure slider, and it's a fantastic way to increase or decrease tones in certain places within your scene in a calculated, controllable way.

When it comes to fixing exposure errors with outdoor images, the major concerns should be:

- Creating an image that looks unrealistic, unless you prefer surreal digitally altered imagery.
- Causing deterioration, most noticeably in shadow areas where digital noise and potential banding issues occur.
- Losing highlights when attempting to bring out more shadow detail.

For these reasons, you can't make all of your adjustments in Aperture, Lightroom, or ACR. You may have to work with specific tools within Photoshop to bring out detail important to your scene. When in Photoshop, the History tool is an excellent way to judge your changes, to see if you've gone too far or just far enough

Photoshop Filters and Plug-ins

There are Photoshop filters that emulate warming and cooling effects, much like warming and cooling filters, as well as others, including the graduated ND filter I mentioned. A multitude of plug-ins are also offered by companies like Nik software or Alien Skin software. These filters can create, change, alter, or enhance your scenes. They can improve detail through sharpening functions, or add color and effects, even including looks that match a variety of films from the past. Noise reduction software is included in the latest versions of Photoshop, but plug-ins provide the chance to cut digital noise, adding smoothness to your images while maintaining detail in all subject matter. I use Neat Image and Topaz DeNoise, which offer plug-ins for Aperture, Lightroom, and Photoshop. I wouldn't recommend using in camera noise reduction, since it is usually not as good as post-capture plug-ins.

Screenshots of Topaz DeNoise (above) and Neat Image (opposite), two noise reduction software plug-ins.

Converting Raw to PSDs or TIFFs

The beauty of a raw file is that it can always be accessed and stores not only the original unprocessed information (known as the camera raw defaults) but also any changes made in a raw converter such as ACR or Apple's Aperture. Generating final files from raw images is no different than a photographer producing a fine art print from a negative. Before raw made it to the digital party, the TIFF file format was the best option for capturing digital images in their highest form. TIFF files can be uncompressed or compressed, yet still retain full image quality. Compression is a nice aspect of a TIFF file because it can be done without losing any information (also known as lossless compression), and thus can conserve disk space. I save my prepped raw files as TIFFs or PSDs and preserve all of my layers, paths, masks, and all other file components in an uncompressed format (whereas JPEGs lose layers once you close and open the file).

Color to Black-and-White Conversion

Another marvelous feature of digital nature photography is the precise control you have when converting a color image to black and white. To the untrained eye, color is incredibly difficult to judge when it comes to transforming it into a tone, particularly when in the field. Certain hues seem to pop off of others, but if you judge their tone or change them to black-and-white, you realize they're closer than you think, or match exactly. The masters of black-and-white photography worked with tonal ranges, and by choosing images based on light and form, and through dodging and burning processes in the darkroom, they were able to create their masterpieces. This is why I choose very specific images to convert, ones that transfer well into black and white, where subject matter, light, and form are accentuated by tonal values. Not all images work; some look better in color and others are natural black-and-white conversions. Many software programs have black-and-white conversion tools that offer sepia toning or duotoning and presets that match filters used in black-and-white photography.

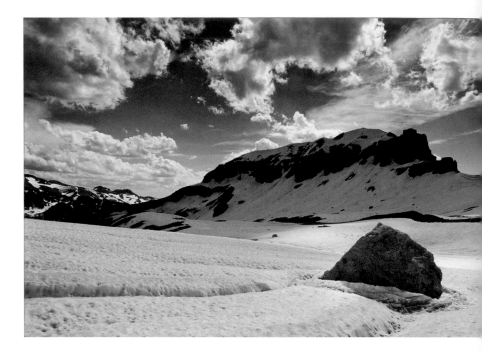

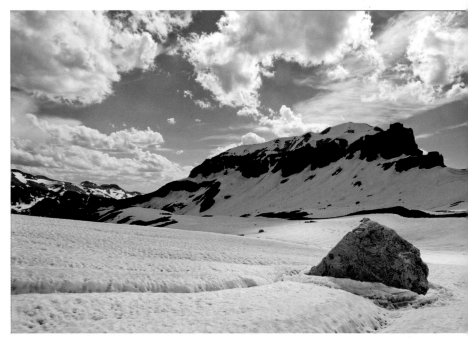

Photographing a glacier on the backside of the Grand Tetons, I had a feeling the color tones, clouds, and light would transfer well into black and white. The landscape was originally captured with my 24mm F2.8 wide-angle lens, set to $f/16$ for 1/50 sec. using ISO 100, then converted to black and white using Nik software's Silver Efex Pro.

DIGITALLY ALTERING NATURE

There are so many ways to alter your outdoor images post-capture through a variety of software choices. If I had the ability to create everything in the computer, I don't think my imagination could match the scenes I find in nature. In most cases when I open a file, I make minor adjustments, remove any dust or spots, and attempt to match the natural tones and light I saw when I was photographing the scene. I may also remove small human artifacts—a small sign or street light in the distance, an airplane's contrail, or a telephone wire—correcting or fixing an image otherwise solid in quality. Although I rarely do this, I consider most photos with inconsequential changes to still be straight photographs.

When it comes to larger manipulations of my outdoor images, I may create something completely out of this world, making it obvious to most that it is not real, or I may simply add an element or two to the scene—the moon, an animal, a person—that may appear bona fide to most. Regardless of which path I take with software editing techniques to create these altered images, I market both renditions as digitally altered photo illustrations.

Adding the Moon

The ability to add a moon to your images digitally negates the need to do so using multiple exposure techniques. By including the moon, you can create a dramatic or realistic photo illustration. If done in a realistic way, attention to detail in regard to matching the actual light, exposure, and size of the moon as compared to the lens used is critical. If used for dramatic effect, all of that goes out the door. Just recognize that there is a fine line between fantasy and cheesy.

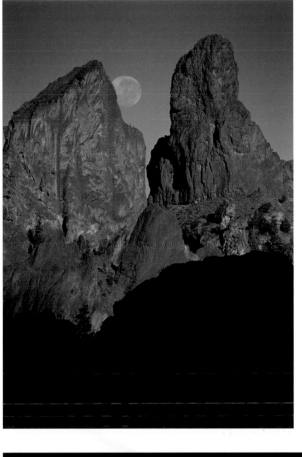

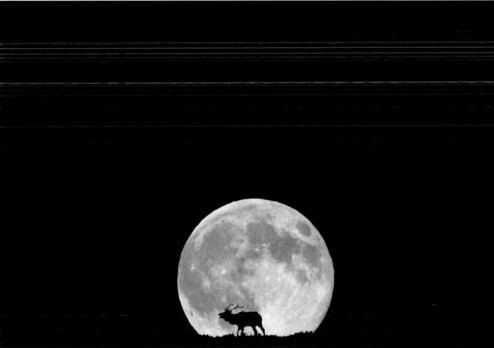

Here are two scenes in which I added the moon after the fact for dramatic effect. The first is a sunset in Argentina, in which the moon is incorporated in a realistic way, and the second is a sandwiched image of a tule elk and the full moon—possible to capture in real life with a very long lens and a lot of luck.

ORGANIZING AND CATALOGING YOUR DIGITAL FILES

Digital asset management is just a big word for organizing all of your images into a visual database that allows you to view, reference, and use the thousands of images you capture. Many companies make these programs for both Mac and PC, including Microsoft's Expression Media 2 (now owned by Phase One), Extensis's Portfolio, and Apple's iPhoto (bundled in their digital lifestyle application called iLife). Import your images into a database and organize your images by name, date, event, or keyword. Many databases also permit you to add additional albums or galleries and offer direct ways to order prints, print photo albums, or create slide shows.

I categorize my images by geographic region using Extensis Portfolio as my professional database, giving me the power to cross-reference tens of thousands of images in a single application. I can sync folders that change when I add new images, add caption and keyword files, or import that information from the original image file. When it comes to captioning my images, I chose a letter and number system more than 20 years ago that is still in effect. This way I can also search for an original file by number. As a pro, I'm all about obtaining detailed facts and figures about the areas I photograph, so I add as much information as I can to each photo. The process is long and tedious, but the information is a recorded history of the places I've photographed, the people I've met, and the moments I've experienced as a nature photographer.

Nature Assignment #10: Process a raw nature image

Import and edit one of your raw nature shots to correct potential white balance issues, color saturation, and exposure problem areas. Attempt to recover areas without altering color, then open the file, make minor adjustments as needed, save, and archive it.

While working on this assignment, record the steps you take in Photoshop's Adobe Camera Raw in regard to the sliders and the numbers used before opening the raw file. Make a note of the process so you can attempt to duplicate it at a later time.

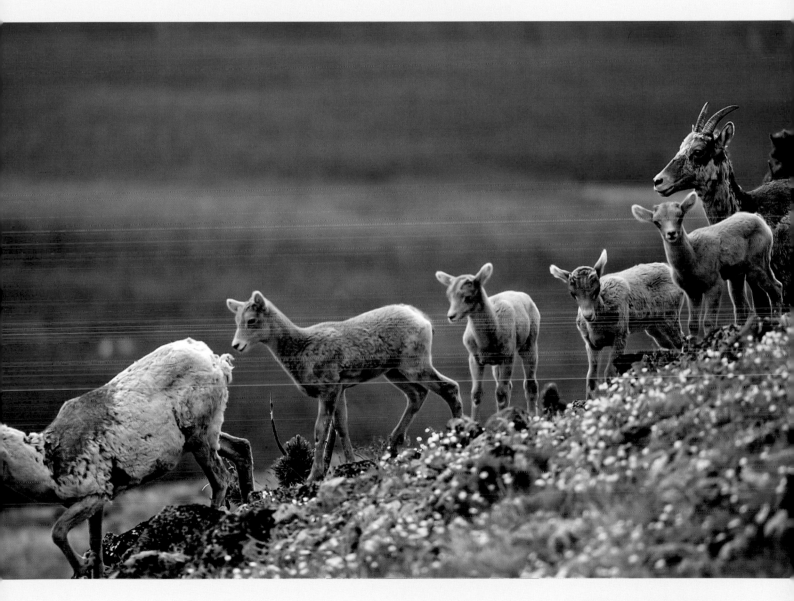

For this last assignment, I prepped an image captured in Yellowstone National Park, correcting the slight blue shift from the white balance preset, recovering a tiny bit of detail in the bighorn sheep fur, and saving the TIFF file to my computer, adding a copy to my backup files.

ABOUT THE AUTHOR

As a 43-year-old commercial photographer and native Californian, Sean Arbabi specializes in adventure, lifestyle, nature, and travel imagery for advertising, corporate, and editorial clients. In 1991, with a bachelor of arts degree in commercial photography from Brooks Institute of Photography, he embarked on a career that has been successful for the past 20 years, with images captured from all around the world.

Today, Arbabi shoots in medium format and 35mm, digital and film, and brings a background of on location, studio, outdoor, lighting skills, and experience to every job. His assignment travels incorporate much of the United States as well as international locations, including Canada, Mexico, Europe, Asia, and South America. His stock image files, currently more than 400,000 images, have been published worldwide in advertisements, books, brochures, magazines, newspapers, and websites. He has had freelance and contracted assignments with more than 250 publications and 150 companies, including American Express, *Backpacker*, the California Division of Tourism, Endless Vacation, Fuji Film USA, GEO Germany, *National Geographic,* the *New York Times*, Nikon, the North Face, Outside, REI, Sunset, Timex, and Via.

Sean is developing a television show on photography, and his first book, *The BetterPhoto Guide to Exposure*, was published in January 2009 (Amphoto/Random House), landing in the top fifty photo books numerous times and selling thousands of copies around the world. His television appearances, radio and newspaper interviews, Web, and podcasts include The View From the Bay (ABC7 KGO-TV, San Francisco), ABC Radio WPKT Southeast, Inside Digital Photo Radio, *Rangefinder* magazine, *Sunset* magazine, The Candid Frame podcast, and the Bay Area News Group.

Over 20 years as a professional photographer, he has backpacked over mountain ranges, helicoptered above jungles, ridden horseback across plains and mountains, rafted down rivers, mountain biked along forest trails, sailed on oceans, and hung over cliffs, all to capture images he and his clients were seeking. Photography is Sean's passion. Down-to-earth, easygoing, and fun to work with, he takes pride in being a professional photographer and businessperson, and feels lucky to succeed in a career that provides so much happiness.

He resides with his family in the San Francisco Bay Area, base camp for all his travels. During his off time he defuses bombs, kisses babies, designs killer paper airplanes, and makes a mean chicken and rice with Thai peanut sauce.

RESOURCES

Digital Equipment, Photo Gear, Photography Instruction, Software and Editing Programs

Here are some of the companies and products I used for the production of this book and use on a regular basis in my photo business—the best software, photo gear, and accessories I can recommend.

Acratech Inc.
Pro photographic and imaging products, great tripod ball heads
Acratech.net
2502 Supply Street, Pomona, CA 91767
909-394-1802

Adobe Systems Inc.
Software: Photoshop, Photoshop Elements, Lightroom, Bridge, Adobe Camera Raw
Adobe.com
345 Park Avenue, San Jose, CA 95110
800-833-6687

Apple Inc.
Computers and software: Aperture, iLife (includes iPhoto), Mac desktops and laptops; I have used Apple for more than 20 years for all my business needs
Apple.com
1 Infinite Loop, Cupertino, CA 95014
800-676-2775

Arbabi Imagery/Sean Arbabi Photography
Images, information, photo workshops, products, fine art prints
SeanArbabi.com, Photogurutv.com
Facebook fan page: facebook.com/pages/
Arbabi-Imagery-Sean-Arbabi-photography/122003760806
Flickr page: flickr.com/photos/arbabi/
Twitter page: twitter.com/thephotoguru
Book: *The BetterPhoto Guide to Exposure* (Amphoto/Random House, 2009; ISBN 978-0-8174-3554-7)

ArcSoft, Inc.
Panorama stitching and multimedia software provider
Arcsoft.com
46601 Fremont Boulevard, Fremont, CA 94538
510-440-9901

The BetterPhoto Guide to Exposure
Sean Arbabi's first book on photographic exposure
Amphoto Books
ISBN: 978-0-8174-3554-7
Available wherever books are sold.

Bogen Imaging Inc./Gitzo/ Manfrotto
Tripods, light stands, filters, video equipment
Bogenimaging.us
565 East Crescent Avenue, Ramsey, NJ 07446
201-818-9500

Bokeh
iPhone application for hyperfocal distance and depth of field. Visit iTunes to download the Bokeh free application.
Lars-oppermann.com/bokeh/

Calumet
Photographic equipment and software retailer
Calumetphoto.com
1111 North Cherry Street, Chicago, IL 60622
800-CALUMET

Camera West
Photographic equipment and software retailer; two locations in California: Rancho Mirage and Walnut Creek
CameraWest.com

Digital Photo Academy
The leader in in-person photographic workshop courses, including Sean Arbabi's San Francisco courses
DigitalPhotoAcademy.com
877-372-2234

Epson
Color printers, ink jet paper, scanners, and supplies
Epson.com
3840 Kilroy Airport Way, Long Beach, CA 90806
800-463-7766

Extensis
Digital image management software: Extensis Portfolio
Extensis.com
1800 SW First Avenue, Suite 500, Portland, OR 97201
800-796-9798

FujiFilm USA, Inc.
Camera equipment and film
Fujifilmusa.com
200 Summit Lake Drive, Valhalla, NY 10595
800-800-FUJI

Hoodman Corporation
Hood loupes, memory cards, digital camera accessories
Hoodmanusa.com
20445 Gramercy Place, Suite 201, Torrance, CA 90501
800-818-3946

Hunts Photo and Video

Photographic equipment and software retailers since 1889
Huntsphotoandvideo.com
100 Main Street, Melrose, MA 02176
800-221-1830

Joby

GorillaPod lightweight and flexible tripods—compact and
bendable
Joby.com
1535 Mission Street, San Francisco, CA 94103
888-569-JOBY

Kata

Lightweight protection for photographers: cases, rain
covers, photo bags, vests
kata-bags.us
565 E. Crescent Avenue, Ramsey, NJ 07446
201-818-9500

Lacie

External desktop and portable hard drives, digital storage
Lacie.com
22985 NW Evergreen Parkway, Hillsboro, OR 97124
503-844-4500

LensBaby

Flexible lens mounting system for soft focus and other
creative effects
LensBaby.com
516 SE Morrison Street, Suite M4, Portland, OR 97214
877-536-7222

Lightware

Photo cases: lightweight, airline shippable, and portable
Lightwareinc.com
1329 West Byers Place, Denver, CO 80223
303-744-0202

Neat Image

Digital noise reduction software, Aperture and Photoshop
plug-in software for Mac or PC
Neatimage.com

Nik Software, Inc.

Software for digital imaging and photography
niksoftware.com
7588 Metropolitan Drive, San Diego, CA 92108
619-725-3150

Perfect Picture School of Photography (PPSOP)

The leader in online photographic workshop classes, includ-
ing Sean Arbabi's online courses
ppsop.com
877-428-8730

Pelican Products Inc.

Photographic cases, tripods, memory cards, digital media,
and accessories
Pelican.com
23215 Early Avenue, Torrance, CA 90505
800-473-5422

Promaster Digital

Photographic equipment, tripods, memory cards, digital
media, and accessories
Promaster.com
360 Tunxis Hill Road, Fairfield, CT 06825
203-336-0183

Rawworkflow.com, a division of PictureFlow LLC

WhiBal certified white balance reference cards
Rawworkflow.com
4068 Chastain Drive, Melbourne, FL 32940
321-752-9700

REI/Recreational Equipment Inc.

Outdoor and camping equipment; locations in 28 U.S. states
REI.com
800-426-4840

SanDisk Corporation

Memory cards and flash drives
Sandisk.com
601 McCarthy Boulevard, Milpitas, CA 95035
866-SANDISK

Sekonic

Photographic light meters
Sekonic.com
8 Westchester Plaza, Elmsford, NY 10523
800-462-6492

Singh-Ray Corporation

Filters: graduated neutral density, polarizers, and more
Singh-ray.com
153 Progress Circle, Venice, FL 34292
800-486-5501

Tamron
Lenses
Tamron.com
10 Austin Boulevard, Commack, NY 11725
800-827-8880

Think Tank Photo
Photo backpacks, luggage, and accessories
Thinktankphoto.com
3636 N. Laughlin Road, Suite 170, Santa Rosa, CA 95403
866-558-4465

Topaz Labs LLC
Photography software and plug-ins (including Topaz
DeNoise)
Topazlabs.com
5001 Spring Valley Road, Suite 400, East Dallas, TX 75244
972-383-1588

US National Park Service
NPS.gov
1849 C Street NW, Room 7012, Washington, D.C. 20240
202-208-6843

X-Rite/Mac Group
Color calibration hardware and software
Xritephoto.com
8 Westchester Plaza, Elmsford, NY 10523
800-462-6492

INDEX

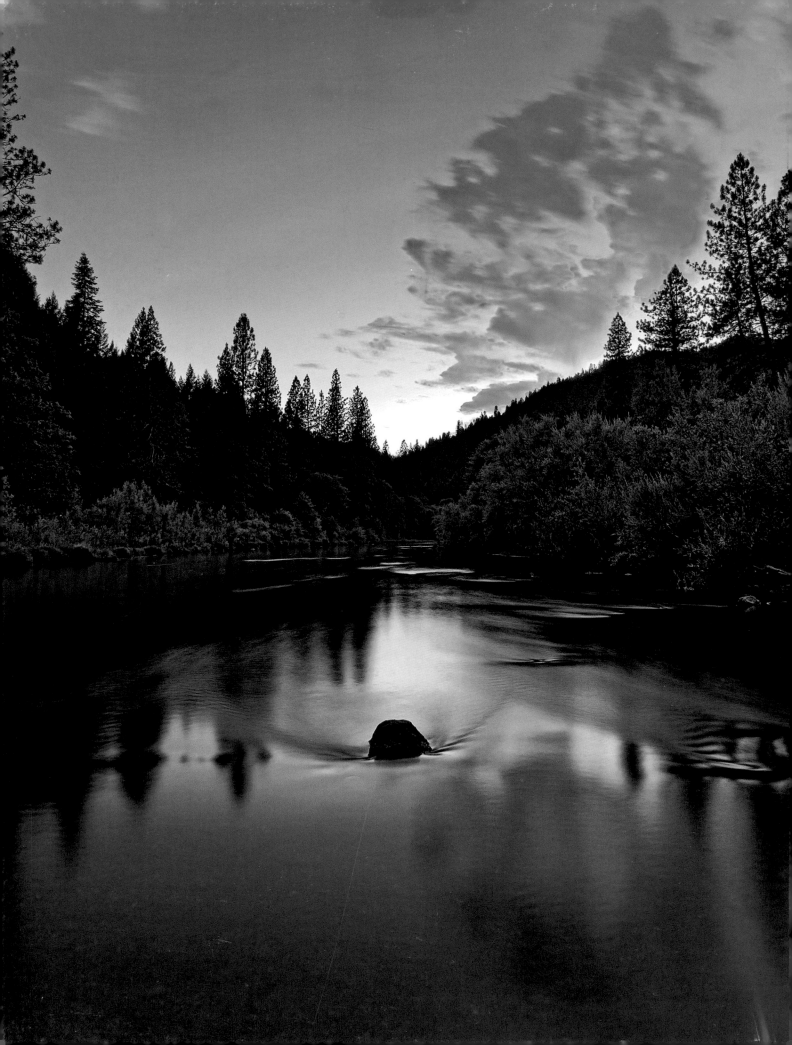